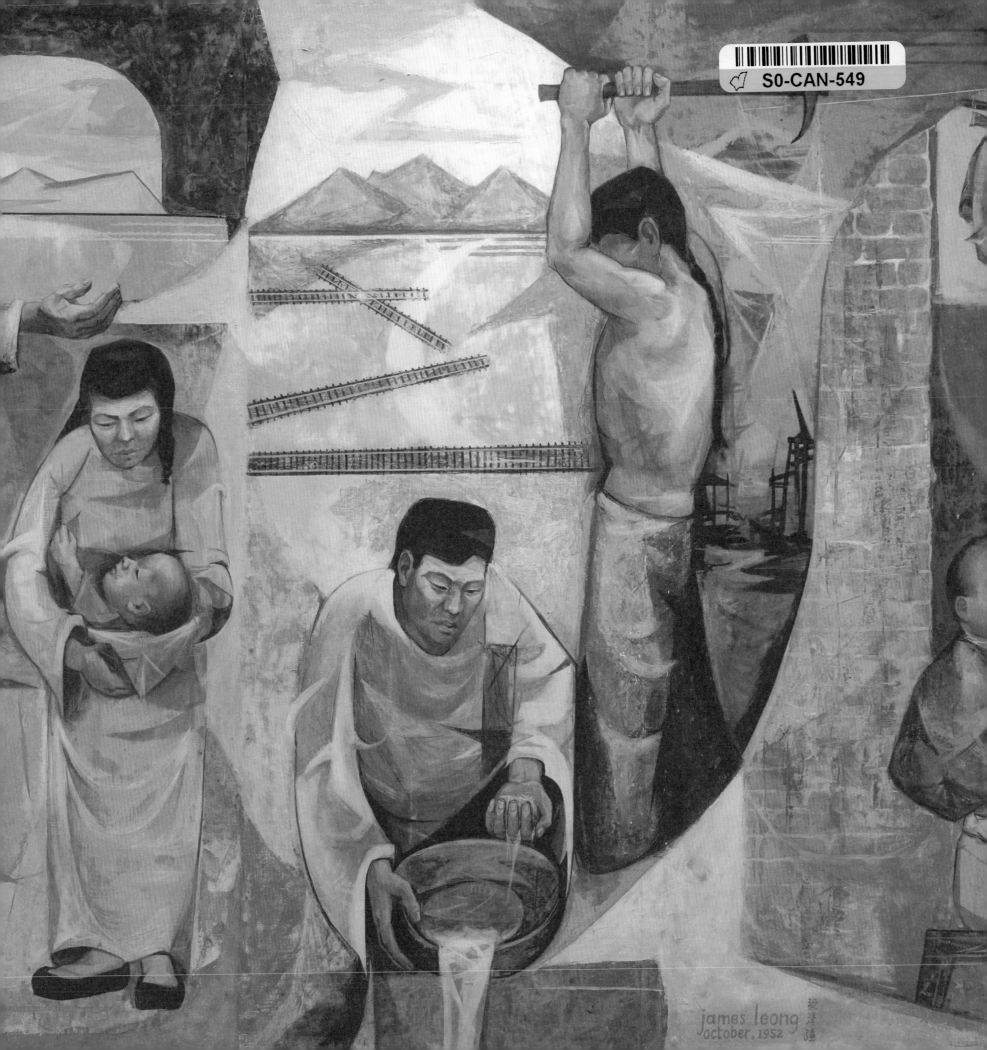

james leong
october, 1952

SAN FRANCISCO'S
CHINATOWN

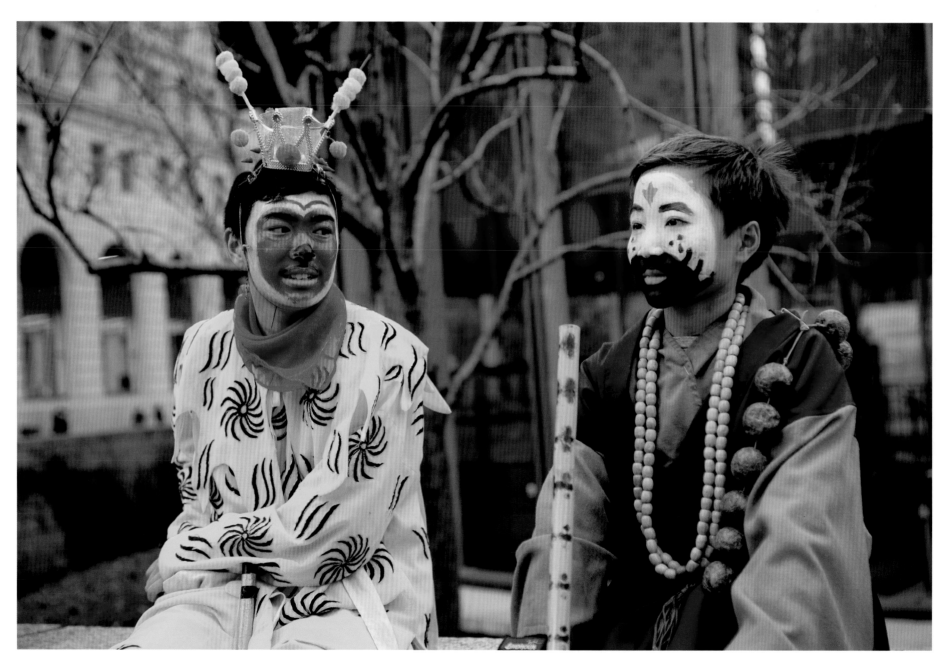

Ryan Javier and Vincent Ngo, both age 14 and graduates of West Portal Elementary School's Chinese Performing Arts Program, chat prior to the Chinese New Year parade.

SAN FRANCISCO'S
CHINATOWN

PHOTOGRAPHS BY DICK EVANS
TEXT BY KATHY CHIN LEONG

HEYDAY, BERKELEY, CALIFORNIA

Library of Congress Cataloging-in-Publication Data is available.

Cover and Interior Design: Ashley Ingram
Front cover: Red lanterns on Grant Avenue in front of the historic Four Seas Restaurant building, now occupied by Mister Jiu's Restaurant.
Endpapers: *One Hundred Years' History of the Chinese in America*, by James Leong, on permanent display at the Chinese Historical Society of America Museum.
Back cover: Mural inside Dim Sum Corner.

Published by Heyday
P.O. Box 9145, Berkeley, California 94709
(510) 549-3564
heydaybooks.com

Printed in Korea through Four Colour Print Group, Louisville, Kentucky

10 9 8 7 6 5 4 3 2 1

This book is dedicated to Philip P. Choy, revered historian, educator, community leader, and author of *San Francisco Chinatown: A Guide to Its History and Architecture*. His book was a valued guide and source for this project.

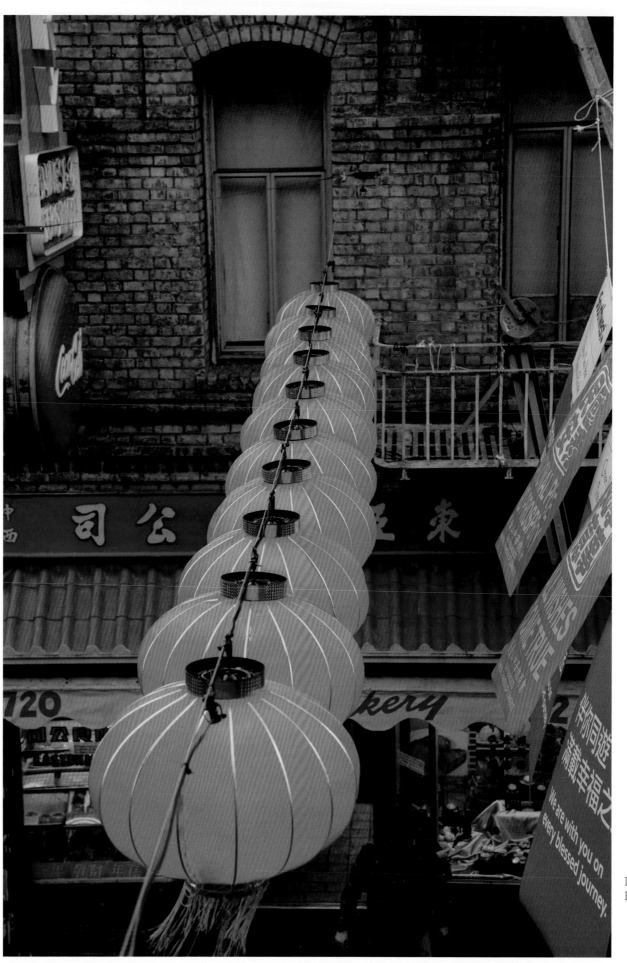

Lanterns above Eastern Bakery on Grant Avenue.

CONTENTS

Decorative gate at Portsmouth Square.

INTRODUCTION

As cable cars rumble up California Street and Chinese grandmothers haggle with shopkeepers, two stone lions at the base of the Dragon Gate guard the oldest Chinatown in North America. For the uninitiated, strains of high-pitched music, odd smells, and the myriad of Asian dialects can be overwhelming. For others, the cacophony is thrilling. There's no doubt that entering San Francisco's Chinatown is like visiting a foreign country, except that this one is less than a fifth of a square mile.

This book is the third in a series of neighborhood-themed documentary photography books by San Francisco resident and photographer Dick Evans. His previous works include *San Francisco and the Bay Area: The Haight-Ashbury Edition* (2014) and *The Mission* (2017). The approach in each case has been to develop an in-depth understanding of each neighborhood through close collaboration with leading nonprofits, community organizations, artists, and local businesses. As you browse this visual time capsule, you'll observe a tension of opposites, Chinatown's yin and yang. Tourists amid locals. Hip restaurants opposite basement cafés. Stuff that's chic versus things quite cheap. The three sections of this book seek to unleash the essence of the Chinatown story, highlighting tourism, daily life, and Chinese celebrations.

According to the San Francisco Planning Department, Chinatown is bordered by Bush, Powell, Broadway, and Kearny streets. Ever-vigilant advocates want to keep it this way, for the community has battled for territorial and immigration rights since the beginning.

Before you visit, it helps to know a little backstory and to get some context related to how Chinatown came to be. The birth of Chinatown harkens back to the California gold rush. As many as thirty thousand men from southern China's poverty-stricken Guangdong Province sailed to America, known then as Gum San, or Gold Mountain. Upon landing, they made a beeline for the gold mines; later, they heeded the treacherous call to build the Central Pacific Railroad. Others settled in San Francisco to set up practical businesses, such as restaurants, produce stands, and herb stores. Chinese with few resources took on the most menial of jobs, such as washing clothes and sorting vegetables.

This original Chinatown was called Tong Yun Fow, Cantonese for the "town of the Tang people," after the highly respected Tang Dynasty. Chinese leaders quickly established family associations, organized by language and village, to give kinsmen assistance with jobs and lodging.

When the Civil War erupted, the quarter morphed into a light industrial sector. As part of the war effort, Chinese laborers rolled cigars and stitched shoes for paltry wages. By American standards, these foreigners were dirt poor, but Guangdong peers considered them wealthy. The immigrants routinely sent portions of their paychecks back home to support their families overseas.

Meanwhile, Anglo workers blamed the Chinese for stealing jobs. Rising anger culminated in the Chinese Exclusion Act of 1882, the only immigration law created to target a specific race. It banned immigration of Chinese laborers for ten years. It forbade citizenship through naturalization. Hoping to eliminate all Chinese from America, the public pressured the federal government to squeeze harder. Legislators extended the exclusion act indefinitely under different names with additional restrictions. The 1892 Geary Act forced Chinese to carry residency papers with them or face arrest and deportation. Chinese American leaders were so outraged that they said this law was equivalent to being required to wear a dog tag.

In the Chinatown "bachelor society," it was illegal to bring wives from China unless the women could prove they were not prostitutes. Few Chinese wives possessed the courage to endure the interrogations. Worse still, California miscegenation laws forbid Chinese and whites from marrying. Some of these bachelors turned to gambling and smoking opium to assuage their loneliness. Others turned to brothels. At the time, houses of ill repute were legal and prolific.

In fact, the San Francisco port served as the entry point for the flesh trade, as gangsters tricked and kidnapped thousands of Chinese women and girls for sex trafficking and domestic servitude. This did not go unnoticed, however. Christian churches and missionary societies in Chinatown stepped up to rescue the enslaved. The most successful of these was the Occidental Mission Home for Girls, later renamed Donaldina Cameron House, which saved close to three thousand women and girls from fates that often led to beatings and eventual death.

Even as deliverance efforts were under way, the neighborhood garnered a reputation for gambling, drugs, and prostitution. Secret-society Chinese gangs, or *tongs*, controlled the illicit industries, and the so-called tong wars lasted for decades as disputes over honor and turf resulted in ritualistic murders. Nineteenth-century newspapers published articles about this den of iniquity, and curious tourists around the country had to see for themselves. They hired police guides who kicked down doors of Chinese families and shined flashlights in their faces so that clients could see the living conditions of the inscrutable "celestials." (Chinese were referred to as *celestials* because in ancient times, the Chinese emperors were regarded as sons of heaven. By the nineteenth century, English-language newspapers commonly referred to Chinese immigrants as "celestials" in their articles.)

On April 18, 1906, at 5:12 a.m., all activity in San Francisco screeched to a halt. The city's most devastating earthquake, sparking fires and explosions, reduced the urban landscape to a heap of smoldering ashes. Fire destroyed all the birth and immigration records from the city's Hall of Records. This proved to be a boon for Chinese, who now claimed they were rightful American citizens. A whole world opened

up for immigrants who purchased fake documentation papers to identify themselves as children of Chinese American citizens. Anyone with a false Chinese name was known as a "paper son." An estimated 150,000 Chinese claimed "paper son" and "paper daughter" names. This secret practice had started even earlier, when the US government enacted the Chinese Exclusion Act and the only Chinese who could immigrate were those of elite merchant status. Today, the majority of Chinese Americans still bear the paper-son surname.

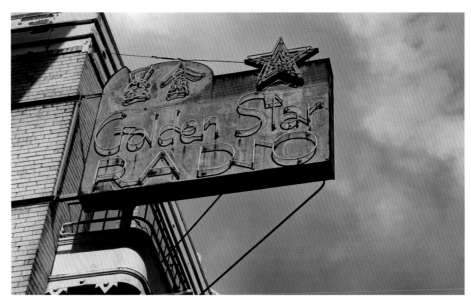

A vintage neon sign for Golden Star Radio is a remnant of old Chinatown on Clay Street.

After the 1906 disaster burned down most of Chinatown, San Francisco officials attempted to pressure the Chinese to move to Hunters Point on the outskirts of town, something the city leaders had already been plotting. But Chinatown's most outspoken merchants and leaders convinced officials that a Chinatown could be rebuilt in the same area, but this time as a profitable tourist attraction that would enrich San Francisco coffers.

The idea took hold, and the rebuilding began. For the first time, Chinatown was festooned with dragon flourishes, swooping pagoda rooftops with upturned corners, and flower motifs in exacting detail. Red, green, and yellow hues, considered lucky colors in Chinese culture, accented newly built association buildings, temples, and souvenir stores.

And although the reinvented Chinatown thrived economically, clouds of discrimination hung heavy.

In San Francisco Bay, Angel Island, a former military bunker, was repurposed as an immigration station for anyone entering the West. Angel Island officials singled out the Chinese, separated families, and detained them in barracks for weeks and even years. This continued until 1940, when a fire destroyed the administrative building. The government shut down the station and moved operations to San Francisco, where interrogation and detention practices continued until 1952. In all, 175,000 Chinese immigrants landed on Angel Island with hopes of a better future, and each one was blindsided by a hostile reception. Many detainees were so traumatized, they refused to speak of their experience. Upon departing Angel Island, the former detainees built lives in San Francisco's Chinatown and in pockets of Oakland and Sacramento where Chinese congregated.

On the political front, the US and China became allies during World War II, and officials in China were incensed over their countrymen's treatment. To appease the Chinese government, the US government reluctantly repealed the Chinese Exclusion Act in 1943, ending institutionalized racism that had lasted more

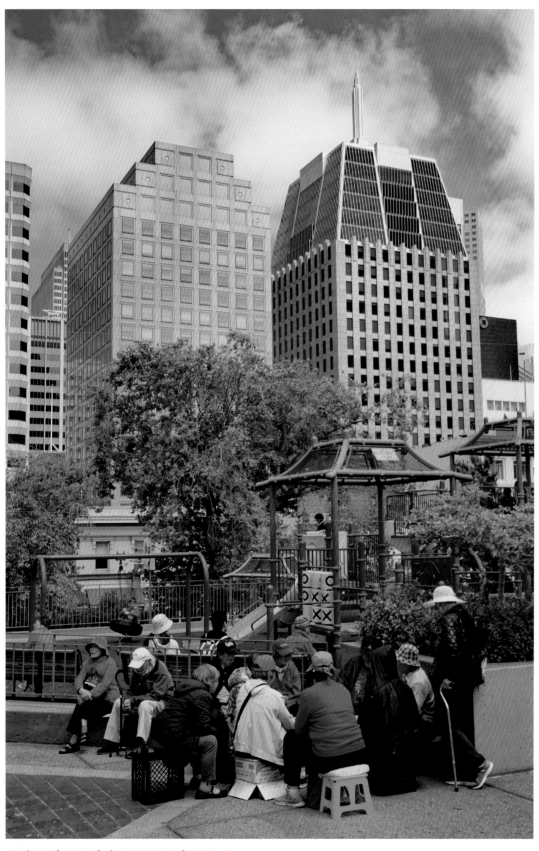

Seniors play cards in Portsmouth Square.

than sixty years. This boosted the confidence in the community, as its residents could now apply for citizenship.

By the 1950s, space was tighter than ever in Chinatown, but racism was still so rampant that Chinese had nowhere else to go. Families crammed into apartments with relatives or other clans. Soon, laws loosened to allow Chinese to purchase real estate. Some became Chinatown landlords. Others couldn't wait to leave the quarter to buy houses, even in the face of prejudice. The remaining residents were largely the poor and elderly. Still, Chinatown's mom-and-pop enterprises held steady, and suburban Chinese frequented the old neighborhood for church services and Chinese produce and dry goods.

In the 1960s, against their parents' wishes, second- and third-generation Chinese Americans refused to remain the silent minority. They demanded fair representation and an equal voice. Against the backdrop of civil rights, activists insisted that the truth be told about their embattled history. In 1963, five Chinese Americans founded the Chinese Historical Society of America, a museum and historical archive that would set the record straight, once and for all. A rush of advocacy organizations in Chinatown formed, such as the Chinese Newcomers Service Center, Chinese for Affirmative Action, and the Asian Law Caucus, to protect the rights of immigrants and aid in their adjustment to America.

If there was ever a seminal moment when Asian rights were on the line, it occurred on August 4, 1977. Overseas landlords who had purchased the International Hotel apartments called for the eviction of the residents. Occupants were predominantly elderly Filipino and Chinese. Despite a two-thousand-strong human barricade, police forced tenants out of homes they had known for decades. Although activists lost the battle, they redoubled efforts to defend Chinatown's low-income renters. Organizations such as the Chinatown Community Development Center still operate today to ensure that the single-room occupancy (SRO) apartments are protected from skyrocketing rent hikes. Called the "housing of last resort," these tiny units—ten-by-ten feet or smaller—often have no elevators; communal restrooms and kitchens are the norm.

In the 1970s, neighborhood demographics began shifting as a breakthrough immigration law allowed twenty thousand Chinese to enter the country annually. Chinatown's pioneers had been from southern China. Now immigrants were flooding in from Hong Kong, Vietnam, and Taiwan, with different languages, cultures, and mind-sets. Frustrated by unfamiliar surroundings and unable to speak English, recently arrived teens and young adults formed gangs, terrorizing shopkeepers and shooting at rivals in broad daylight. Thugs forced store owners to pay protection money. Chinatown was no longer a safe tourist destination but a war zone. The infamous Golden Dragon Restaurant shooting on September 4, 1977, killed five innocent people and injured eleven in a bloodbath that would haunt Chinatown for decades. Although police apprehended the assailants, people feared walking the streets, and, for a season, Chinatown became a ghost town.

Meanwhile, pristine and modern Asian shopping centers suddenly popped up around the Bay Area, giving local Chinese little reason to visit the aging Chinatown. The Loma Prieta earthquake of 1989 collapsed the main freeway artery leading to the enclave, and customers and tourists went elsewhere. Around the millennium, the Internet shopping craze meant that anything offered in a Chinatown souvenir store could be purchased online.

In the twenty-first century, the Chinatown of fifteen to twenty thousand residents and more than 950 small businesses soldiers on. Family associations, nonprofits, churches, and charities collectively add up to more than 250 entities—each one passionate about Chinatown's future. Although they speak little to no English, older residents muster the fortitude to picket City Hall to safeguard their rights. Philanthropists donate tens of thousands of dollars to support community infrastructure. Thanks to elected officials and advocates, Chinatown has remained a cultural landmark amid the changing landscape of its surrounding neighborhoods.

Progress is visible. City departments and nonprofits are transforming neglected alleys into attractive streets with plantings and murals. Also adding to the beautification are artfully designed public benches and decorative crosswalks. Community pride is on the upswing. The photographs that follow underscore Chinatown's vibrancy, its authenticity, and, most of all, its humanity.

YAP LAI! (入來): COME IN!

Cherry blossoms embellish the Portsmouth Square gate each spri

WHEN THE CHINESE ARRIVED EN MASSE in North America in the mid-1800s, they pioneered communities in large cities, where they secured employment. Today, New York, Los Angeles, Oakland, and Vancouver, British Columbia, boast Chinatowns with classic dim sum haunts and incense-burning temples.

Of all these Chinatowns, however, none is as old or dynamic as San Francisco's. This one stands above the rest, steeped in history and saturated with tradition, food, art, and one-of-a-kind architecture. Bordered by the Financial District, North Beach, and Nob Hill, it rates among the top three most-frequented neighborhoods in the city, along with Union Square and Fisherman's Wharf. For Chinese Americans, Chinatown represents a cultural rootstock; for travelers, a must-see icon.

"The best way to visit is to be open and not be afraid to ask questions," says tour guide Linda Lee, owner of All About Chinatown Tours. "When you look at something in a store, go ahead and ask, 'What is that?' Do not hesitate to inquire about what makes you curious."

Absorbing in one day all there is to know about Chinatown is like trying to sip water from an open fire hydrant. Take a deep breath and go slowly; don't miss the treasures surrounding you among the twenty blocks and forty-three alleyways. Upon entering, it's apparent that this is not quite America, not quite China. The Sino-architecture is a concoction of what American architects and engineers dreamed of in the early 1900s. And although Chinatown was designed to be an "Oriental" city, building materials came from regional sources, and construction methods were based on Western techniques. Since then, designers and artists have added Chinese motifs to blend in so that the eye cannot distinguish between old and new.

Although it appears ancient, the impressive Dragon Gate archway at the intersection of Grant Avenue and Bush Street made its debut in 1970 after three Chinese Americans won a design competition. It is the only one in North America built according to Chinese gateway specifications, as it uses stone, not wood, from the base to the top. Close by, the red street lanterns on turquoise posts are the result of the Chinatown reconstruction after 1906. Walter D'arcy Ryan, a prized illumination engineer who was director of lighting at the 1915 Panama-Pacific International Exposition, gets credit for the design and implementation of the chinoiserie streetlamps detailed with dangling bells and slithering dragons.

On a balcony on Grant Avenue, Chinese stone warriors stand guard. They look as though they were pulled from the same archaeological site as the famous terra-cotta warriors of Xi'an, China. Yet these are silent new neighbors of circa 2015. Chinatown real estate maven Betty Louie commissioned these fellows from China, and they are made of lightweight fiberglass, not heavy stone.

In the Portsmouth Square plaza, a ten-foot-tall bronze *Goddess of Democracy* statue raises a torch celebrating freedom and independence. It has become quite the landing spot for pigeons these days. She is one of ten replicas cast after the *Goddess of Democracy* statue that students created in Beijing during the 1989 Tiananmen Square protest.

One thread is apparent in the Chinatown of the twenty-first century: Chinatown is on the cusp of a new era. The destination is merging the new with the old as shopkeepers and restaurateurs retire and entrepreneurs set up businesses. You will find trendy boutiques next to fading jewelry stores, ancient landmarks and contemporary murals, traditional Cantonese fare and Asian nouvelle cuisine.

The quintessential Chinatown day trip should start off with an overview of the neighborhood's history and culture. This is accomplished through visiting Chinatown museums and galleries. At the museum of the Chinese Historical Society of America, interactive exhibits cover Chinese immigration, early maps of Chinatown, and current issues facing Chinese Americans. (The original architect behind this repurposed YWCA building was none other than Julia Morgan, who designed Hearst Castle for legendary newspaper publisher William Randolph Hearst.)

To view contemporary works by local Asian American and overseas Chinese artists, or to go on a Chinatown social justice tour, head to the Chinese Culture Center of San Francisco, located in the Hilton Hotel across from Portsmouth Square. Blocks away, the one-room art gallery called 41 Ross curates themes often related to Chinatown. If you want to dive deep into this neighborhood, go to the Chinatown Visitor Information Center on Kearny Street and book a tour.

As you wander Grant Avenue's souvenir stores, you'll find yourself stuck in a time warp. You'll recognize the same bamboo backscratcher found perched on your grandmother's nightstand. That kite shop where your dad purchased your first kite in the 1970s? Yes, it's still there on Grant Street after half a century. In curio shops, those rice paddy hats and faux-jade buddhas seem so out of date, yet Chinatown wouldn't be Chinatown without them.

Immerse yourself in the Chinatown lifestyle by eating where the locals eat and ordering what they order. The enclave is, and has always been, tantamount to one big food hall. Each bite tastes different from dishes in Asia, because certain produce is not grown overseas. Some classic entrées in Chinatown are probably not even on menus in Beijing or Shanghai.

In early Chinatown, hole-in-the-wall joints proliferated with peasant cooks whipping up home-style

Cantonese meals. They invented chop suey and egg foo young to cater to Western tastes. Restaurant owners later offered American and Chinese fare, so it was common for spaghetti and meatballs and wonton soup to be listed on the same menu.

Anyone who has been here will tell you that service can be, well, sketchy. Waitresses ask patrons to sit with strangers to make room for others. Waiters sometimes demand a higher tip after guests have paid the bill. In Cantonese culture, bluntness, not courtesy, is standard. After all, customer service has never been a Confucian value. Diners should be prepared not to get offended. The oldest eatery in Chinatown is tiny Sam Wo, built after the 1906 earthquake and notorious for Edsel Ford Fung, dubbed the world's rudest waiter. He told customers they were fat or ugly. Other times, he forced them to take his place and serve meals to other guests. This waiter, who passed away in 1984, was so popular that tourists wanted him to be their server. Now that he is gone, the noodle shop posts photos and articles about Fung on the walls.

Meanwhile, dim sum teahouses remain a staple, but the rolling carts carrying steamed savories and sweets are harder to find. However, at New Asia (which is no longer new) and City View (which has no view), workers veer carts between tables as customers work up the courage to try the black bean tripe and sautéed chicken feet, toenails and all.

Of late, younger chefs are bringing polished techniques from culinary school. The glamorous four-story China Live and the Michelin-starred Mister Jiu's Restaurant are two players upping the ante in Chinese cuisine. Both opened after 2015 with high-end menus, innovative takes on Chinese flavors, and luxurious interiors. Kathy Fang, who grew up helping at her parents' Chinatown business, House of Nanking, started Fang Restaurant near the Financial District. Fang represents the emerging group of Chinese American chefs committed to incorporating local ingredients (think portobello mushrooms) into innovative dishes.

Restaurateurs from other regions of China, not just Guangdong, have expanded people's palates with Hunan and Szechuan dishes. You can thank revered restaurateur Cecilia Chiang for that. The hundred-year-old matriarch of fine Chinese dining introduced the world to pot stickers, tea-smoked duck, and minced squab in lettuce cups in 1968. Dubbed the Julia Child of Chinese cooking, she opened the elegant Mandarin Restaurant in Ghirardelli Square, exposing patrons to northern Chinese flavors and entrées.

In addition to Chinese fare, foodies who look hard enough can locate Japanese, Thai, Vietnamese, and Korean cuisine mingled throughout Chinatown.

Aromatic bakeries on every street tout treats relying on recipes used for over a century. If you see no

prices or labels, the best way to communicate is to point. Most popular are custard tarts, lotus seed cakes, and sesame balls. Asian desserts are generally less sugary than American ones, and use ingredients such as rice flour and various beans for filling.

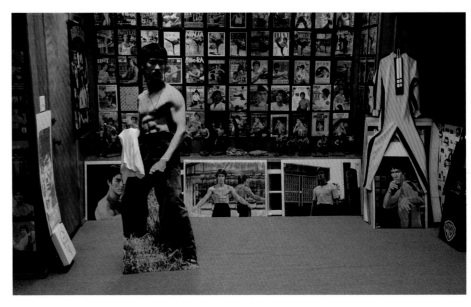

Life-sized image of Bruce Lee from Jeff Chinn's private Bruce Lee museum.

Newer entrants to the snack scene include Dragon's Beard candy, handmade in only a couple of places in the US. In the window of Dragon Papa Dessert on Grant Avenue, owner Derek Tam labors to create the Dragon's Beard, an ancient sweet created for Chinese royalty. In this ballet of the arms, he stretches a hockey puck of dark molasses into thousands of delicious delicate white threads later mixed with chopped peanuts or other ingredients. These strands form the "dragon beard" appearing on customers' chins upon consumption.

Since its inception, Chinatown has welcomed young and old, poor and rich, anonymous and famous. Kung fu legend Bruce Lee was born at the Chinese Hospital in 1940, and there's a plaque in the lobby in his honor. Keeping his legend alive is San Franciscan Jeff Chinn, who is the world's foremost collector of Bruce Lee artifacts and memorabilia. From time to time, he gives Bruce Lee Chinatown tours, noting special places where the action hero spent time. As for other star sightings, John Lennon and Ringo Starr escaped for a late-night drink at the Ricksha nightclub during the Beatles' inaugural American concert tour in 1964.

Today, anyone can find a reason to come to Chinatown. First-timers learn to use chopsticks while regulars scan delis, searching for thick strips of *char siu*, barbecued pork. Next time you visit, poke around the alleyways. Read the fine print under the landmarks. Converse with a tea merchant. This community is eager to be relevant to a new generation. As it says in Chinese on the Dragon Gate arch, "All under heaven is for the good of the people."

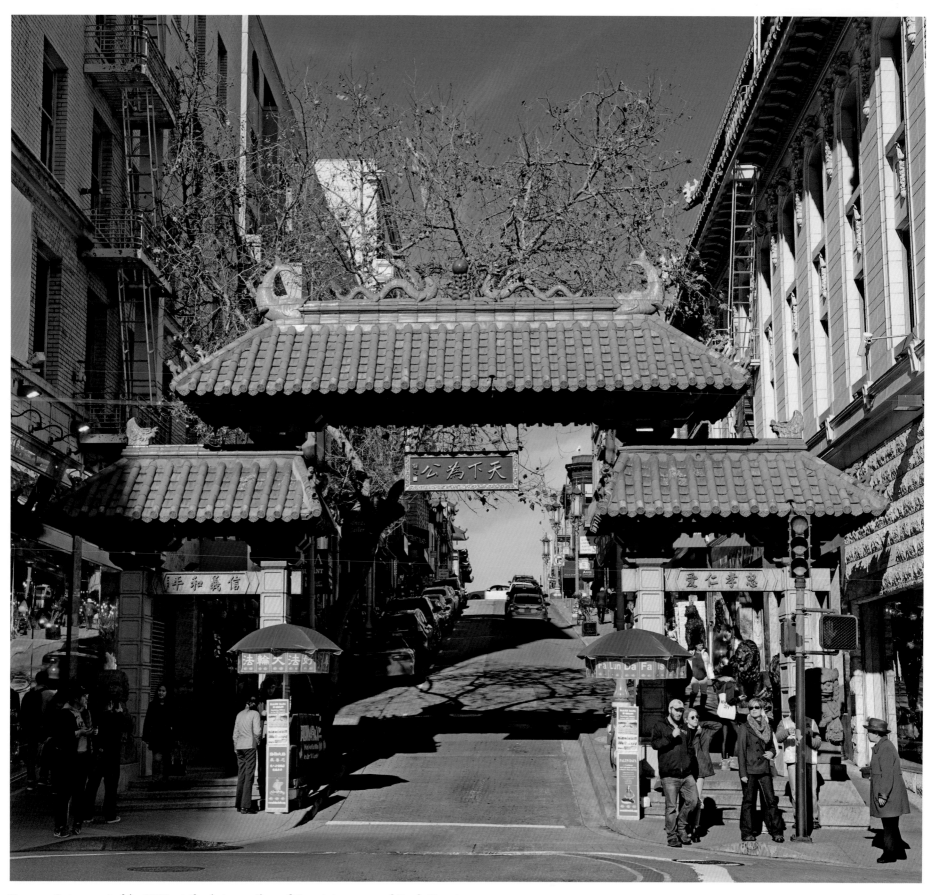

Dragon Gate, erected in 1970, at the intersection of Grant Avenue and Bush Street.

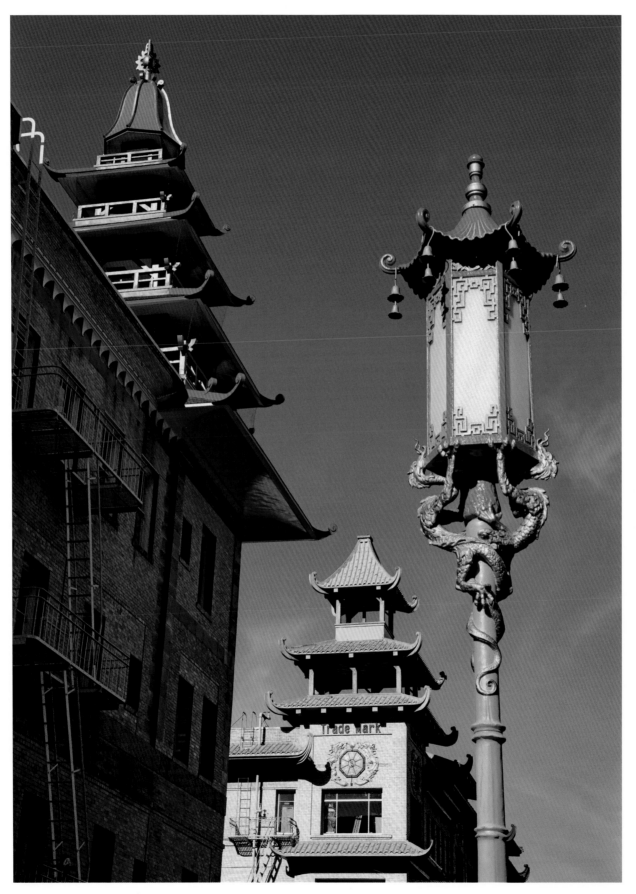

Lamppost, built after 1906, at Grant Avenue and California Street.

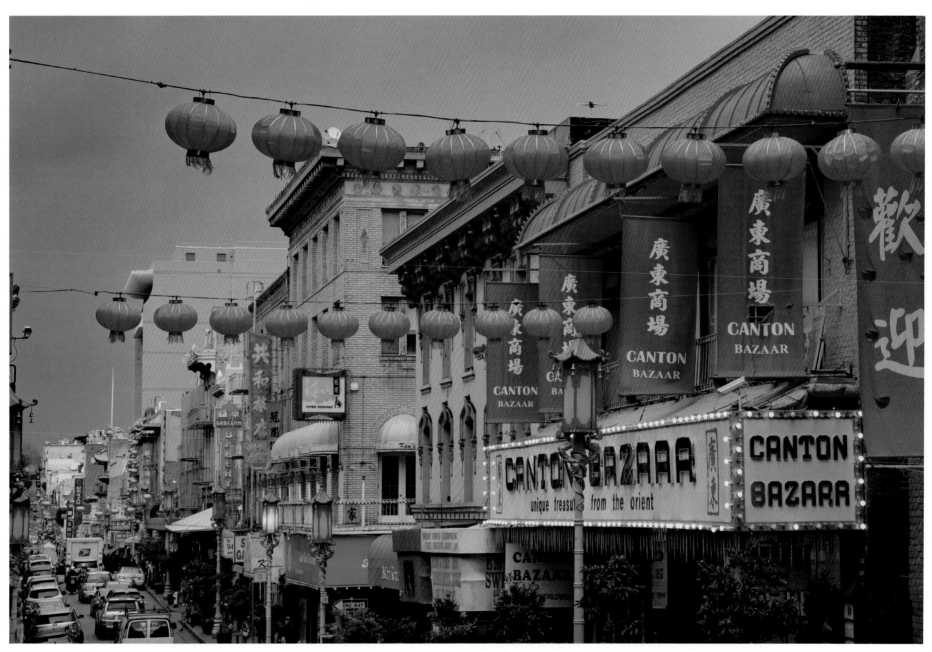

Grant Avenue from Downtown District.

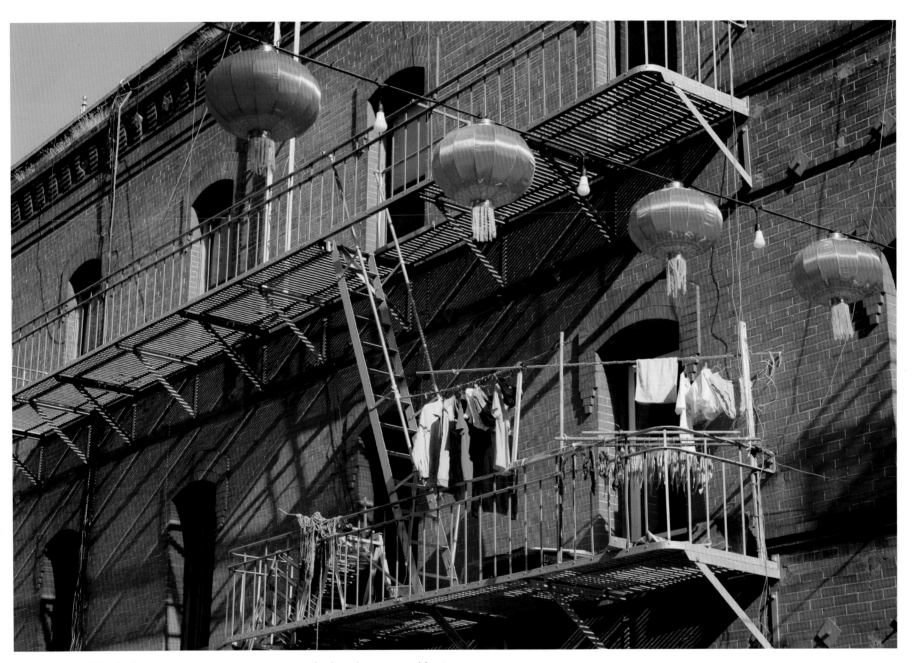

Lanterns outside single-room occupancy apartments for low-income residents.

CHINESE HISTORICAL SOCIETY OF AMERICA

When US citizen Wong Kim Ark returned to the country after visiting his parents overseas in 1895, immigration officials blocked his entry only because he was Chinese. This humiliating act was a clear breach of the Fourteenth Amendment, but with widespread anti-Chinese sentiment at the time, it seemed acceptable to the public. Nonetheless, Wong refused to accept this injustice and was awarded victory after taking the issue up to the US Supreme Court.

This Chinese immigration story, juxtaposed with current events, comes alive at the Chinese Historical Society of America (CHSA) Museum on Clay Street. Eavesdrop on an Angel Island interrogation during which authorities pummeled Chinese with difficult questions designed to halt their immigration. View a dollhouse miniature of a crammed SRO apartment with rice cooker and half-smoked cigarettes. The mural near the entry shows where it all began in Guangdong, at the Port of Canton, where ships carried peasants to Gum San, Gold Mountain—America.

On the walls are watercolor paintings of early Chinese workers in America by the late Jake Lee. These were rescued through the efforts of then–CHSA executive director Sue Lee (no relation). Back in 1959, the sophisticated Kan's Restaurant commissioned the Chinese American artist to paint twelve pieces for the dining room. Years after the restaurant changed hands, the masterpieces disappeared. After much sleuthing and fundraising, Sue Lee has reunited all the pieces; some are on loan, and others are owned by the museum.

Through exhibits, films, books, and lectures, the CHSA shatters Chinese stereotypes and assumptions, accurately depicting the arrival of Chinese to America and their current triumphs and struggles. Founded in 1963, the organization was the first to promote the legacy and contributions of the Chinese in the US.

The museum is poised to continue to tell more fascinating stories and unleash more innovative programming relevant not just to Chinese Americans but to all.

CLOCKWISE FROM TOP: Poster of the late Ed Lee, San Francisco's first Asian American mayor. Enlarged identification cards from National Archives at San Francisco. *Laborers Working on Central Pacific Railroad*, by Jake Lee. Chinese Historical Society of America Museum exhibits. Quote from Angel Island Immigration Station detainee.

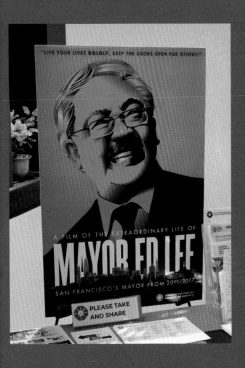

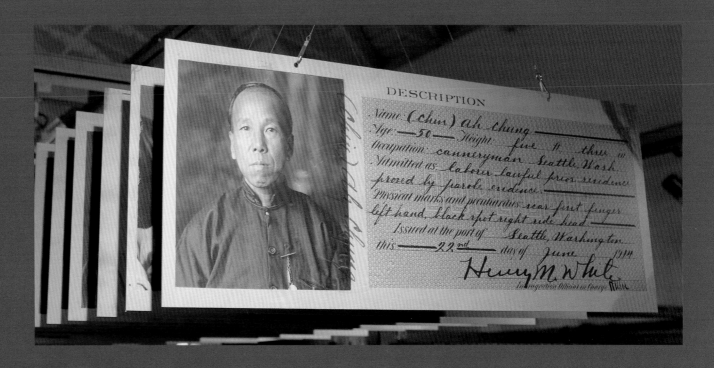

"Everybody's got a number.
I think my number is **80340**.
They would put your number on the blackboard, and you know you have to go to interrogation. Or, a health check-up.
They didn't use names.
On the day they let you go,
your number is on the blackboard and it says San Francisco."

—Don Yee Fung Lee, age 11, 1939

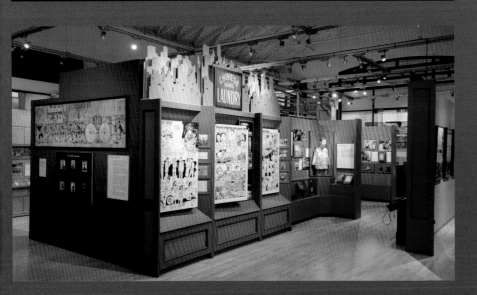

LEFT AND RIGHT: In Chinese culture, red lanterns are said to bring joy and good fortune.

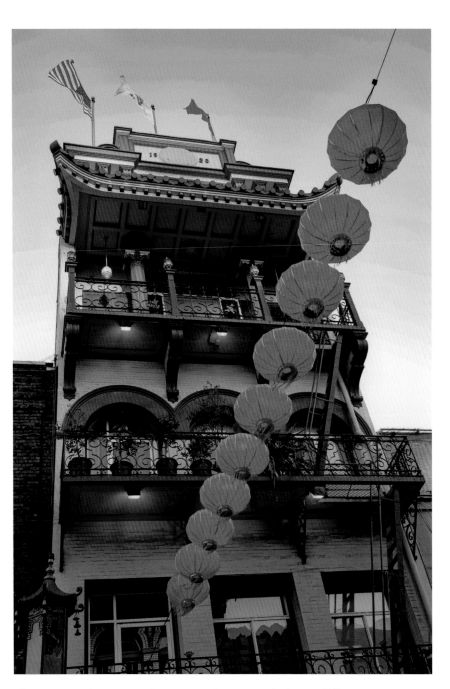

Ying On Merchants & Labor Benevolent Association Building on Grant Avenue.

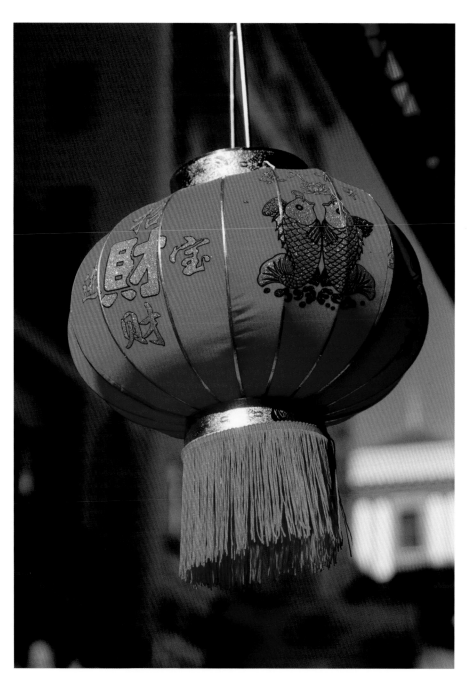

Lantern inscribed with the Chinese dictum "Gather much wealth and treasure."

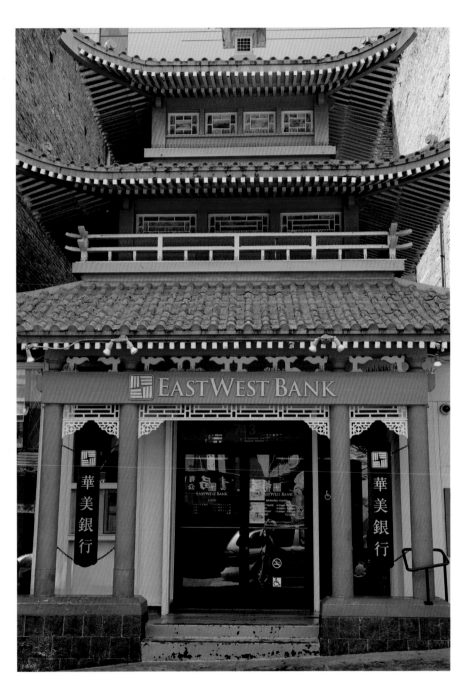

LEFT: Sing Chong Building, built in 1908 at the corner of Grant Avenue and California Street. RIGHT: East West Bank, formerly the Chinese Telephone Exchange Building, completed in 1909 on Washington Street.

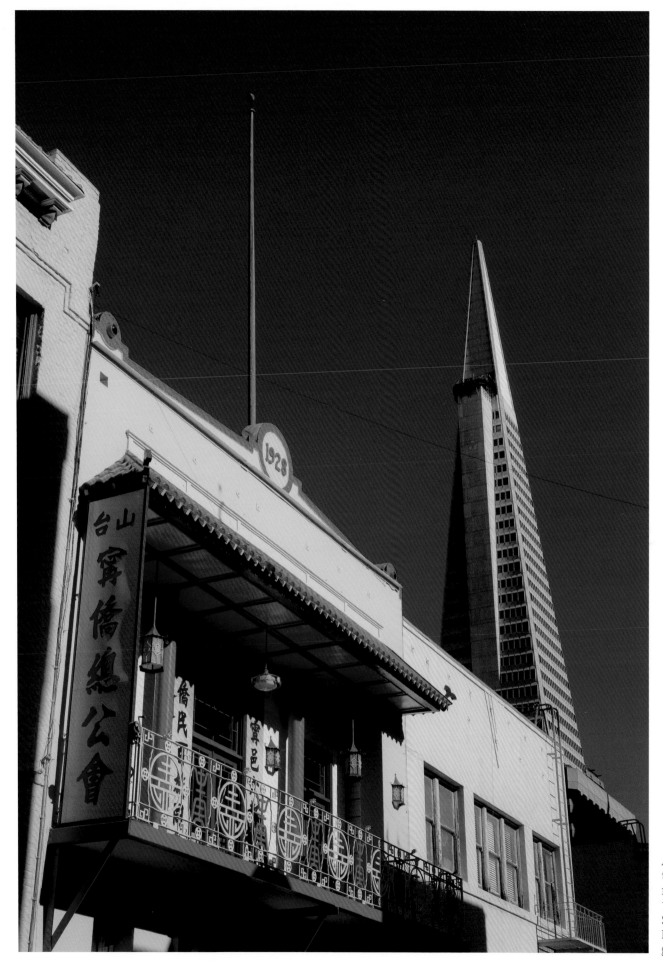

Association headquarters for the Toisan region, established in 1928, on Commercial Street. Transamerica Pyramid is in the background.

15

COMFORT WOMEN

Hak Soon Kim's pained expression evokes a mother's suffering. *Column of Strength* is a group of life-sized sculptures, one being an image of Kim herself, who in 1991 was the first sex slave survivor to speak out publicly. She gazes up at a trio of young women with joined hands, representing Korea, China, and the Philippines. The monument tells the story of the "comfort women," the young women from thirteen Asian countries who were coerced into serving as sex slaves for the Japanese Imperial Armed Forces soldiers before and after World War II, from 1931 to 1945.

Erected in 2017, the monument stands in the annex of St. Mary's Square on the edge of Chinatown. It leaves a lingering effect on passersby, and a nearby placard summarizes the ugly historical truth it commemorates. In 1991, thirty-seven women's groups from Korea boldly came forward, bringing the issue to light. The wartime atrocities are estimated to have impacted hundreds of thousands of women and girls throughout Asia when Japanese soldiers occupied these countries. During that time, many of the enslaved died during captivity.

After the two-year, $205,000 project was unveiled to the public, San Francisco's sister city of Osaka, Japan, was so incensed by the sculpture that it cut off its sixty-year relationship. San Francisco city leaders refused to remove the memorial, however, agreeing that wartime sex trafficking is a crime against humanity. Sculpted by artist Steven Whyte, the memorial is a project commissioned by the Comfort Women Justice Coalition, which calls for an end to sex trafficking, exploitation, and all violence against women.

CLOCKWISE FROM LEFT: *Column of Strength*, by Steven Whyte, in St. Mary's Square. Detail of young woman from Philippines. Detail of young woman from Korea.

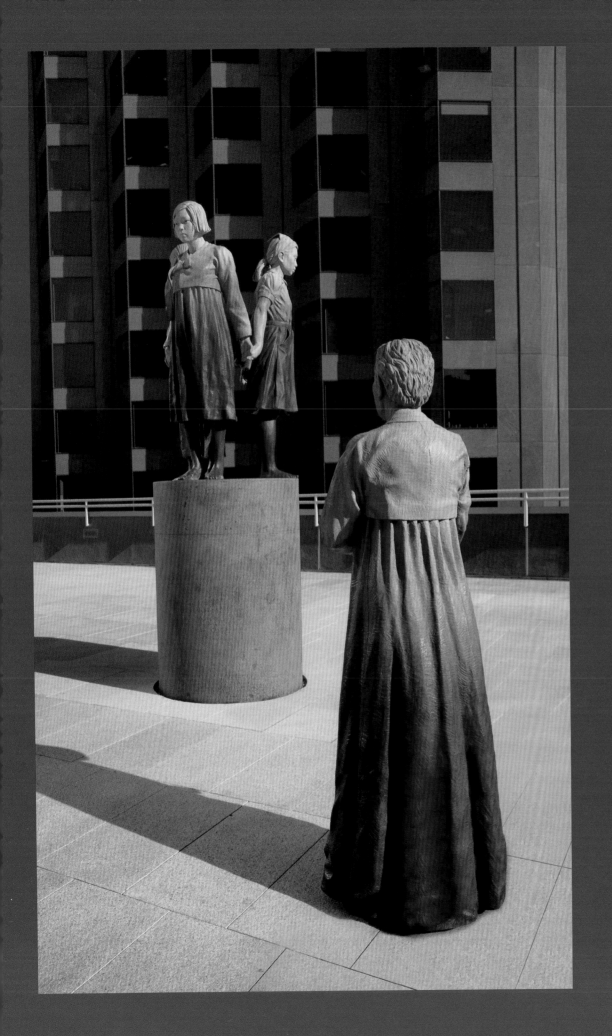
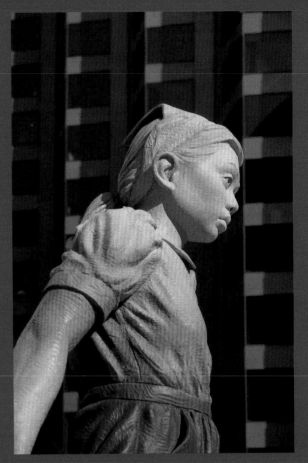
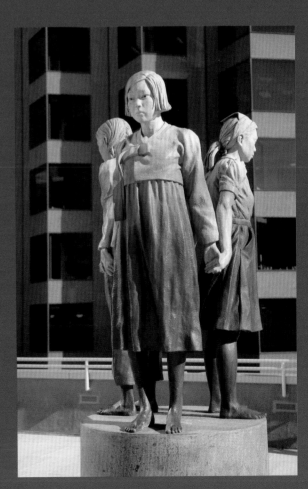

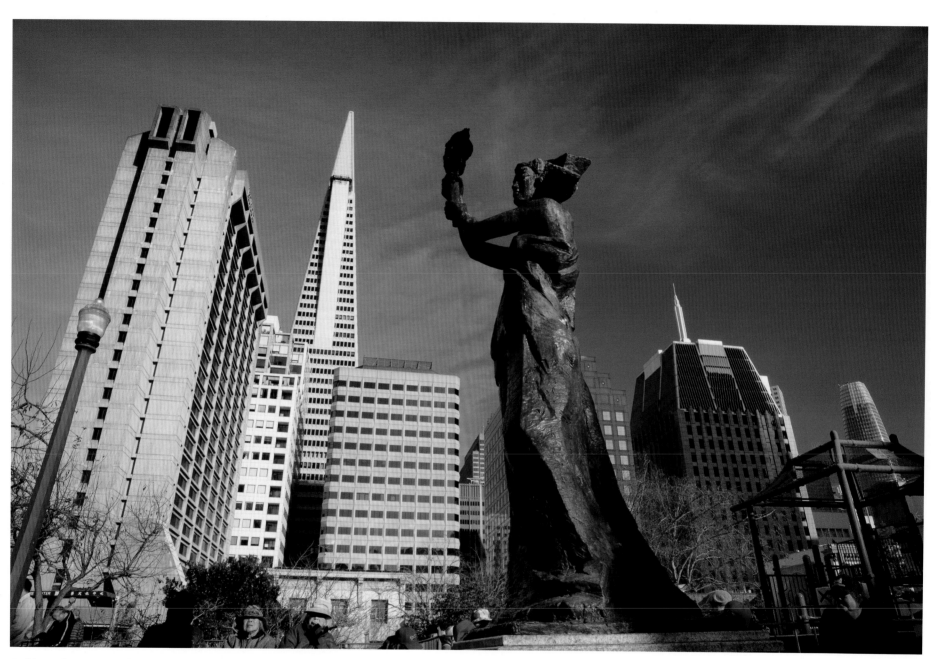

Goddess of Democracy, by Thomas Marsh, in Portsmouth Square.

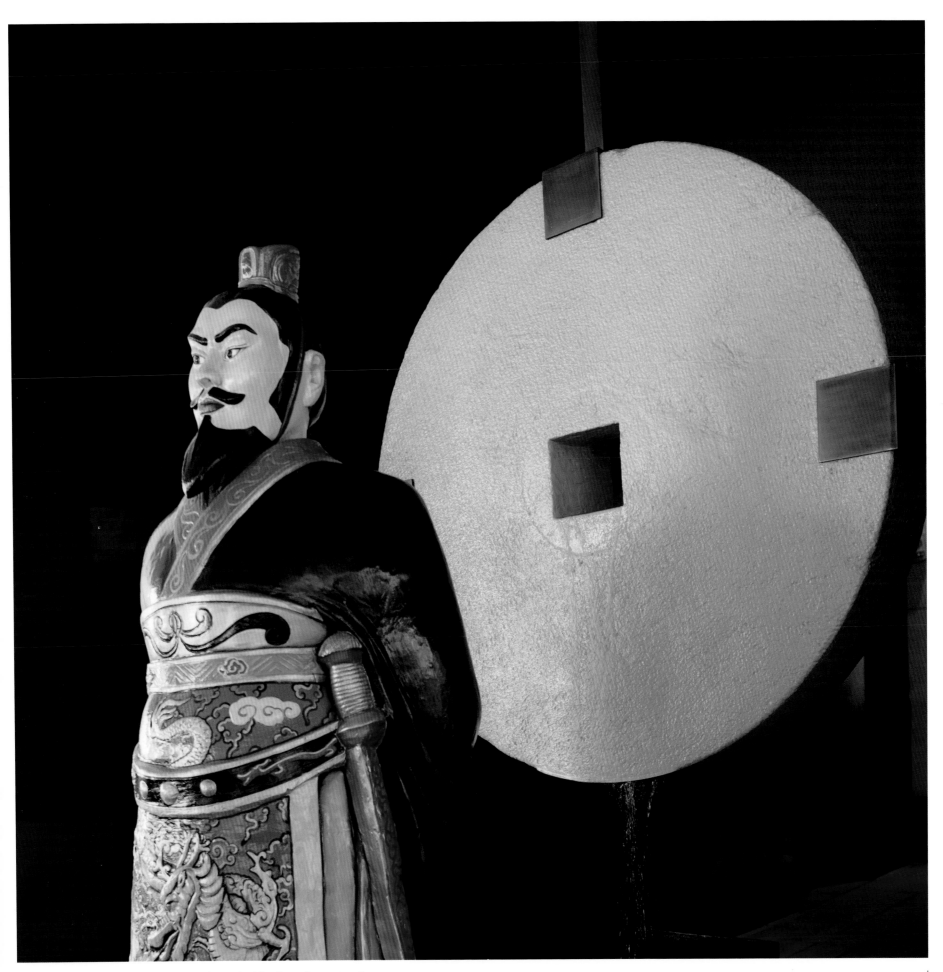

Terra-cotta Soldier, by Stephanie Muison, inside the Hilton Hotel.

Mural on the Wah Ying Social Club Building on Commercial Street, by Tanja Geis, commissioned by the Chinese Culture Center of San Francisco.

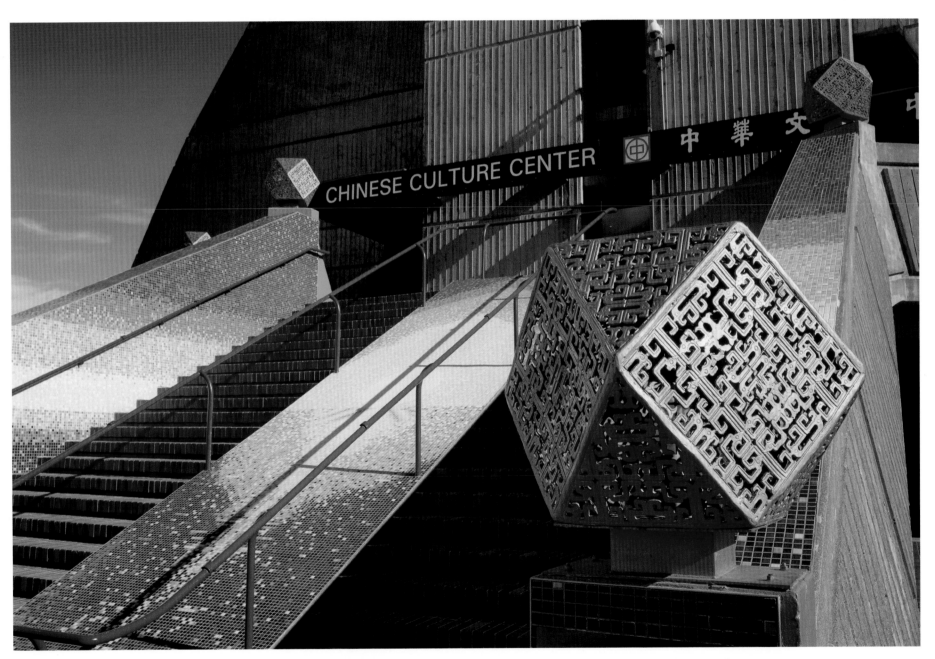

Outdoor mosaic installation *Sunrise*, by Mik Gaspay, leading up to the Chinese Culture Center on the third floor of the Hilton Hotel on Kearny Street.

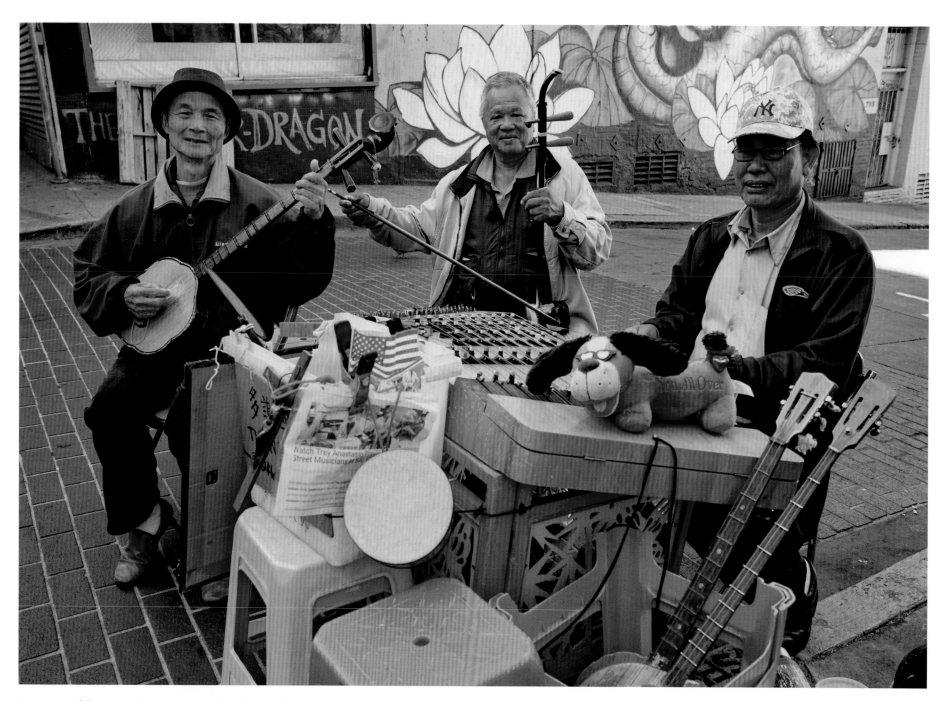

Street musicians on Grant Avenue, from left to right: Mr. Ye, Mr. Liu, and Mr. Zhu.

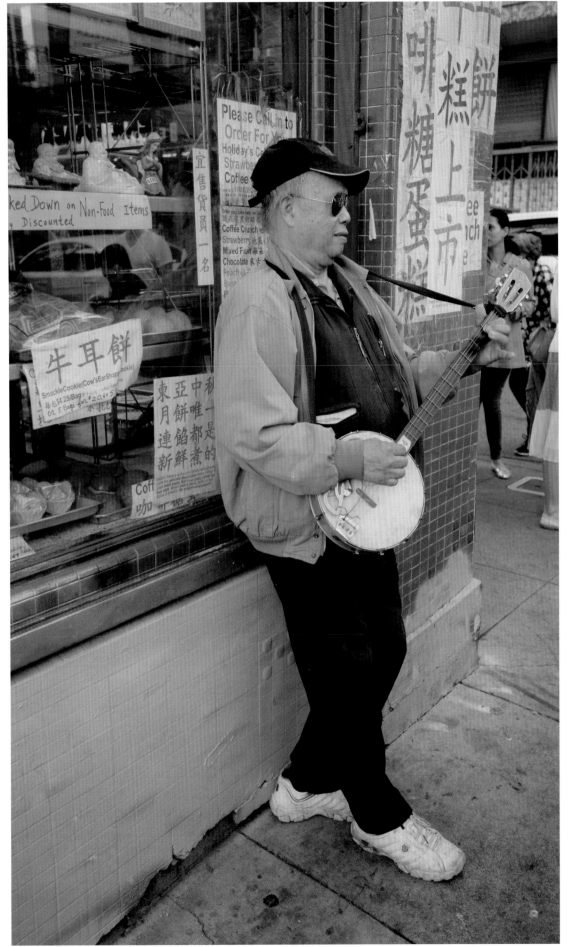

Mr. Liu strums the banjo.

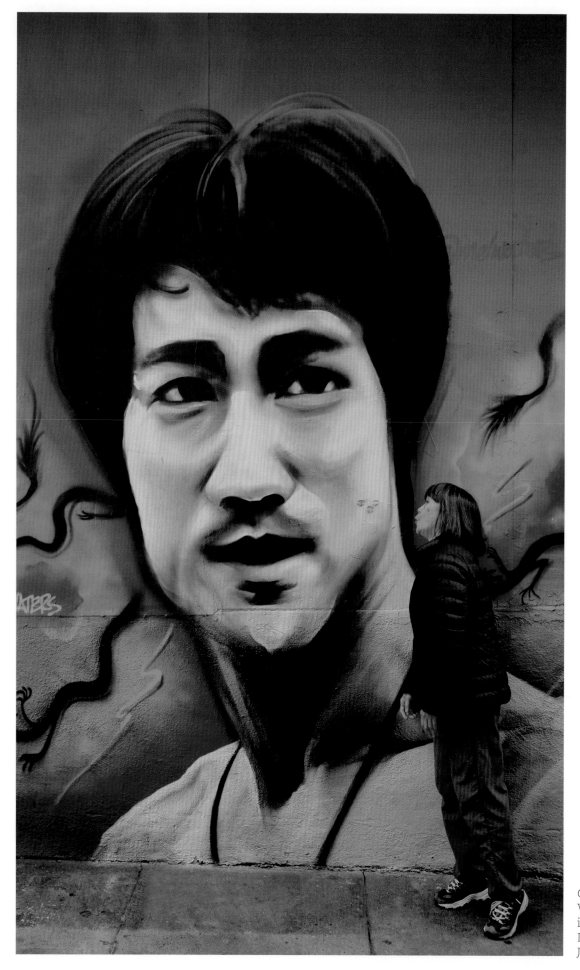

Gimmy Park Li, guide for Wok Wiz Chinatown Walking Tours, kisses the Bruce Lee mural by Mel Waters in Jack Kerouac Alley.

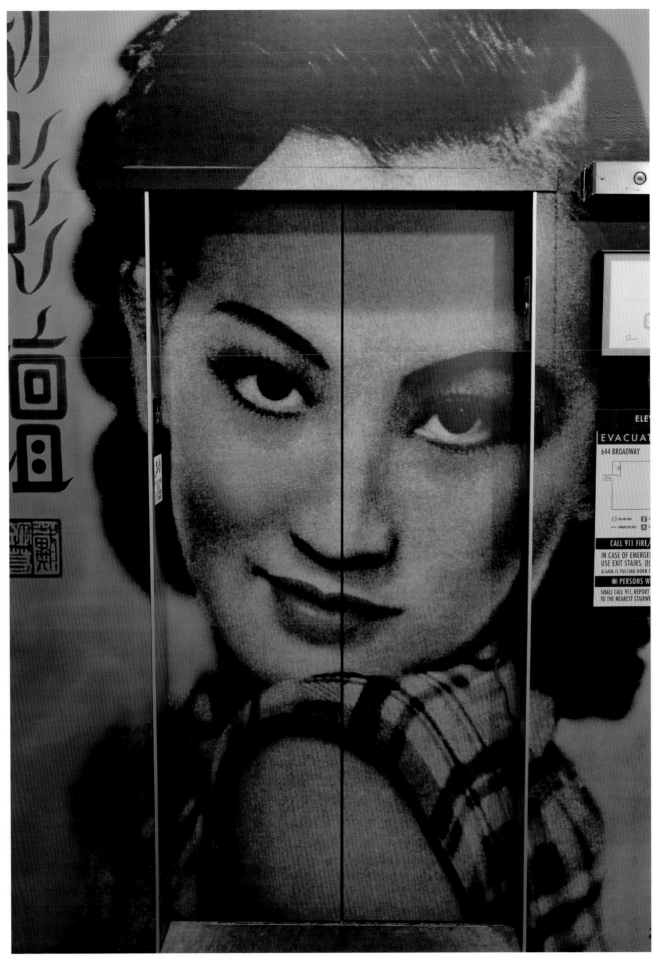

Vintage photo on the elevator at China Live.

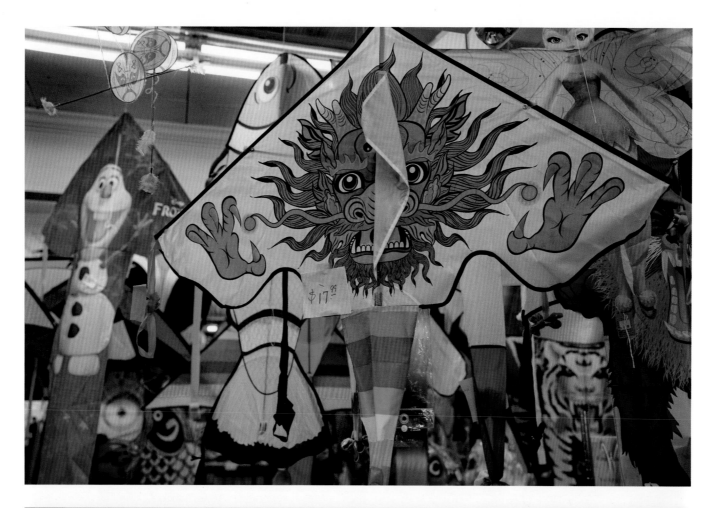

TOP: Chinatown Kite Shop. BOTTOM: Candles surround statuette at China Live Marketplace.

LEFT: 2019 Year of the Pig souvenirs. CENTER: Lucky panda. RIGHT: Rice paddy hats sold alongside baseball caps.

THE WOK SHOP

"A wok is like a woman," grins Tane Chan. "The older, the better!" According to the owner of The Wok Shop on Grant Avenue, the steel wok is the most versatile and dependable cooking utensil there is. "It will last you a lifetime. If it rusts, you can scrub it off. Aging makes it better. It is supposed to discolor. You can steam in it, deep fry, poach, boil, stir-fry. Poor Chinese villagers in the old days had one pan, the wok, and it did everything."

Chinatown's wok ambassador, Chan has been sharing her passion and knowledge since 1972, when she started the business. Born in Albuquerque, New Mexico, she settled in San Francisco and started the Yum Yum Gift Store in Chinatown in 1968. It became The Wok Shop after President Richard Nixon's famous trip to China, which opened up trade relations with the US. According to Chan, media coverage exposed the American public to wok cooking for the first time. Fascinated tourists began asking her questions about the mysterious "wook", and she would happily correct them by saying, "It's 'wok,' like walk in the park."

The narrow wok jungle is packed with every size of wok imaginable. They are hanging from the rafters, lining the walls, and stacked on tables. Recipe books, bamboo steamers, spatulas, and wok-related implements share space with colorful paper lanterns and a giant replica of the Golden Gate Bridge in the back. When she is not downstairs packaging woks for online orders, Chan is advising customers on how to season and care for their pans. For now, retirement is not in her vocabulary. "I love what I do," the eighty-year-old says. "I have good rapport with my customers, and they become friends. Plus, I like telling them all my wokking jokes."

CLOCKWISE FROM TOP LEFT: Knife collection at The Wok Shop. Owner Tane Chan with a giant wok. Lanterns of every color and size decorate the store.

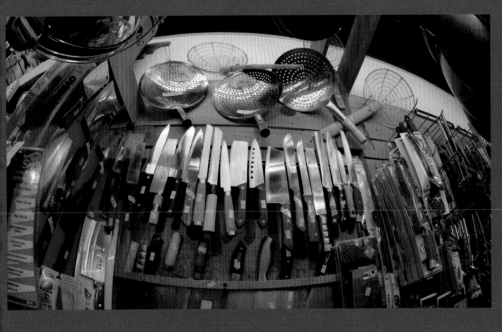

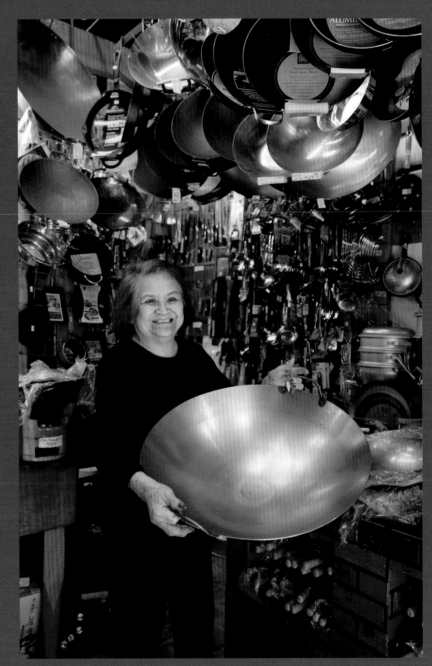

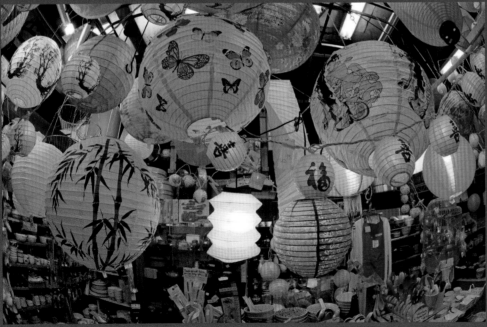

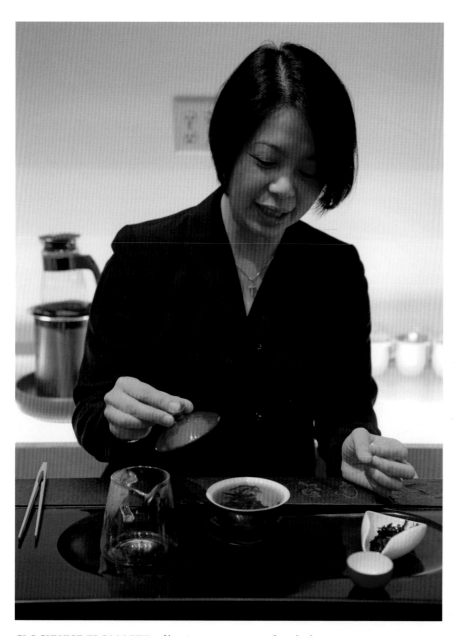

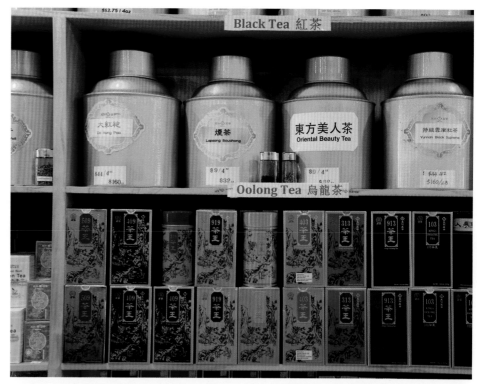

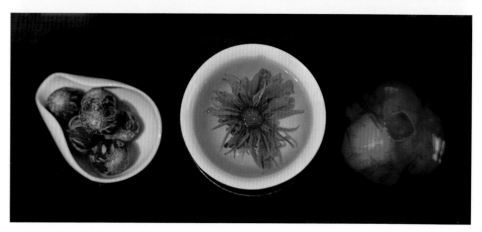

CLOCKWISE FROM LEFT: Alice Luong, owner of Red Blossom Tea Company. Tea canisters at Ten Ren's Tea. Blooming tea leaves at Red Blossom Tea Company.

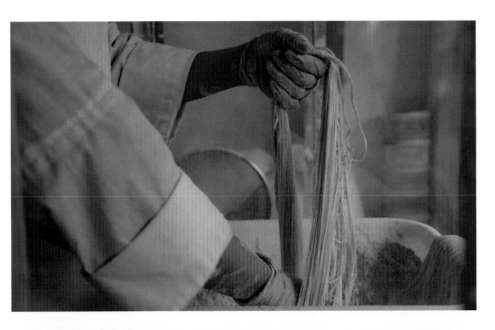

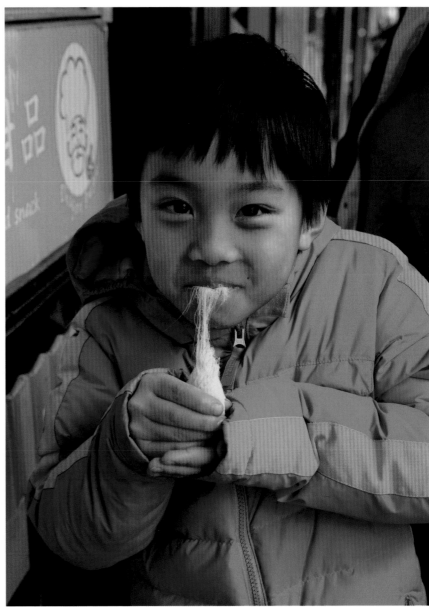

CLOCKWISE FROM TOP LEFT: Maltose syrup block spun into Dragon's Beard candy. Tyler Pham tastes the stringy confection. Dragon Papa Dessert owner Derek Tam serves Sally Chin Pham and her son, Tyler, on Grant Avenue.

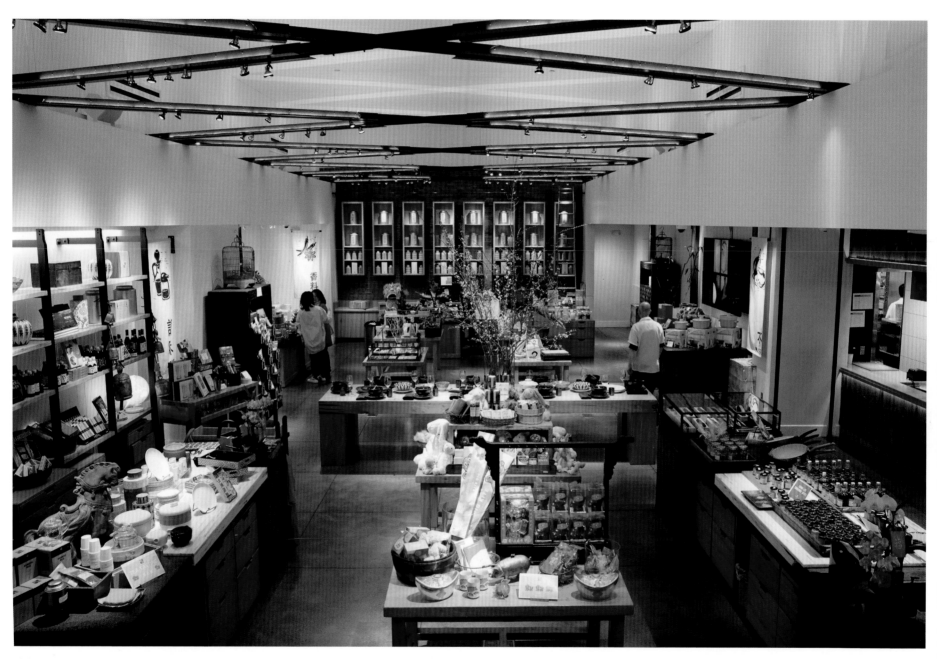

China Live Marketplace, on the first floor of the four-story restaurant-and-lounge enterprise, sells homemade sauces, kitchen goods, and regional artwork.

LEFT AND RIGHT: Trendy Kim + Ono sells jewelry and silk kimonos designed locally and hand-painted in China.

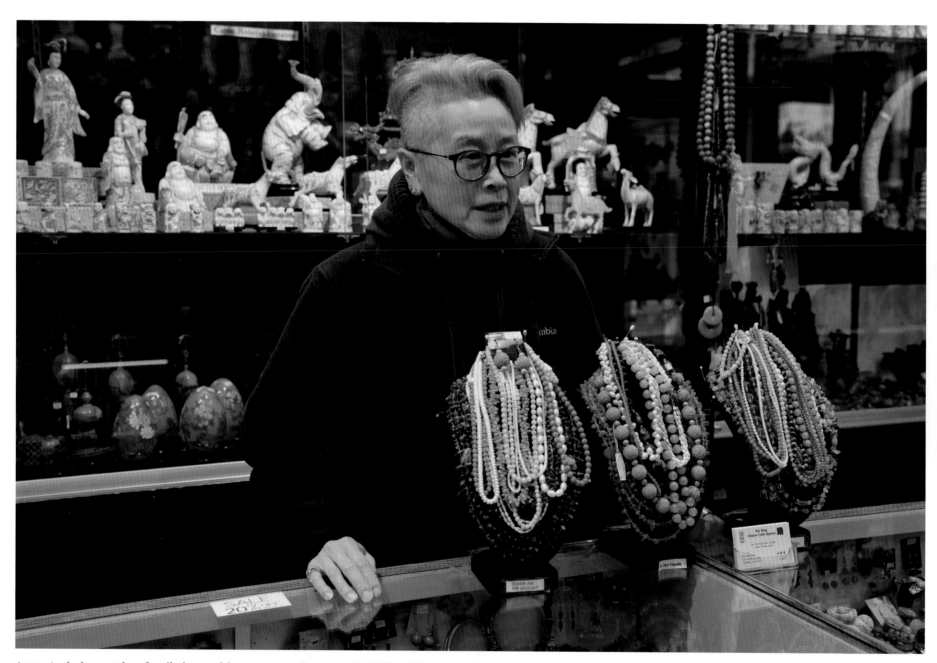

Anna Au helps out her family by working some weekends at Wai Hing Chinese Crafts Imports on Grant Avenue.

Owner Cindy Wong-Chen arranges wares at China Live Marketplace.

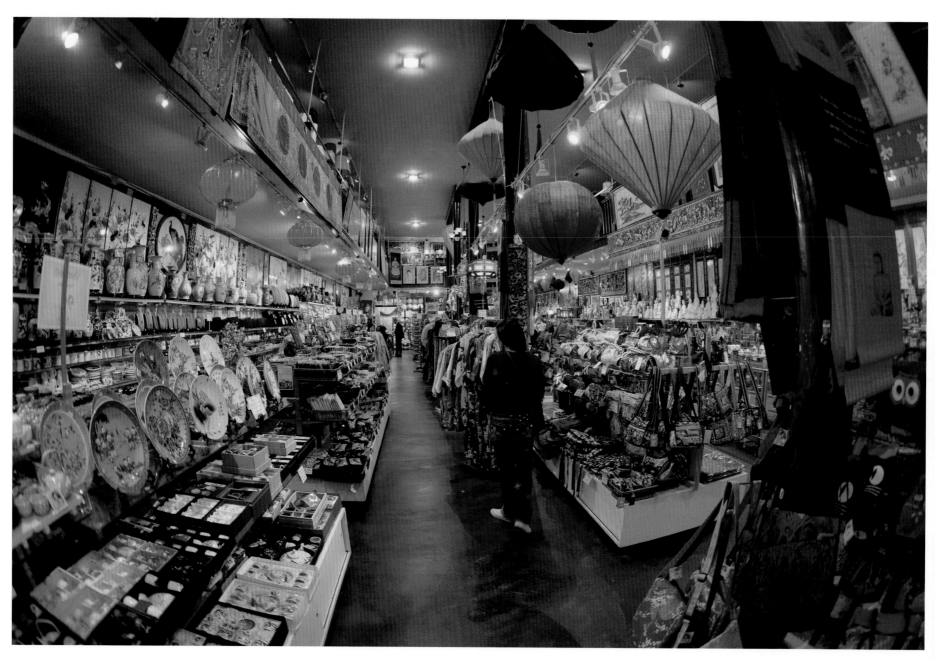

Souvenir stores carry all sorts of Asian goods.

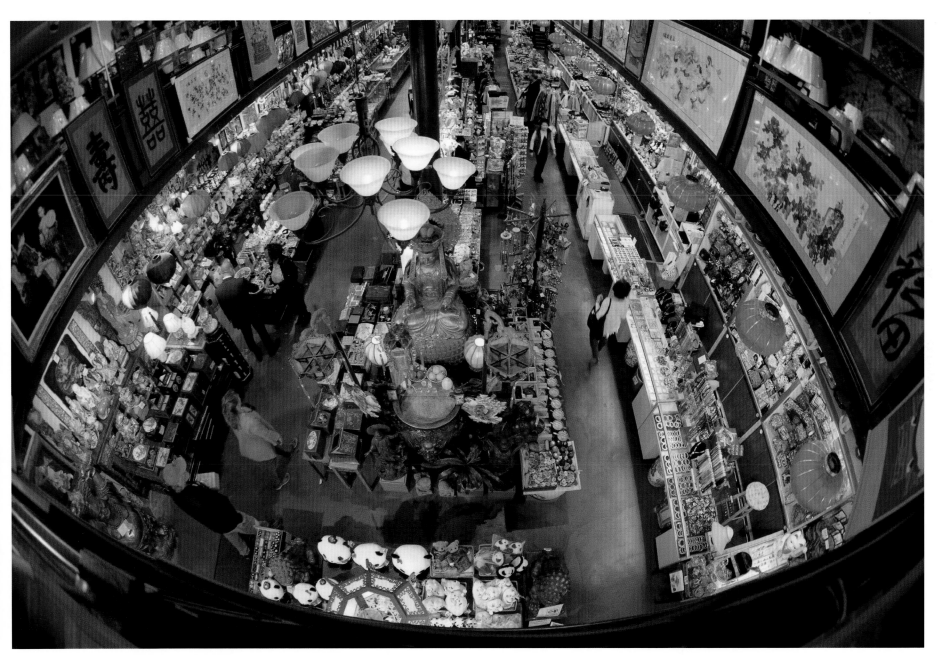

Everything from Thai lanterns to Japanese tea sets can be found in Chinatown's souvenir shops.

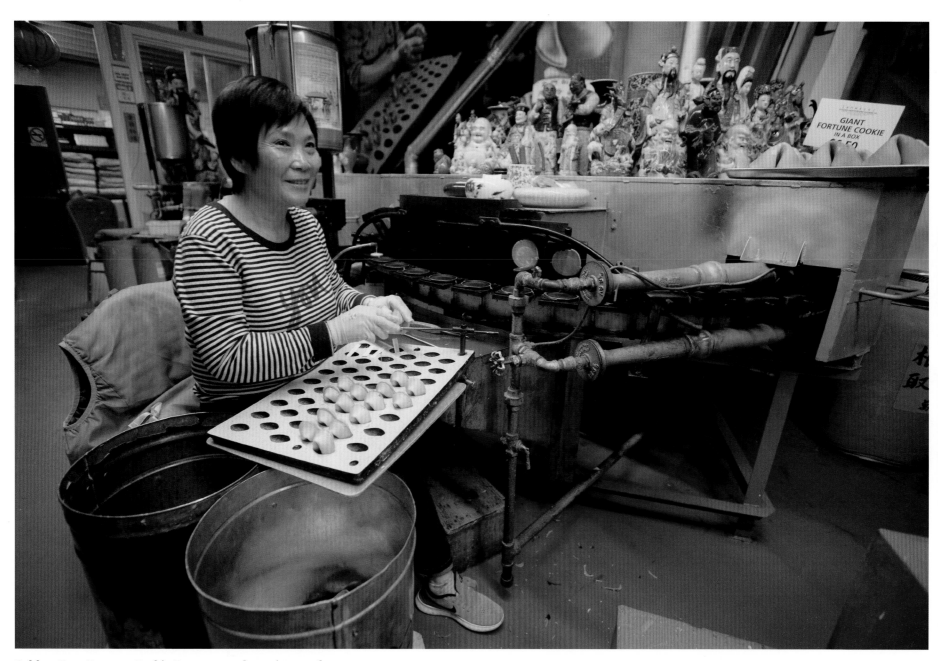

Golden Gate Fortune Cookie Factory employee inserts fortunes.

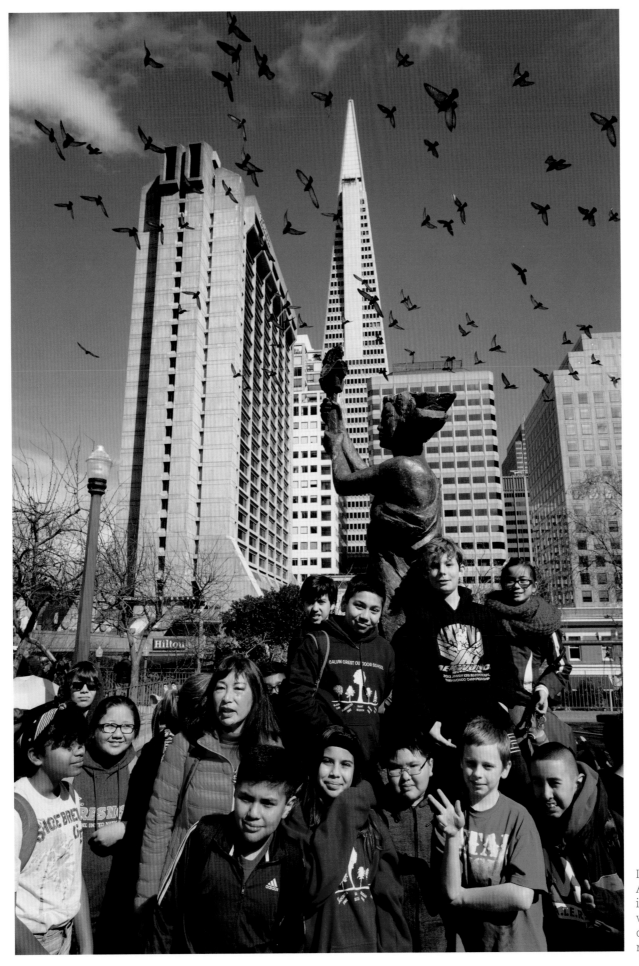

Linda Lee, owner of All About Chinatown Tours, in Portsmouth Square with students from Manchester GATE Elementary School in Fresno.

FACE CHANGING

The pulsating beat of Chinese music blares with militaristic fervor. Xumin Liu, donning a golden headdress and grimacing face mask, sweeps across the restaurant, flinging his red cape so fiercely that patrons at Z & Y Restaurant duck to avoid getting smacked in the face. The choreography is swift and precise. With one swish of Liu's fan, the lemon-colored mask magically changes to indigo.

This is *bian lian*, or face changing, an ancient art form that started in the Sichuan province for the distinctive Sichuan opera more than three centuries ago. In the US, *bian lian* is rarely seen. The instantaneous swapping of masks is deceptive and astonishing, a secret that families pass down only to heirs. Few can master this feat whereby the performer wears a multilayered mask and somehow pulls a hidden trigger to reveal a new "face." Each expression indicates a mood of the opera character.

Thirty-six-year-old Liu was trained under *bian lian* master Shimen Lu more than a decade ago. Master Lu saw his potential when Liu was entertaining masses at a kung fu tea performance. This revered acrobatic form involves pouring a stream of hot water from a copper kettle with an extra-long spout into a tiny teacup at a considerable distance.

When Z & Y Restaurant owner and chef Li Jun Han was looking for a way to showcase Sichuan culture at his eatery, he immediately thought of *bian lian* and convinced Liu, a native of Sichuan, to come to San Francisco in 2018. On specific days, the performer dazzles audiences with his kung fu tea martial arts skills and face-changing abilities at both Z & Y and Chili House SF, Chef Han's Peking duck restaurant in the Richmond District.

ALL: Xumin Liu, a face changer from Sichuan province, entertains at Z & Y Restaurant.

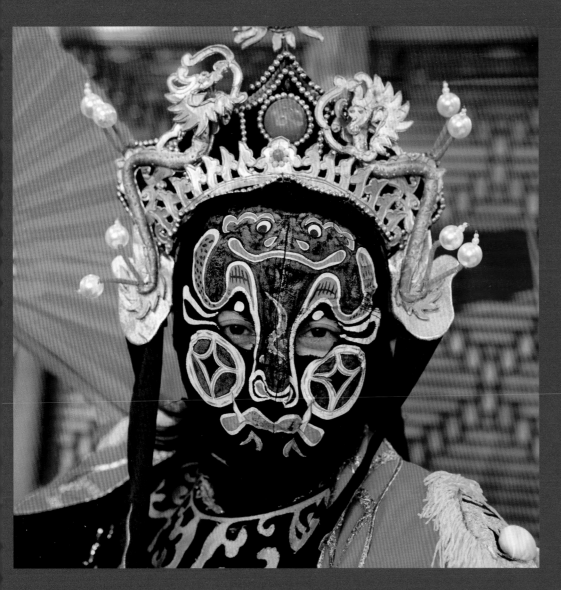
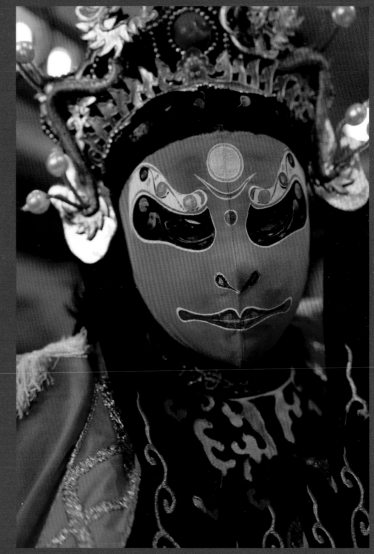
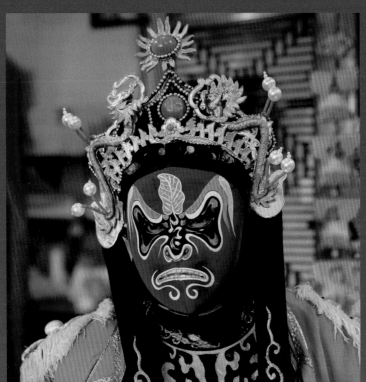
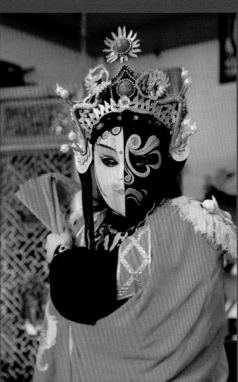
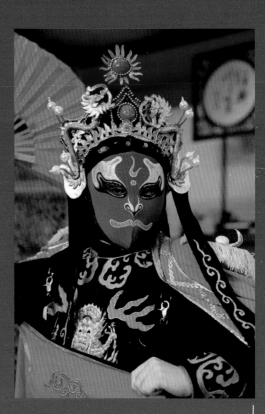

A glimpse of the kitchen at Mister Jiu's.

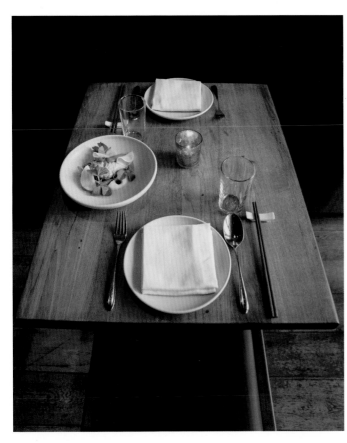
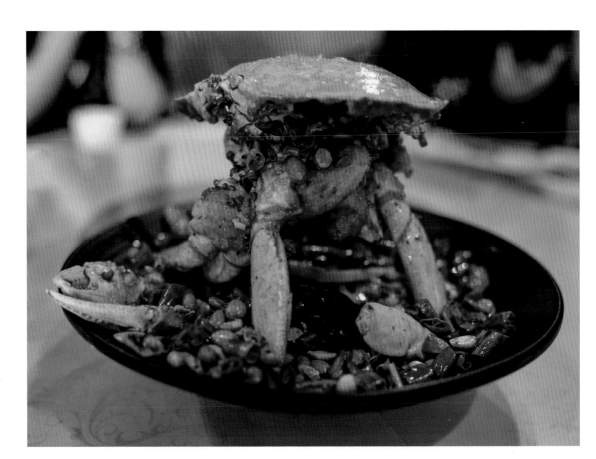

LEFT: A dinner entrée from Mister Jiu's Restaurant. RIGHT: Chili crab from Z & Y Restaurant.

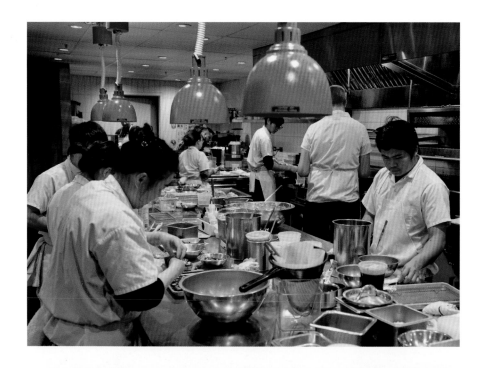

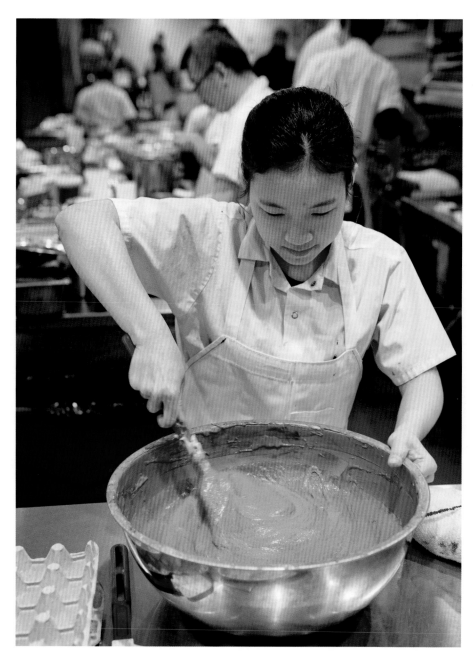

CLOCKWISE FROM TOP LEFT: The kitchen of China Live's Eight Tables by George Chen. Pastry cook Li Jia Qi mixes chocolate mousse for Eight Tables. Steaming dumplings at Dim Sum Corner.

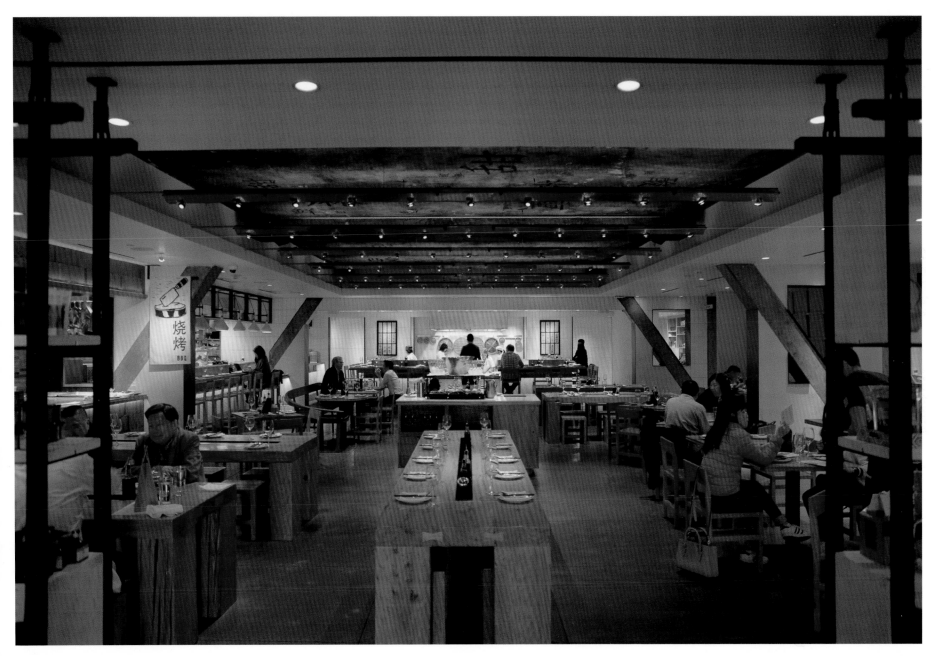

China Live's Market Restaurant.

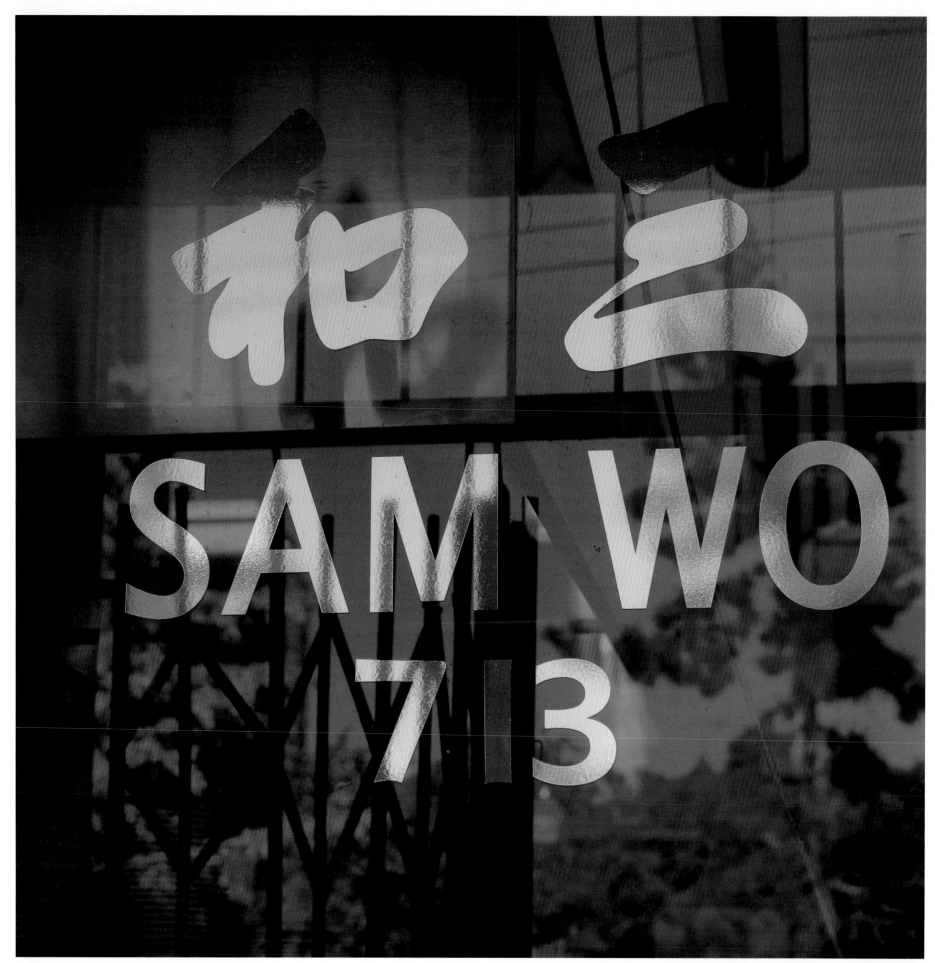

Sam Wo, a popular hole-in-the-wall noodle eatery since 1907 on Clay Street.

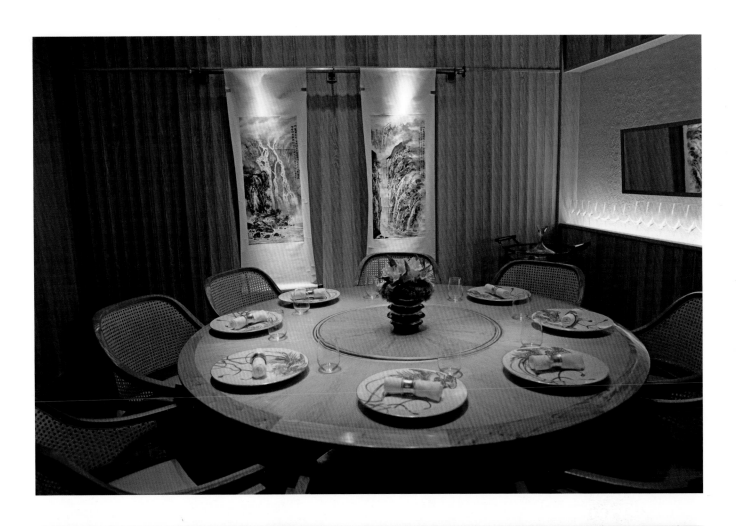

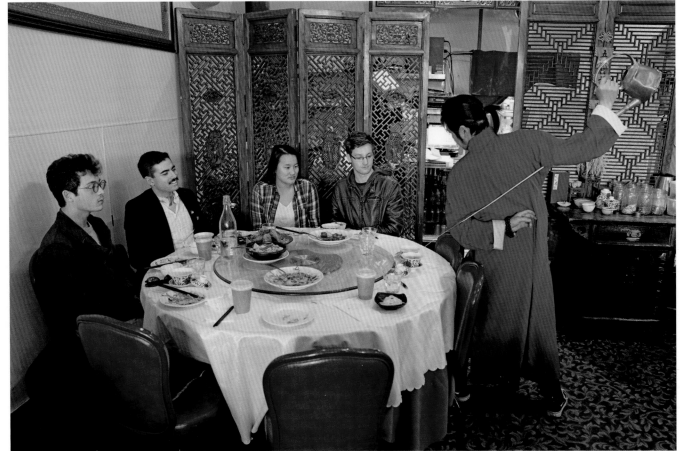

TOP: Formal dining room at Eight Tables by George Chen. BOTTOM: Xumin Liu demonstrates kung fu tea at Z & Y Restaurant.

The light pendant resembles an antique birdcage at Fang Restaurant.

LEFT: Kathy Fang, chef and owner of Fang Restaurant, serves Mongolian stir-fry over noodles. RIGHT: Tanner Young makes boba tea at Dim Sum Corner.

DAILY LIFE

FAAI DI LA! (快啲啦): HURRY UP!

Playing cards between showers at Portsmouth Square on Kearny

TWILIGHT IN CHINATOWN. While tourists retreat to hotel rooms to conclude the day, grandmothers bundled in fleece jackets and clad in Converse tennis shoes stream out of apartments, dragging wire carts ready for cargo. "*Yut mun, yut bao!*" cry the fruit-and-vegetable vendors. "One dollar, one bag!" It is the enchanted discount hour when Stockton Street comes alive with giddy shoppers about to snag a good deal.

"Apricots are so cheap today," proclaims a tiny Cantonese-speaking woman outside a produce shop. Plopping the fruit into a plastic bag she's ripped off the roll, she nods toward the handwritten sign flapping in the San Francisco wind. "Fifty-nine cents a pound! Who cares if it's sweet or sour? They are so cheap, you can take some home and play with them. Just buy some!"

At a nearby seafood market, a shopper waits in line, clutching a flailing frog in one hand and her purse in the other. A second customer grabs a dried squid, announcing to all that she will make *jook* (rice porridge), but the cashier scolds her, saying that the squid should be steamed with rice and a salted duck egg instead. Before the sun sets, the bargain hunters return to their one-room dwellings to prepare dinner.

The neighborhood's fifteen to twenty thousand inhabitants include the retiree, the produce worker, and the bartender mixing his thousandth lychee cocktail. More than half of the populous are age sixty-plus; children and teens represent less than 15 percent. Babies are an extremely rare commodity, which is probably why the new Chinese Hospital has no maternity ward or pediatric services. The surgery department is hopping with cataract operations, however.

According to the San Francisco Planning Department, 70 percent of Chinatown's citizens have a high school education or less. Of total households, approximately 80 percent are Asian speaking, which implies that they are first-generation immigrants.

New residents converge from regions throughout China and Southeast Asian countries. One-third of Chinatown households live in poverty. Collectively, these statistics run contrary to the rest of San Francisco, where the trend leans toward a young, college-educated, and wealthy demographic.

Chinatown's many occupants dwell in low-income single-room occupancy (SRO) apartments. Of the sixty-two hundred housing units in Chinatown, 52 percent are SRO rooms, where life can be suffocating. As one former tenant describes, "You don't live like we did without it doing something to your mind." Renters hand-wash and hang laundry outside windows because they have no laundry facilities. Neighbors fight over using a single stove in a kitchen serving thirty families. Up to seven people have been known to sleep in bunk beds stacked three levels high in a closet-sized room with no windows. No elevators means that the sick and disabled cannot get to the doctor because the stairs are too dangerous to tread.

SRO residents exercise patience daily, waiting to use shared restrooms and showers. This is not transitional housing; this is home. Building inspectors cannot keep up with the mounting infractions of neglected apartments suffering from leaky pipes, antiquated wiring, and poor ventilation. Unsanitary conditions can breed cockroaches and rats. How long people stay in SROs depends on their financial situation. Many spend decades in an SRO if they cannot afford to leave.

Not everyone in Chinatown lives in an SRO, however. On Stockton Street, the sixteen-level Mandarin Tower is an odd duck. It is Chinatown's only condo complex where each unit is individually owned. These have sold for nearly a million dollars each, not including monthly homeowner's association fees. All other condominiums in Chinatown are owned by a single landlord who rents out units.

Neighborhood amenities feature cultural twists—a hospital with acupuncturist offices, a police station with Asian officers, and hair salons stocked with Chinese movie magazines. Unlike at other San Francisco schools, Chinatown schoolchildren bring home permission slips in English and Chinese. Chinatown is home to the Edwin and Anita Lee Newcomer School, the only public elementary school in San Francisco dedicated to helping Chinese children and their parents adapt to America.

Meanwhile, parents seek out open spaces so that the few children who do live in Chinatown can expend pent-up energy. Only four small parks are available in this, the densest urban neighborhood west of Manhattan. Children of early Chinatown entertained themselves outdoors in empty lots and alleys, but by 1927, the city finally built the first Chinatown playground, with swings, a slide, and tennis and basketball courts. The Willie "Woo Woo" Wong Playground, currently under renovation, was eventually named after the phenomenal five-foot-five basketball player, the first Chinese American to achieve success in basketball. His fans shouted "Woo woo!" each time he scored for the University of San Francisco Dons varsity squad in the late 1940s.

For an SRO kid, the after-school ritual involves heading straight to the Chinatown Him Mark Lai Branch Library (part of San Francisco's public library system) to complete homework or play computer games. SRO apartments have neither room for study desks nor access to the Internet. Other children attend Chinese school until their parents pick them up after work.

Chinatown supplies everything necessary to preserve culture, history, and traditions. Students can master the *erhu* Chinese fiddle at Clarion Performing Arts Center. During the Friday night youth program at Donaldina Cameron House, a social services center, teens learn to make Chinese herbal soups. Others can sign up for dragon-boat racing, lion dancing, or kung fu throughout the neighborhood.

Each day, the elderly attend to fixed routines. Retirees "wash" mah-jongg tiles in family association halls. Portsmouth Square, Chinatown's "living room" and largest park, is a pivotal gathering spot. Old bachelors lay out Chinese chess pieces on parchment paper. Widows play cards on cardboard boxes yanked from the bushes.

Chinatown's heart holds a soft spot for these vulnerable immigrants and citizens. Groups such as Self-Help for the Elderly, On Lok Lifeways, and many others empower seniors, offering resources and explanations of current events that affect their lives. The YMCA and the First Chinese Baptist Church provide classes in conversational English, nutrition, and cell phone usage. Opened in 2016, the new Chinese Hospital is the only one of its kind in the country with language assistance in Cantonese, Sei Yap Wa, Mandarin, and other dialects.

Every village boasts its heroes, and Chinatown is no exception. Crusaders and allies have saved Chinatown from relocation, destruction, and gentrification. Founder of the Chinatown Community Development Center in 1977, Gordon Chin has served as a driving force advocating for affordable housing. His foresight to rally for reasonable rents has benefited seniors and the poverty stricken who would have nowhere else to live. His successor after retirement, Rev. Norman Fong, does not shy away from the hard issues either. Fong cannot remember how many times he has been tossed in jail for protesting over tenants' rights and Chinese immigration policies. Born and raised in Chinatown, he finds no greater joy than raising up the next generation of activists.

Supervisor Aaron Peskin, familiarly known as Woo So Lo (the Bearded Man), has been representing the Chinese community for more than a decade. He says that he can finally raise a toast in Cantonese. Chinatown leaders were relieved when he backed their decision to block marijuana dispensaries in the neighborhood. Peskin routinely hobnobs with merchants and, through a translator, takes notes as residents air their concerns.

Never to be forgotten is the late activist Rose Pak, the neighborhood's most controversial ambassador, called both a bully and a hero. As consultant to the Chinese Chamber of Commerce, she swore like a sailor and terrified everyone at City Hall. Pak loved to seize the microphone during the Chinese New Year Parade and mock politicians as they motored by. She died in 2015 at sixty-eight, but her two biggest legacies include championing the Central Subway project, slated for a 2021 opening, and fundraising for the $180 million Chinese Hospital.

This mural of a woman shopping in Chinatown, artist and title unknown, has since been destroyed.

Still praised is the late Edwin Lee, the city's first Asian American mayor. The sixty-five-year-old politician who called himself the "Jeremy Lin of mayors" led San Francisco for six years and died of a heart attack in 2017. In the documentary *Mayor Ed Lee*, former secretary of state Hillary Clinton commented, "Nobody could doubt his deep humanity, his decency, and love for San Francisco." Lee, once managing attorney in Chinatown for the Asian Law Caucus, fought for low-income housing, an increase in the minimum wage, and the creation of the $1.4 billion Chase Center indoor arena, built entirely from private funds.

"To many, his legacy was public housing, but that is too short a list. He continuously sought to expand the opportunity to serve the public," says former San Francisco mayor Willie Brown. When Mayor Lee passed away, the heartbroken city flew flags at half-staff for thirty days.

The Bay Area population is transient. In a 2018 poll by the *San Jose Mercury News*, 46 percent of those surveyed said they intend to leave the area within the next few years due to increasing traffic congestion and the high cost of living. Meanwhile, although Chinatown quarters are cramped, there is strength in community. Younger, English-speaking Chinese and American-born Chinese keep Chinatown strong and vibrant. Former residents, now postcollege professionals living in the suburbs, return to their old stomping grounds to work as doctors, lawyers, and accountants. Families come back for Sunday worship services because they want to maintain their fourth- and fifth-generation legacies. Asians intent on making a difference commute to the area for jobs out of reverence for the neighborhood.

Chinatown's local families and neighbors are tight-knit. All of life's necessities lie within walking distance. Many of Chinatown's residents who have fled oppressive homelands will tell you that, in comparison, life is better here. They have food. They have shelter. They have choices. And they are content to remain.

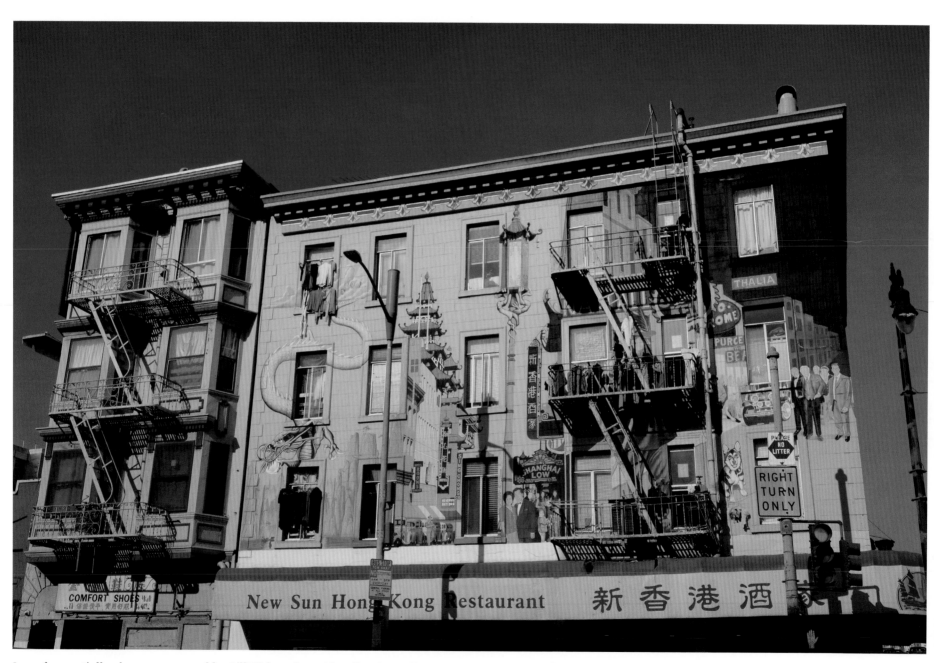

Laundry partially obscures a mural by Bill Weber above New Sun Hong Kong Restaurant on Broadway.

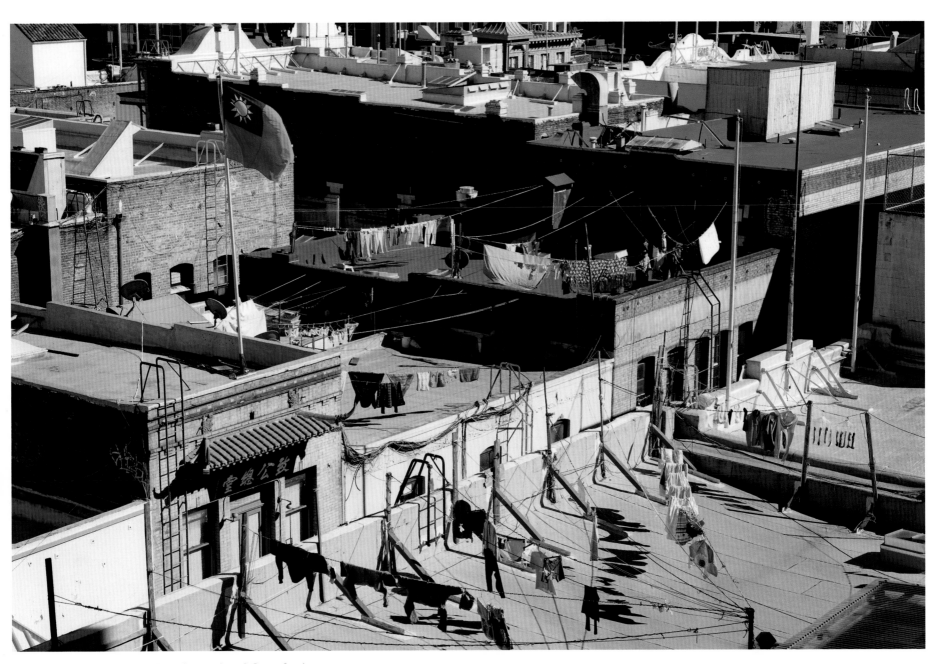

Rooftop laundry sways below the national flag of Taiwan.

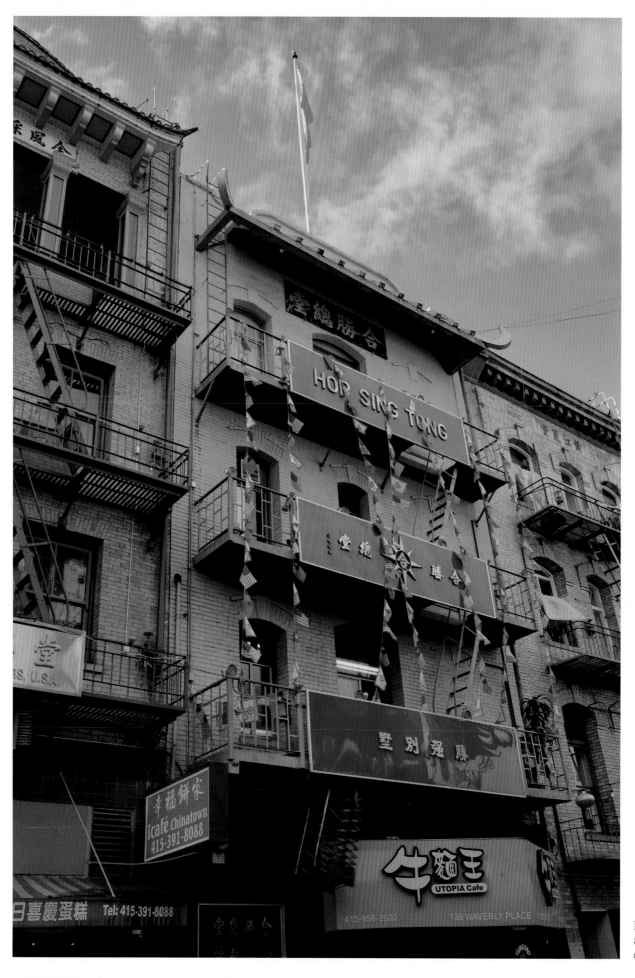

Hop Sing Tong family
association meeting hall
on Waverly Place.

Family association buildings representing several clans on Washington Street.

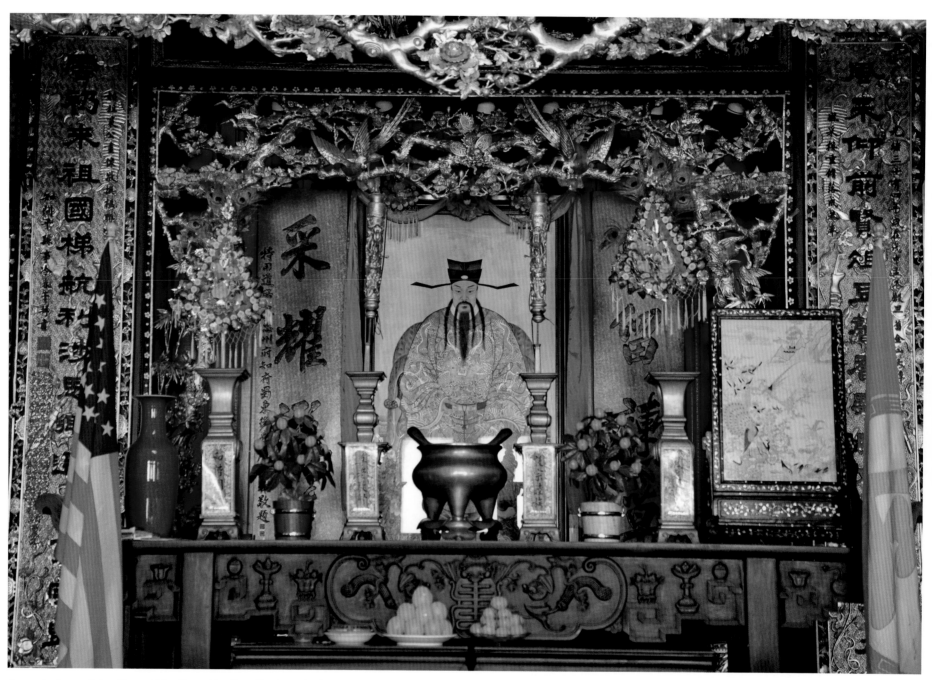

Ancestral worship altar at Yee Fung Toy Family Association.

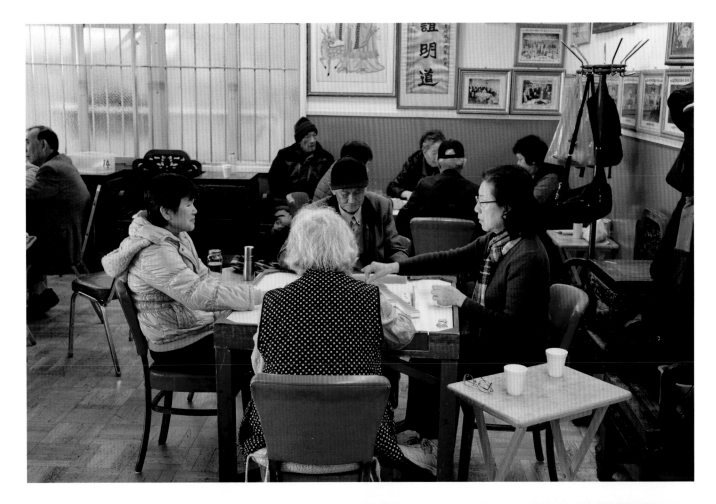

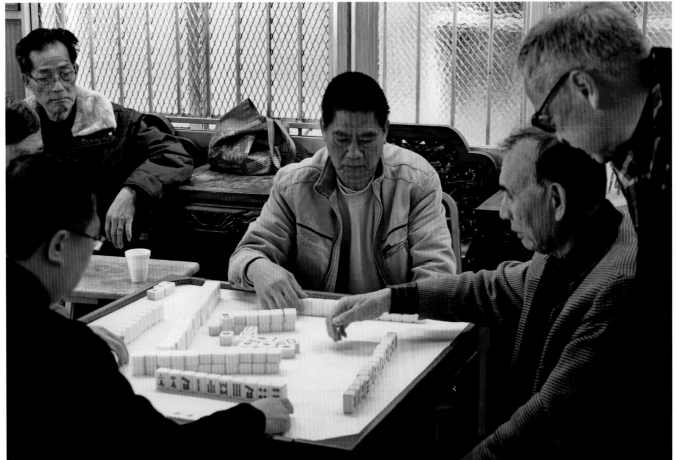

TOP AND BOTTOM: Retirees gather for daily mah-jongg at the Fah Yuen Benevolent Association.

Rooftops of Chinatown
along Clay Street.

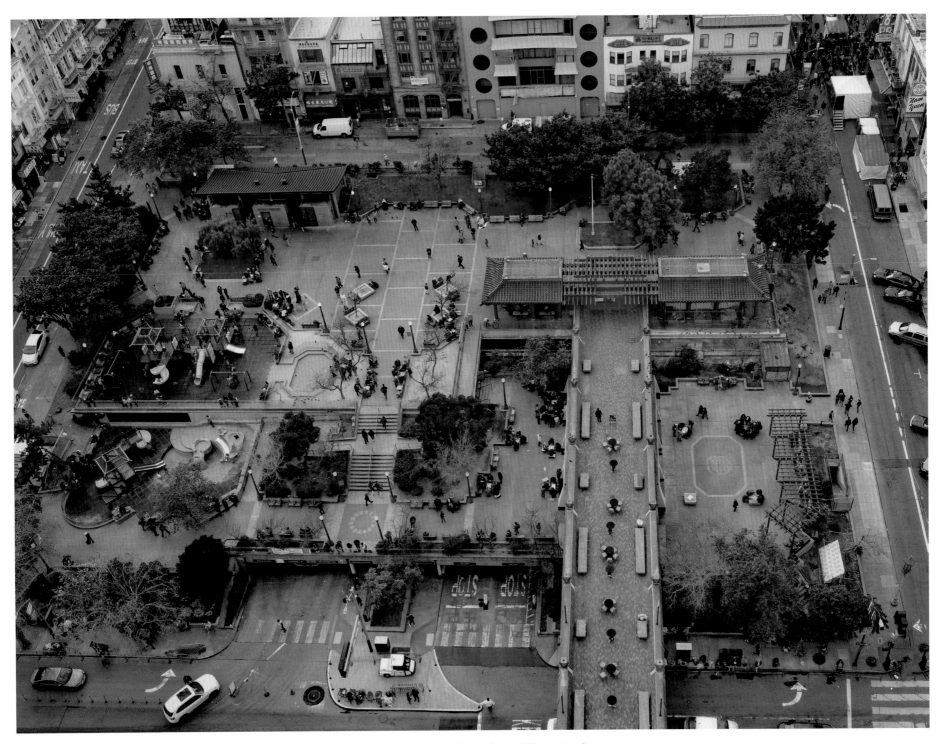

Aerial shot of Portsmouth Square, the "living room" of Chinatown, from the rooftop of the Hilton Hotel.

Overhead view of Edwin and Anita Lee Newcomer School on Merchant Street.

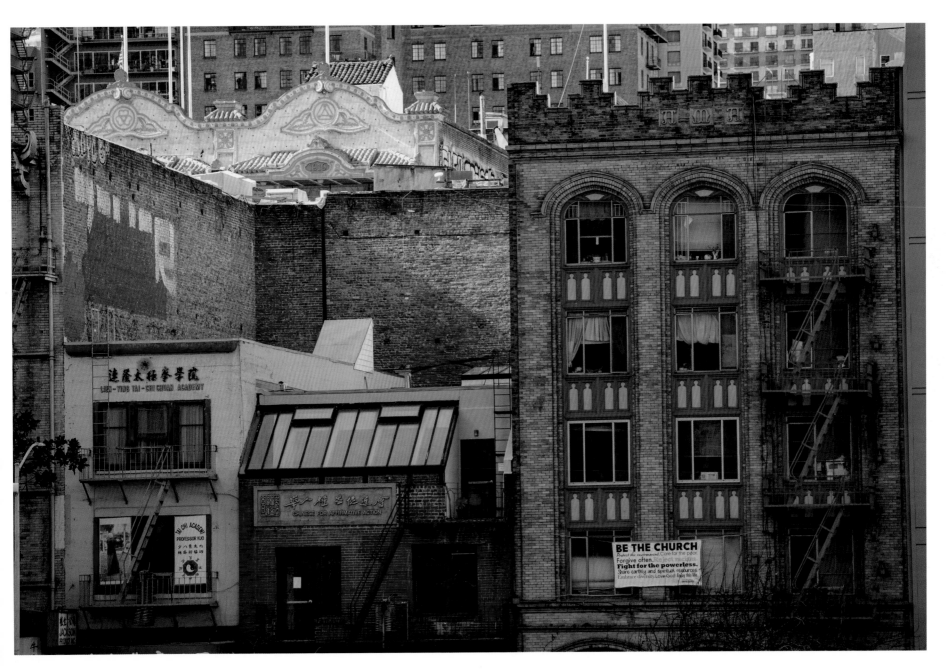

Buildings bordering Portsmouth Square.

SINGLE-ROOM OCCUPANCY (SRO) APARTMENTS

A ninety-year-old grandmother is so ill, she cannot muster the strength to walk. Living in a single-room apartment with her son, daughter-in-law, and grandchildren, she sleeps on the lower bunk while her family crams onto the upper bed or stays the night with relatives elsewhere in the building. Meanwhile, she cannot get to a doctor because she can't make it down the several flights of stairs.

Her family is grieved. When the daughter-in-law spies Rev. Norman Fong in the hallway, she pleads with him to visit. Fong is not only a pastor but also the executive director of the Chinatown Community Development Center, which oversees many of the SRO apartments in Chinatown. As he sits on the edge of the bed, he quietly holds the grandmother's hands in his and whispers a prayer only she can hear. Her furrowed brow relaxes, and she utters a soft thank-you for his kindness.

Across America in the nineteenth century, residential hotels were built to house the working class. They were known as flophouses and tenements. "SRO apartments" is the official name, and they still exist in high-density urban centers. Of the sixty-two hundred units of housing available in Chinatown, 52 percent are SROs, with rents as low as $250 a month.

In Chinatown, the most famous SRO was the doomed International Hotel, where, on August 4, 1977, two thousand housing activists linked arms to block the eviction of its mainly Filipino and Chinese residents. Police avoided the protesters and entered the building via the rooftop. The building was eventually demolished, but in 2005, advocates joined together to have the International Hotel rebuilt. It opened as an SRO complex with eighty-eight studios and sixteen one-bedroom units for the most impoverished of low-income seniors.

CLOCKWISE FROM LEFT: SRO apartments typically have few or no laundry facilities. Rev. Norman Fong prays for a grandmother. Neighbors Mei Ai Xie (left) and Yiu Wing Ngo (right). Property manager Hazel Chen. Chinatown Community Development Center staff: from left to right, community organizing manager Angela Chu, executive director Rev. Norman Fong, and project coordinator Amy Dai.

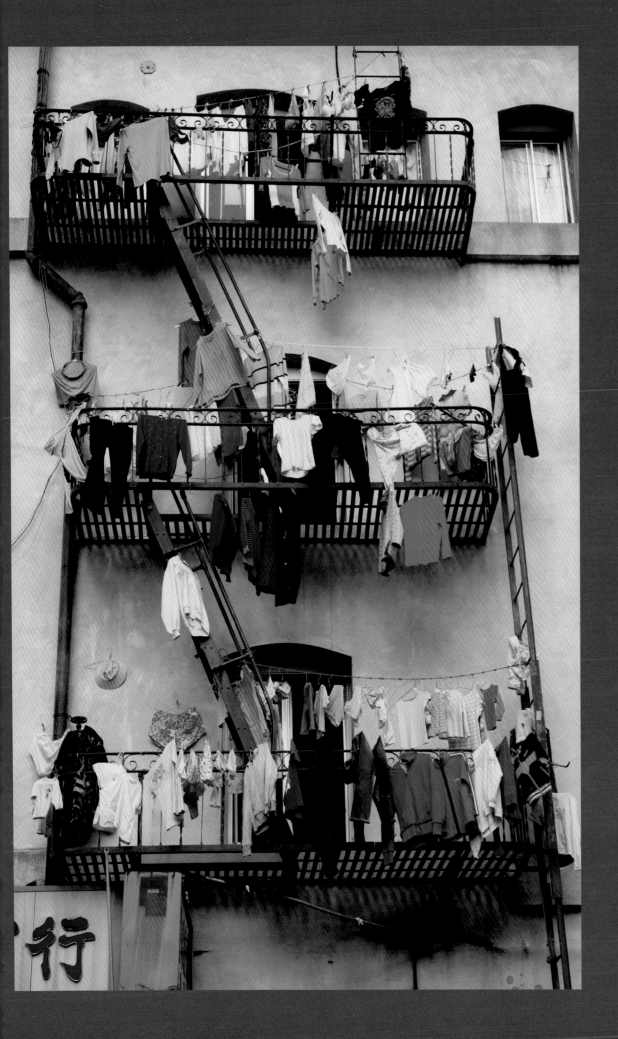

Tonia Chen helps to restore the *Ping Yuen* mural in 2018, nearly twenty years after its creation.

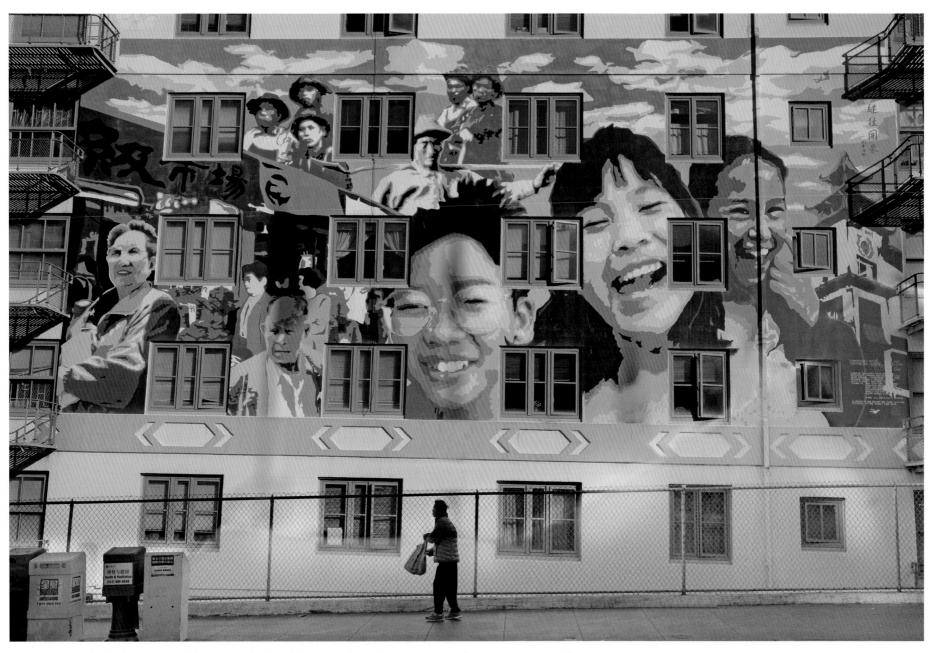

Ping Yuen mural, the largest in Chinatown, designed by Darryl Mar in 1999 on Stockton Street at Pacific Avenue.

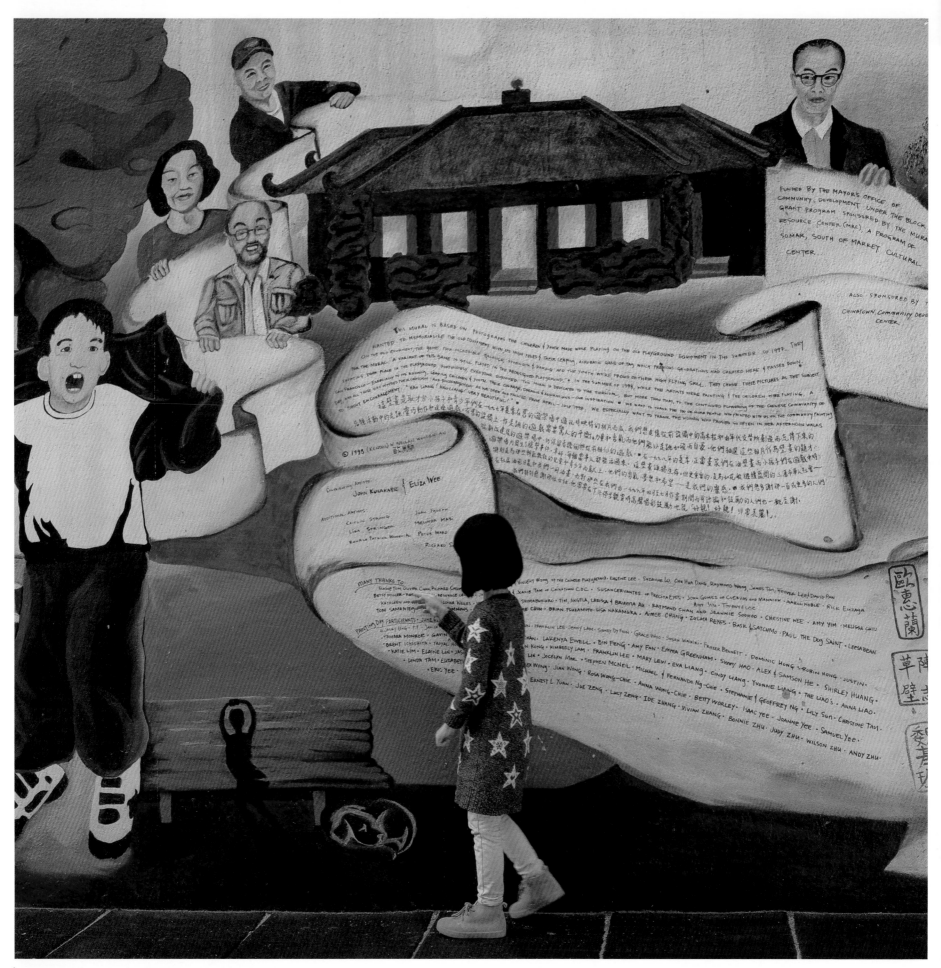

Girl at the old Willie "Woo Woo" Wong Playground on Sacramento Street. The mural wall has since been torn down to make way for the new park.

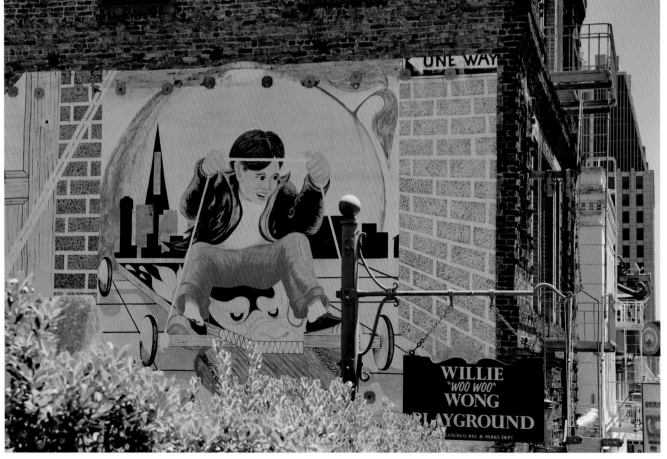

TOP: A mural, now destroyed, behind a play structure depicts kids having fun at the park. BOTTOM: Mural of a boy on a go-cart by Jim Dong.

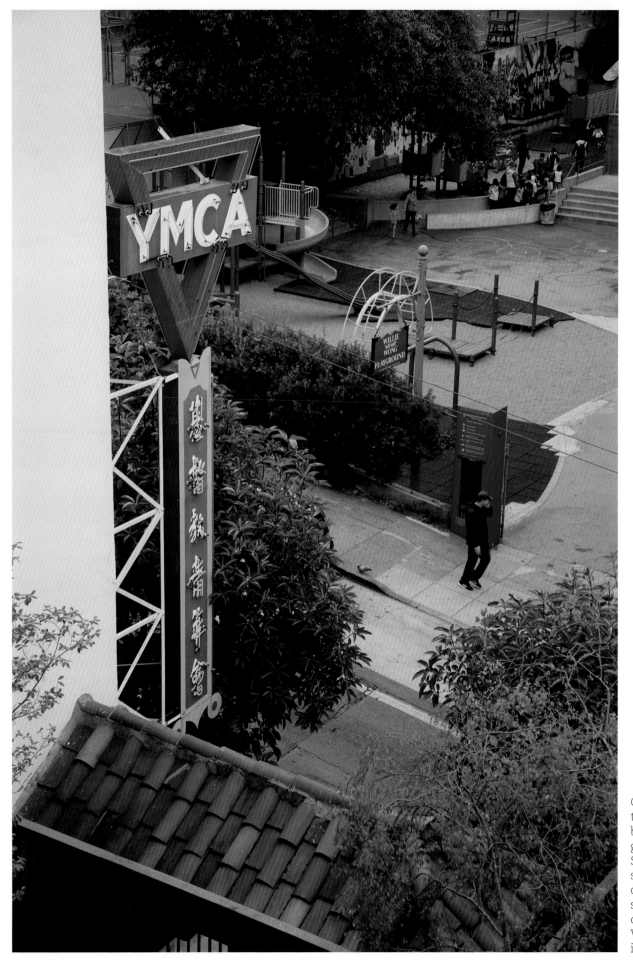

Chinatown kids used to frolic in dirt lots, but by 1927 this new playground on Sacramento Street offered them a safe place to enjoy the outdoors. The unnamed space was officially dubbed the Willie "Woo Woo" Wong Playground in 2009.

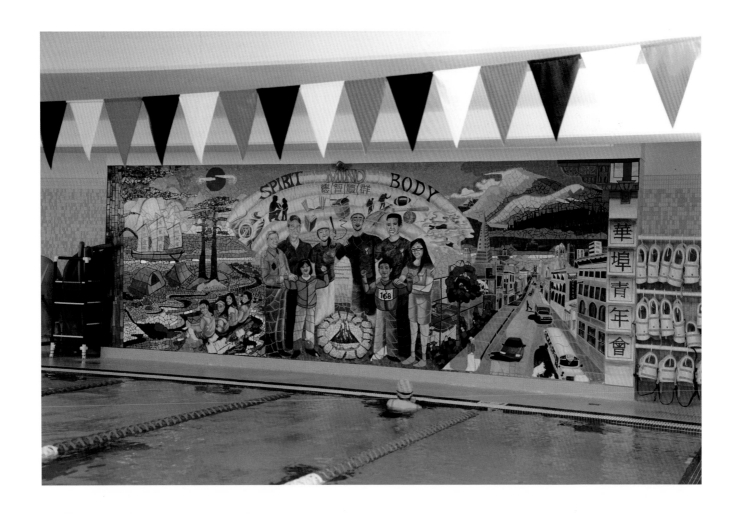

TOP: Chinatown YMCA saltwater swimming pool, the only pool in Chinatown, in front of *100 Years of Serving Youth*, by Susan Cervantes and Elaine Chu of Precita Eyes. BOTTOM: Life vests for little ones.

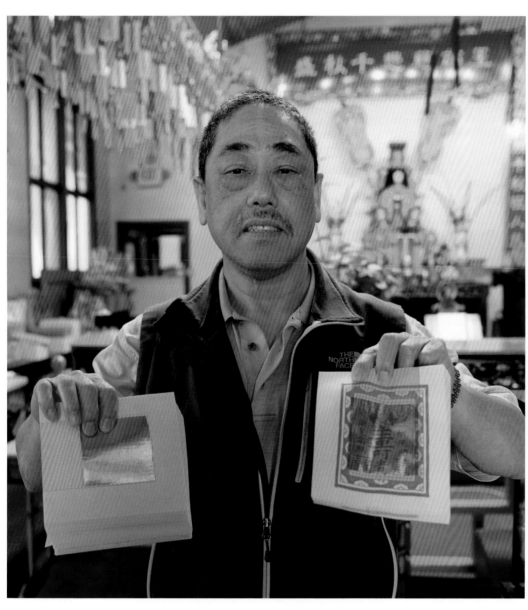
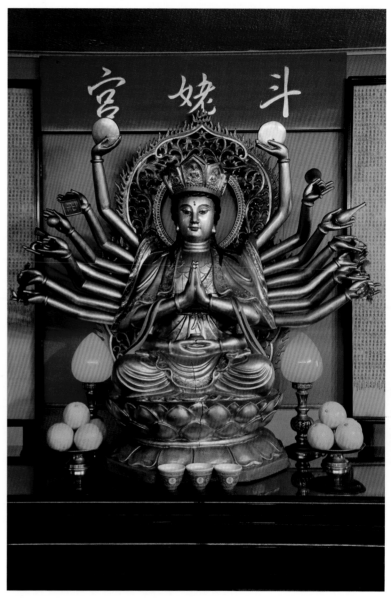

LEFT: Priest Cheuk Kuen Chau holds up ceremonial gold papers to be burned so that ancestors will have wealth in the afterlife at the Quong Ming Jade Emperor Palace temple. RIGHT: Doumu, Mother of the Great Chariot / Big Dipper.

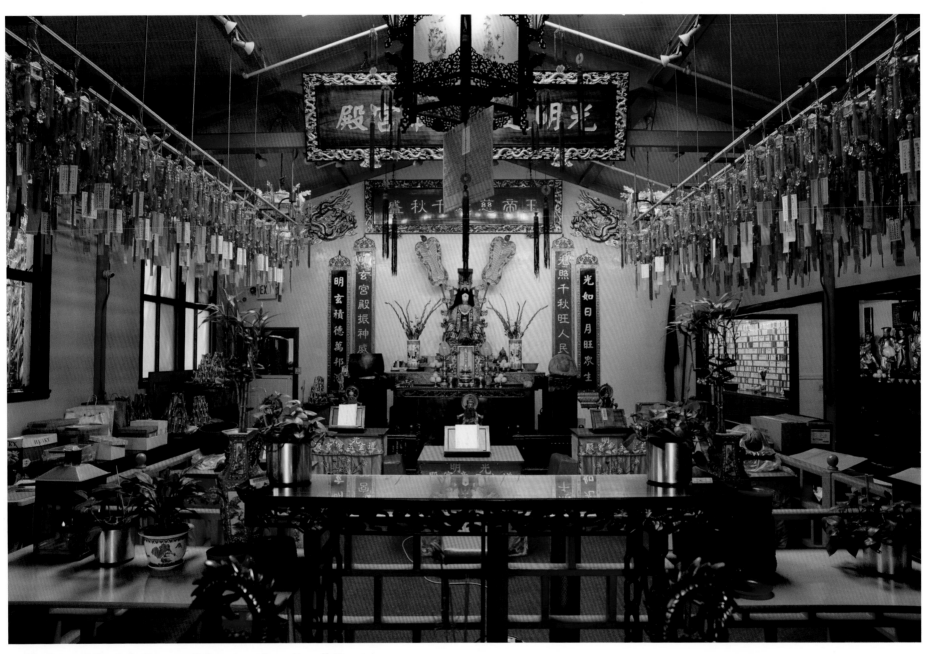
Inside Quong Ming Jade Emperor Palace temple on Powell Street.

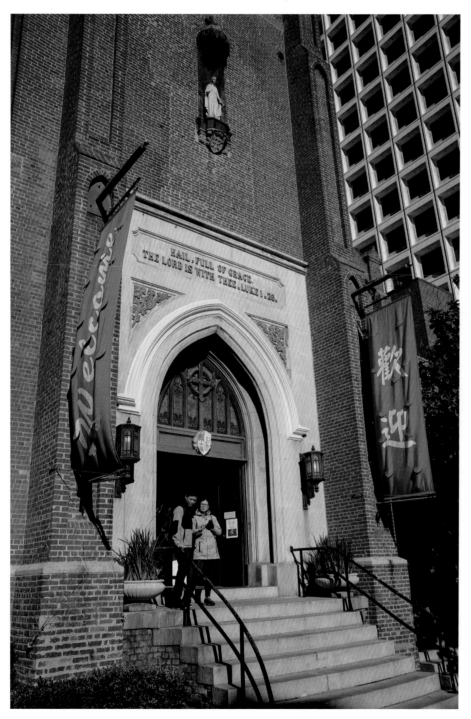
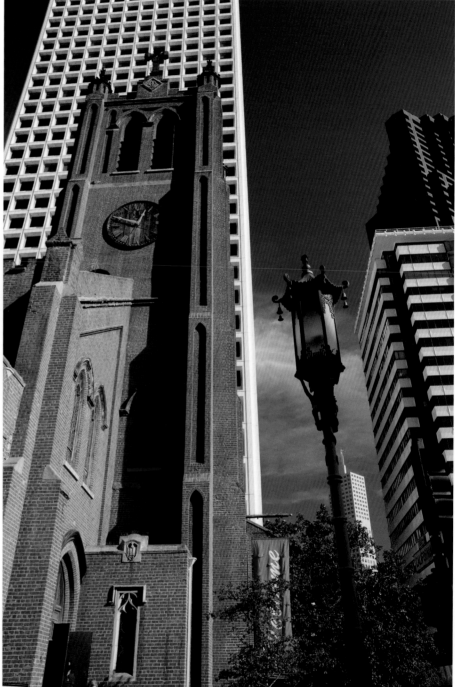

LEFT AND RIGHT: On the corner of California Street and Grant Avenue, Old St. Mary's Cathedral and Chinese Mission, built in 1854 and the city's only Catholic Chinese parish, survived the 1906 earthquake.

LEFT: A Bible on a pulpit at the First Chinese Baptist Church of San Francisco, founded in 1880. RIGHT: Stained glass waterfall window.

CAMERON HOUSE

As superintendent of the Occidental Mission Home for Girls, founded in 1874, Donaldina Cameron was a relentless crusader who, with her team, rescued as many as three thousand women and girls from sex trafficking and domestic slavery in Chinatown. With an uncannily quiet demeanor, she joined police on brothel raids and faced death threats from those opposed to her work.

Later renamed Donaldina Cameron House, the red brick sanctuary on 920 Sacramento Street was the place where Cameron introduced the young women to the Christian faith and taught them life skills. Today, Cameron House is a lifeline for more than a thousand low-income residents, offering Chinese-language cancer support groups, food pantry services, computer classes, family counseling, after-school programming, and parenting workshops.

The center's impact on young lives has been immeasurable, as staff empower kids during weekly clubs, summer camps, and sports programs. Laurene Chan's parents met at Cameron House as teenagers. Today she works there as director of youth ministries. Socially isolated children have blossomed with confidence. Says Chan, "I see miracles of transformation every day. When I can, I tell each of them, 'You are a person of great value.'"

For Martin Ko, now a business manager at Alibaba, leadership skills germinated at Cameron House summer camps when he was a youth. By the time he entered high school, he and the other teens led the program. "We had a planning meeting every week to organize activities. We planned out the supplies we needed and the bus routes to take," he recalls. "We were doing planning logistics, and we didn't even know it. We had to make sure everyone stayed on track, from leading games to making sure the kids all washed their hands. It was exhausting, but it was a great time."

ALL: Cameron House, a social services center, offers youth and adult activities, classes, and support groups. TOP LEFT: May Leong, former executive director, shoots imaginary hoops with Nolan Chow, Cameron House office and operations manager. BOTTOM RIGHT: C. K. Jeong (right) leads volunteers in the Kitchen Medicine program.

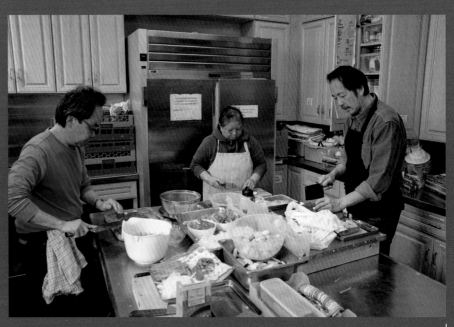

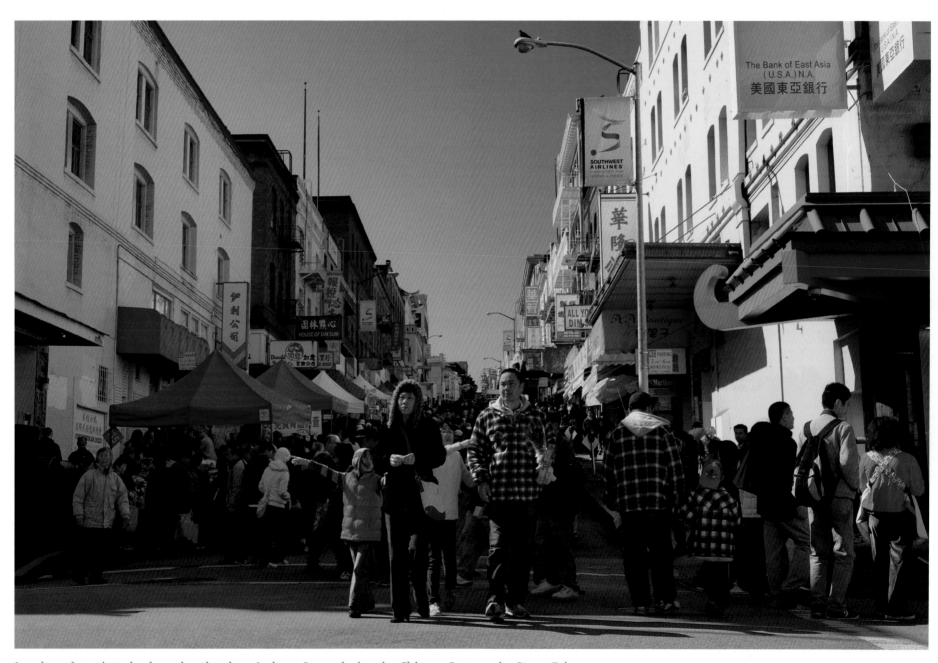

Locals and tourists check out booths along Jackson Street during the Chinese Community Street Fair.

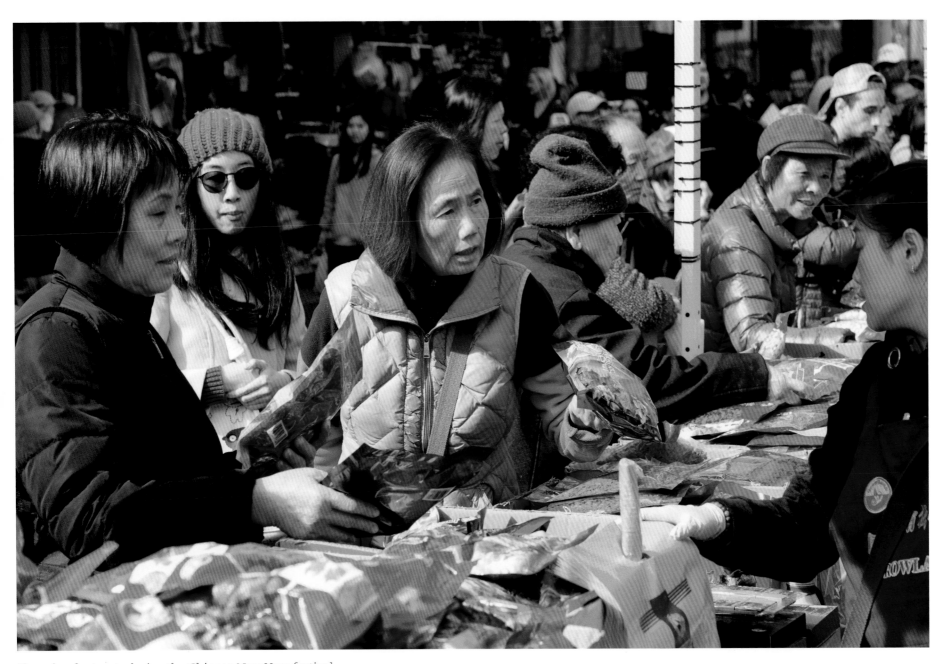

Shopping for treats during the Chinese New Year festival.

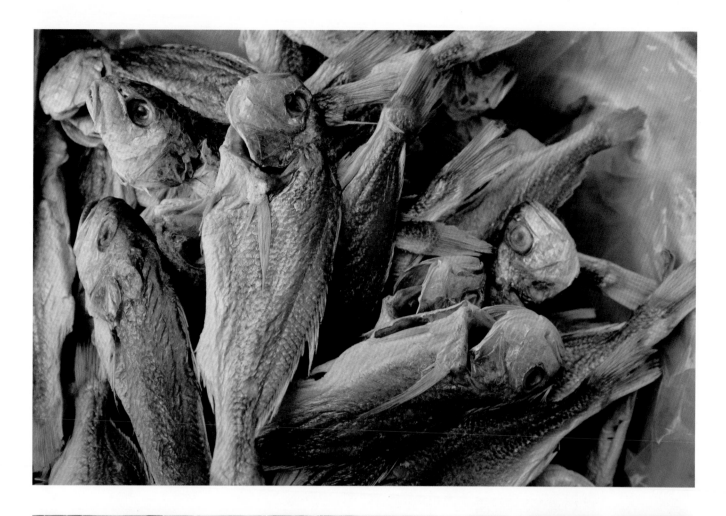

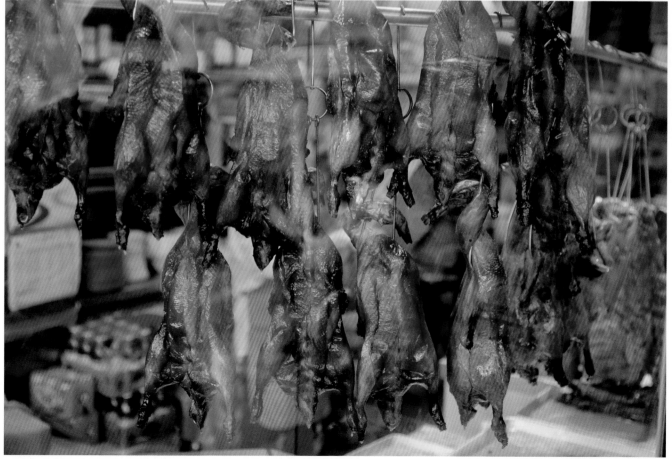

TOP: Preserved salted fish. BOTTOM: Roast ducks hang for display, drying, and purchase.

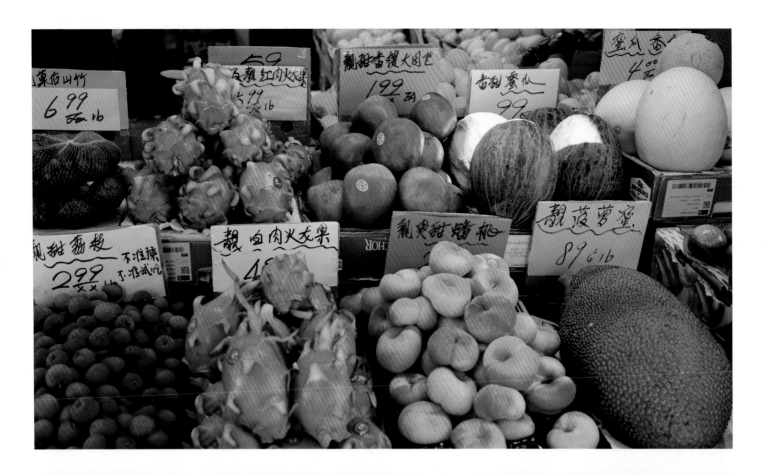

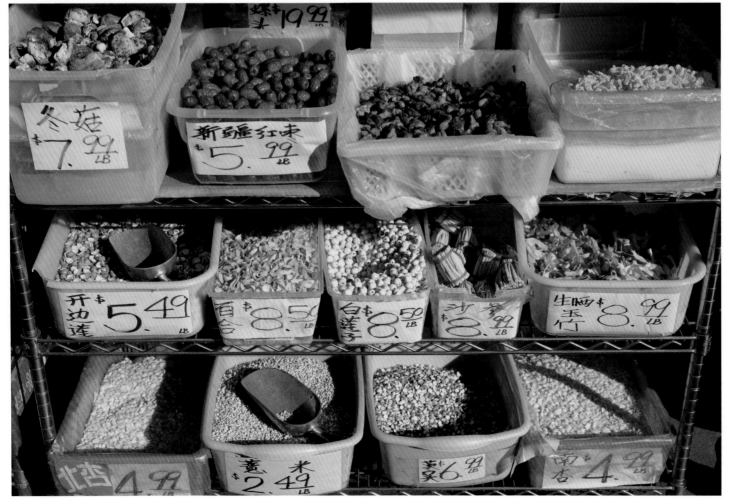

TOP: Dragon fruit, rambutan, jackfruit, peaches, and more. BOTTOM: Dried herbs, dried vegetables, and seeds for soups.

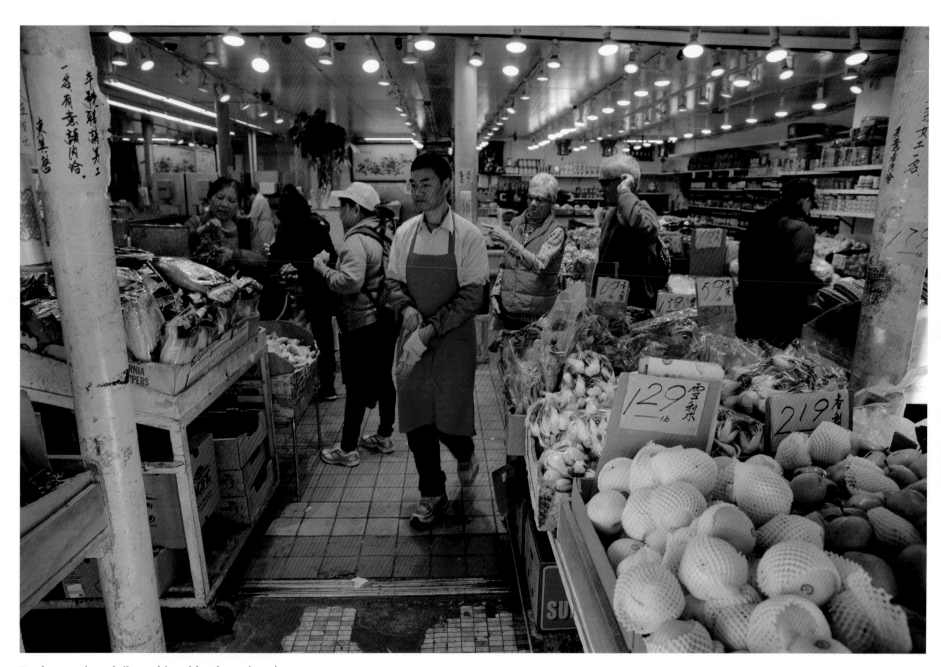

Produce arrives daily and is sold at bargain prices.

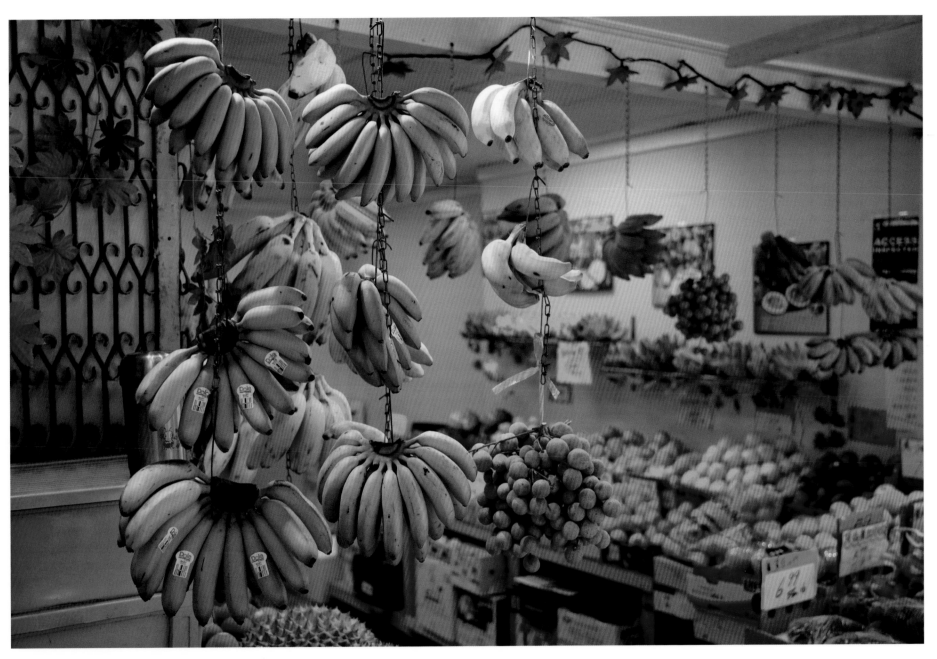

Bananas and clusters of tropical *longan*, "dragon eyes."

Morning delivery on Stockton Street.

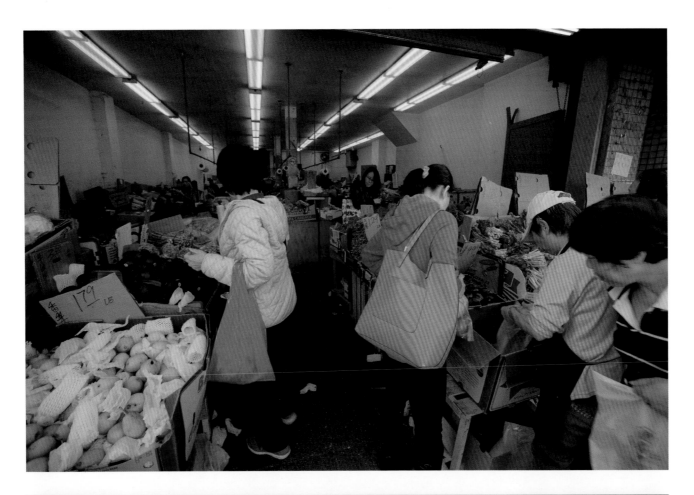

德興燒臘
951-8628

本店新品種
野生山豬肉

TOP: Scouring the aisles for dinner ingredients. BOTTOM: Cooked entrées-to-go make life simpler.

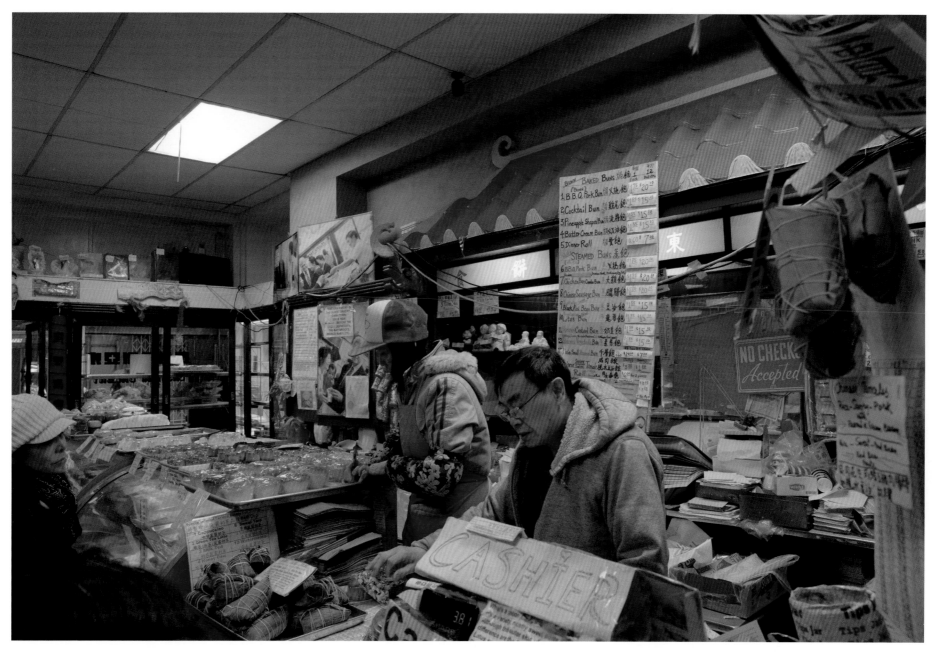

Owner Orlando Kuan at the register of Eastern Bakery, Chinatown's oldest bakery, founded in 1924, at the intersection of Grant Avenue and Commercial Street.

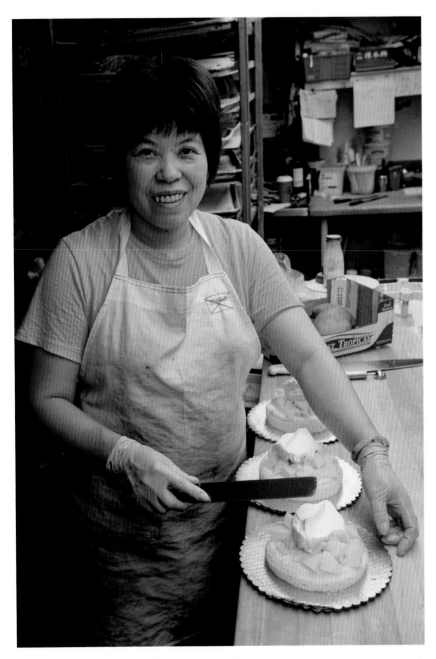
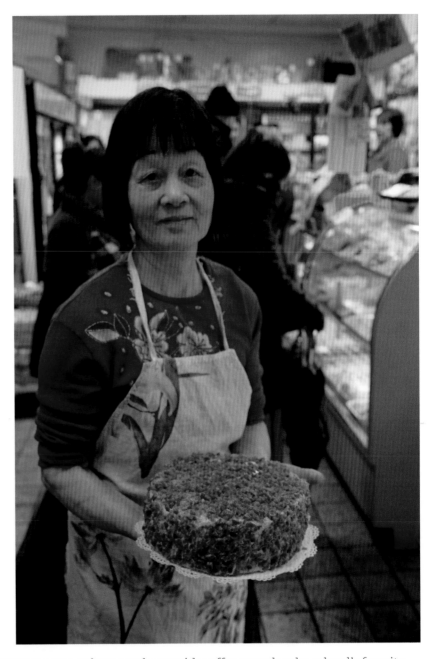

LEFT: AA Bakery and Café employee adds whipped cream to a mango cake. RIGHT: Eastern Bakery employee with coffee crunch cake, a local's favorite.

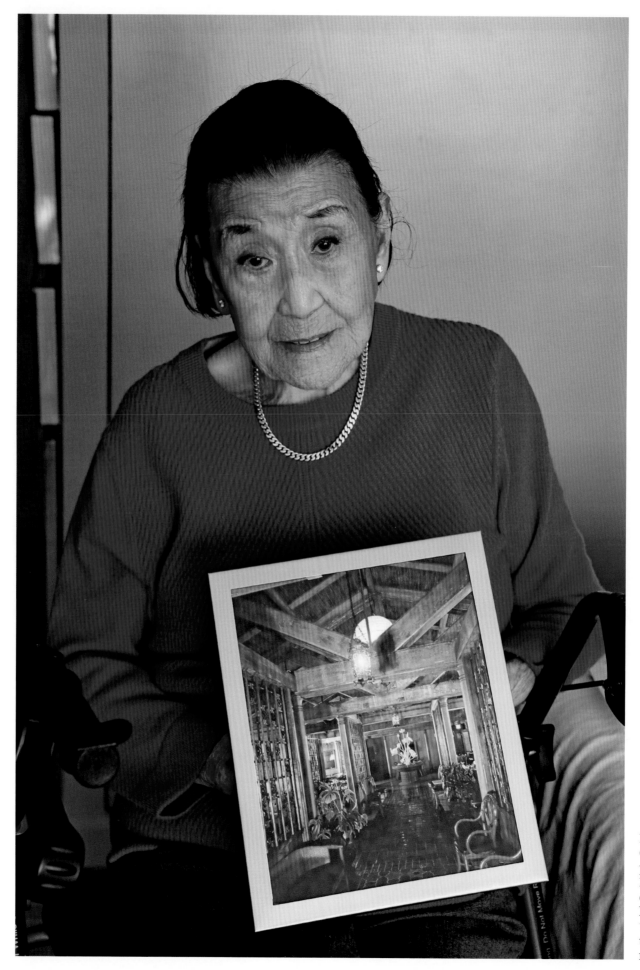

Restaurateur Cecilia Chiang shares a rare photo of Mandarin Restaurant at Ghirardelli Square. Under her leadership from 1968 to 1991, it was hailed as the best Chinese restaurant in San Francisco.

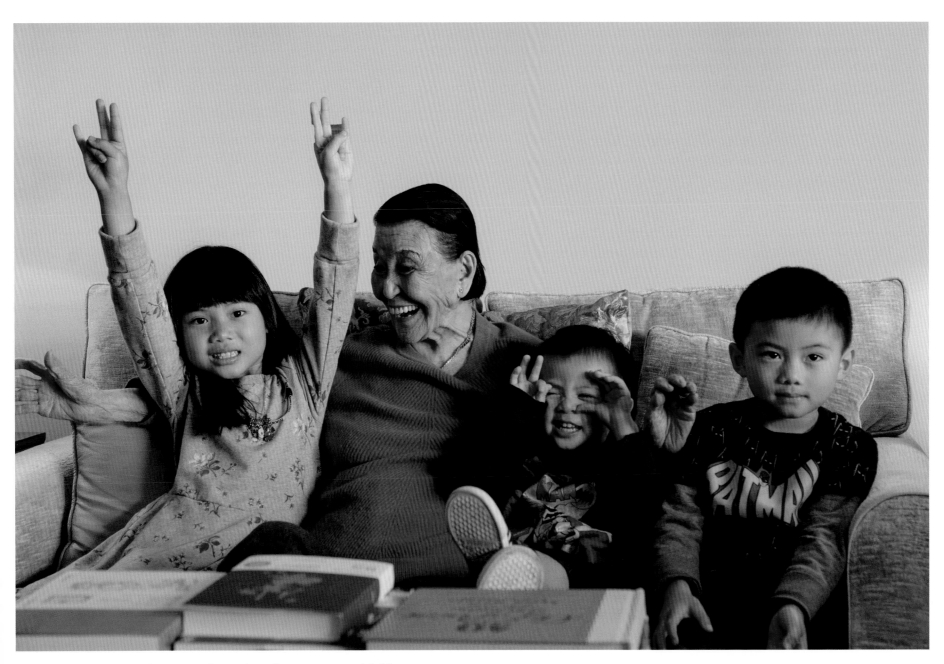
Cecilia Chiang, age 100, laughs at the antics of her great grandchildren.

GRANT AVENUE FOLLIES

From 1936 to 1970, Chinatown nightlife thrived. Well-heeled patrons, even Hollywood elite including Ronald Reagan and Bob Hope, converged for shows and drinks at exquisite nightclubs featuring Chinese American performers. Honey-tongued musicians sang like Frank Sinatra, and dancers swept across the dance floor with the grace of Ginger Rogers and Fred Astaire. Once the era ceased, the performers had to retire—or did they?

In 2003, former dancer Cynthia Yee reunited with three of her peers to form the Grant Avenue Follies. By this time, the women were in their sixties, but they still had the moves. Plus, their doctors told them they needed to exercise to stay healthy. They performed at senior day-care facilities, later at corporations and charity benefits. The four professional members added women to the ensemble who had the desire but no experience. A retired college professor joined at age seventy. "She's having the time of her life," says group leader Yee. Although in their seventies, eighties, and nineties, Follies dancers are as active as ever, performing in three or more shows a month. Led by a professional choreographer, twice-weekly rehearsals last three hours, equivalent to a strenuous workout.

The twelve-member sisterhood is booking gigs around the globe. As a cultural exchange, the troupe went to Havana, Cuba, where they met elderly Chinese Cubans of the Lung Kong Association. The Grant Avenue Follies, including ninety-two-year-old Coby Yee, tap-danced and sang, never missing a beat, even in the pouring rain.

According to Cynthia Yee, this second phase of her dancing career is not that different from prior years. She still needs to rehearse, put on makeup and costumes, and go on the road. "Our audiences are older than before, and we are all getting a big kick out of the whole thing."

ALL: Grant Avenue Follies dancers perform *God Bless the USA* at Herbst Theatre. TOP RIGHT: Follies founder Cynthia Yee.

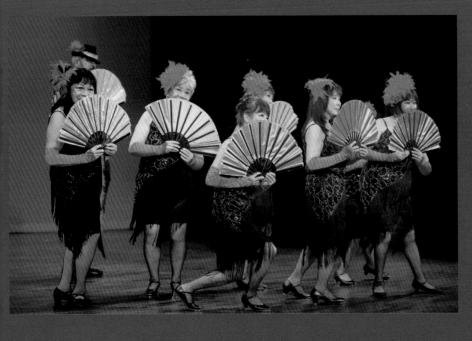

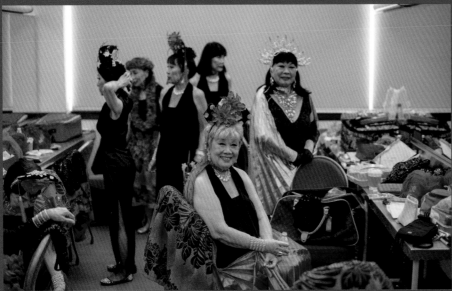

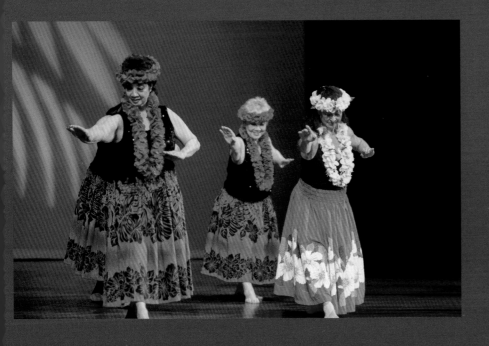

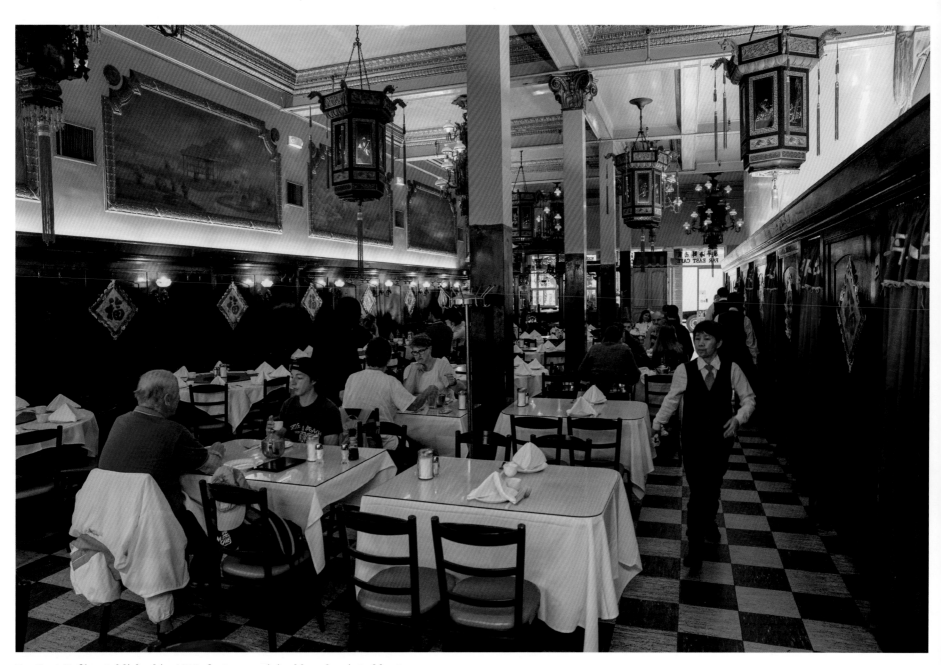

Far East Café, established in 1920, features original hand-painted lanterns.

TOP: At left, "blessings," while on the right says, "peace wherever you go." BOTTOM: Far East is the only Chinatown restaurant with curtained booths seating up to six.

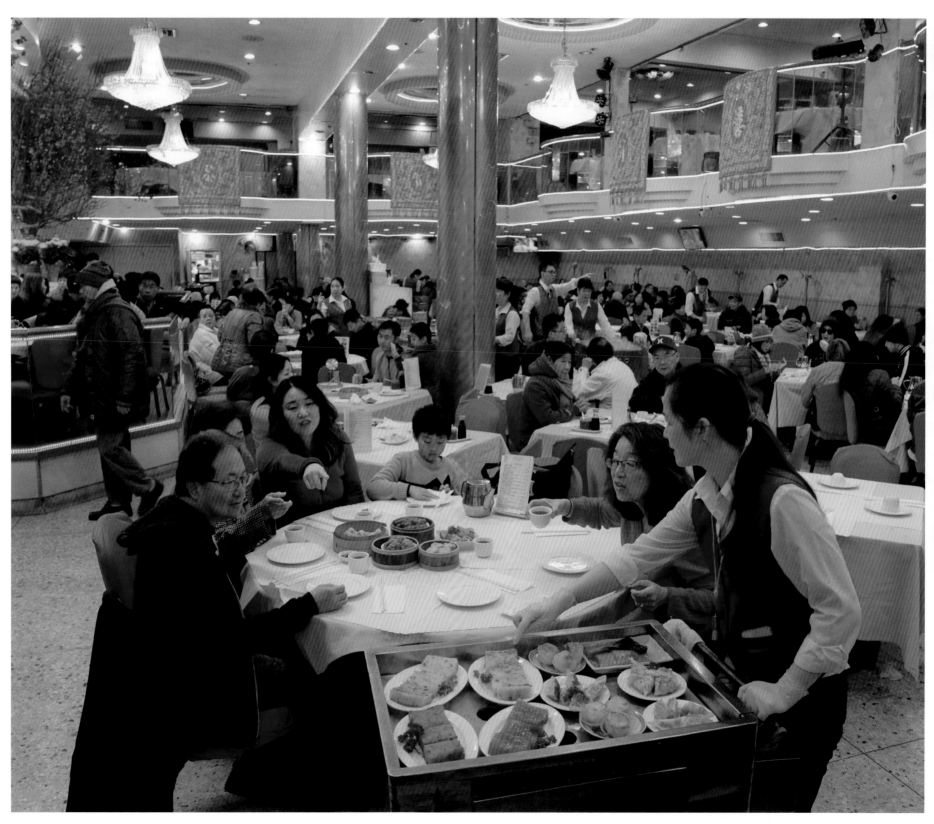

Chin and Leong families catch dim sum at New Asia Restaurant on Pacific Avenue.

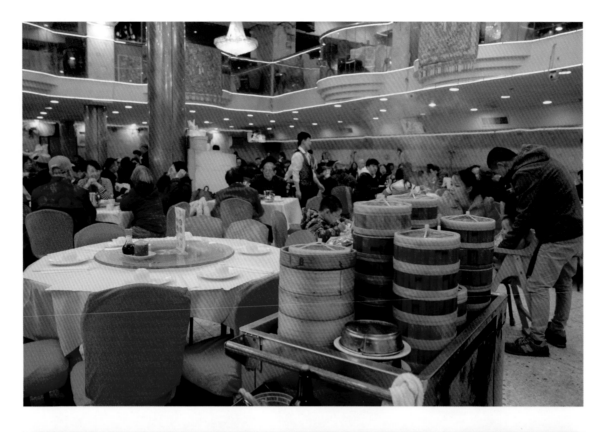

TOP: Rolling carts carry favorites. BOTTOM: New Asia Restaurant's stage.

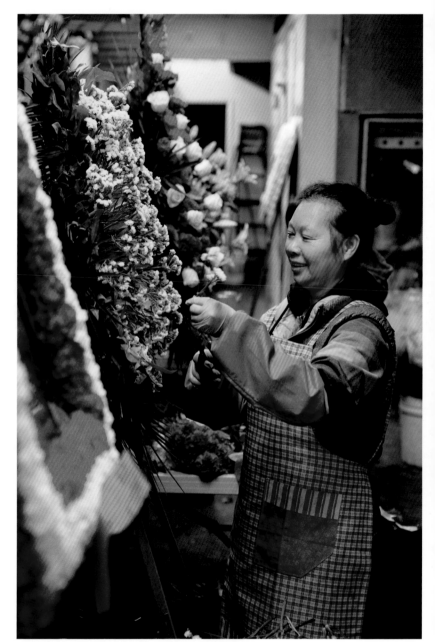

LEFT AND RIGHT: Employees prepare wreaths at Sweetheart Florist on Ross Alley.

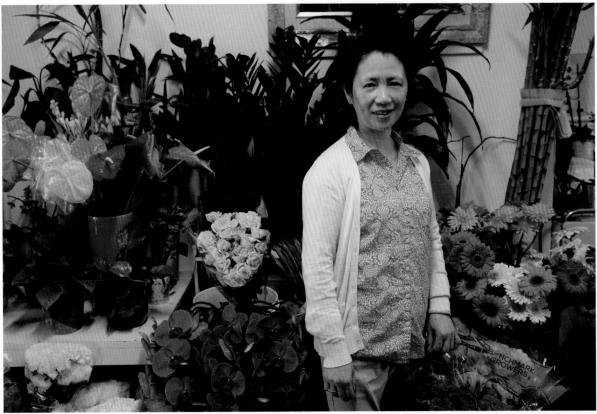

TOP AND BOTTOM: Fresh arrangements are crafted daily under the guidance of Shirley Yu, owner of Sweetheart Florist.

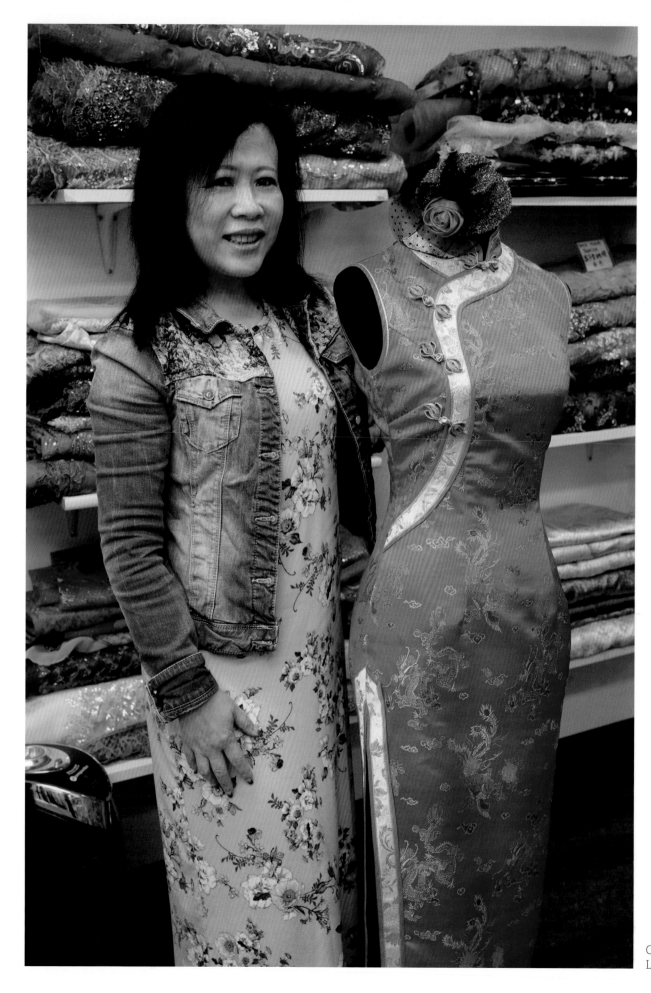

Owner Linda Lai of
LingLing Chinese Dresses.

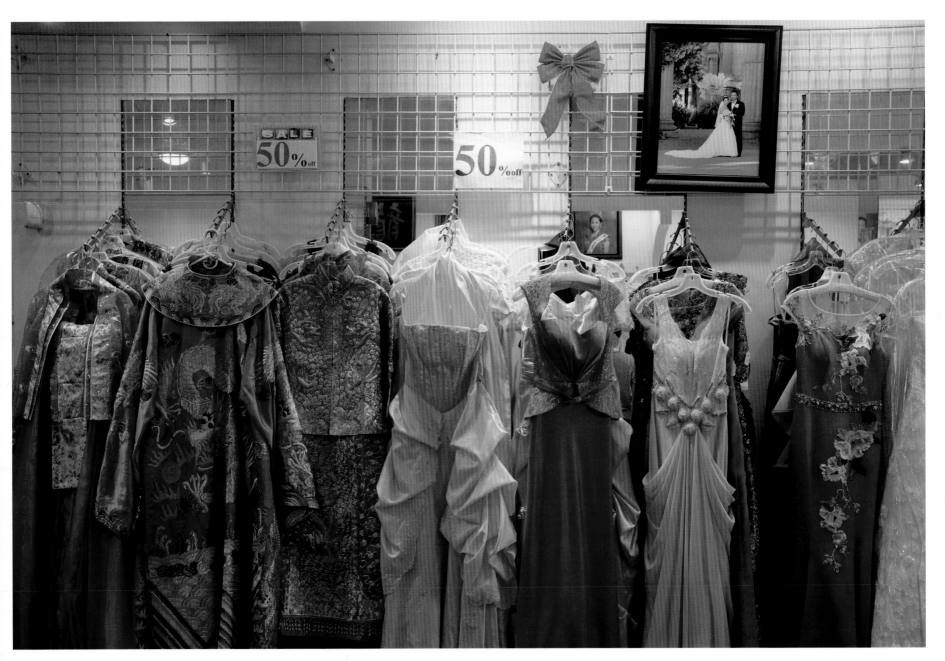

Dresses on display at Dragon Seed Bridal and Photography.

Spools of thread used to sew custom gowns at LingLing Chinese Dresses.

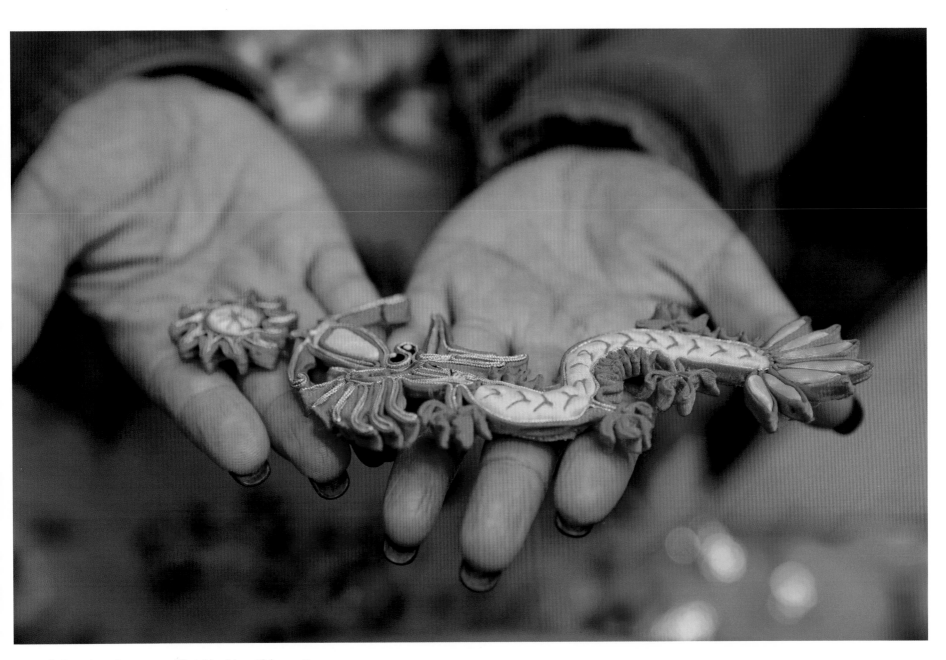

Formal clasp in a dragon motif at LingLing Chinese Dresses.

Henry Kee, owner of
Kee Photo.

Henrietta Tam, proprietor of Dragon Seed Bridal and Photography.

Herbalist Ningyao Li, founder of Ning He Health Center.

Acupuncturist Dr. Joseph Chi Ng, founder of Acupuncture and Associates Inc.

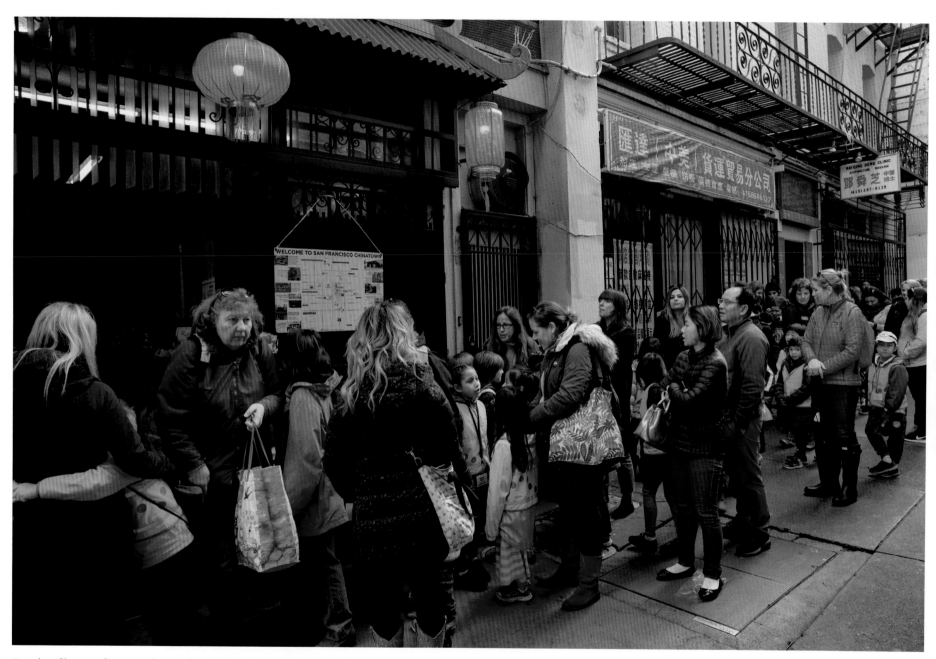
Tourists line up for samples at the Golden Gate Fortune Cookie Factory in Ross Alley.

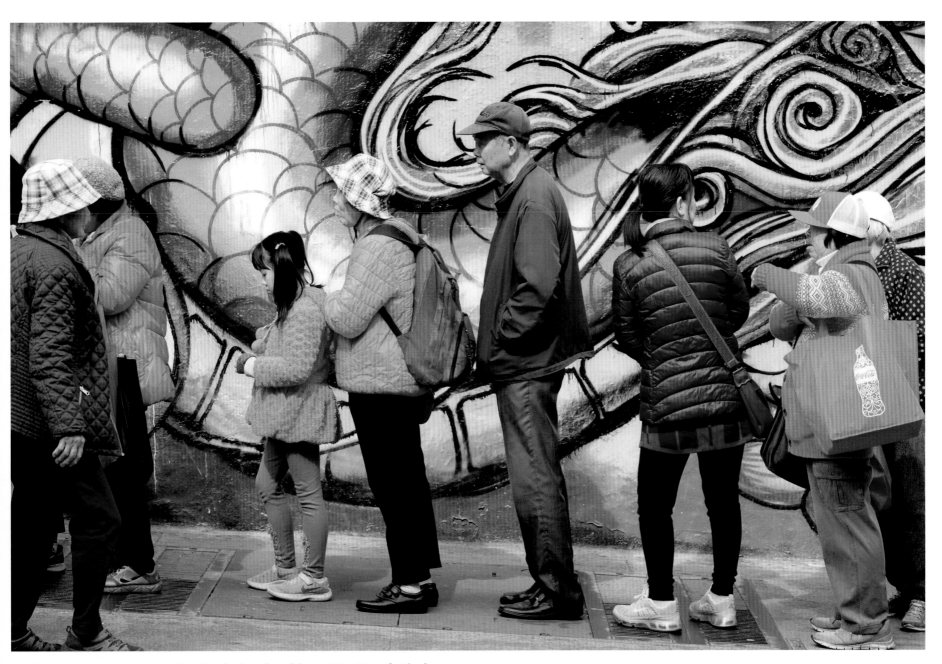

Locals queue up to win a booth prize during the Chinese New Year festival.

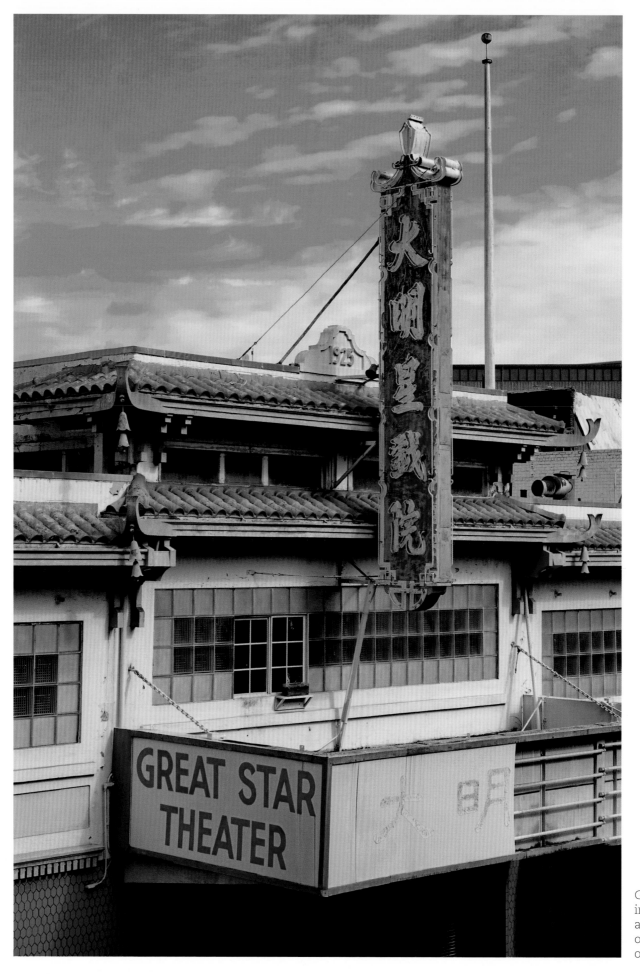

大明皇戲院

GREAT STAR
THEATER

大明

Great Star Theater, built
in 1925 on Jackson Street
and now shuttered,
once premiered Chinese
operas.

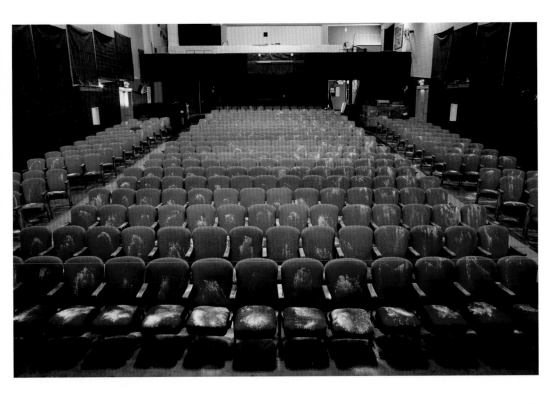

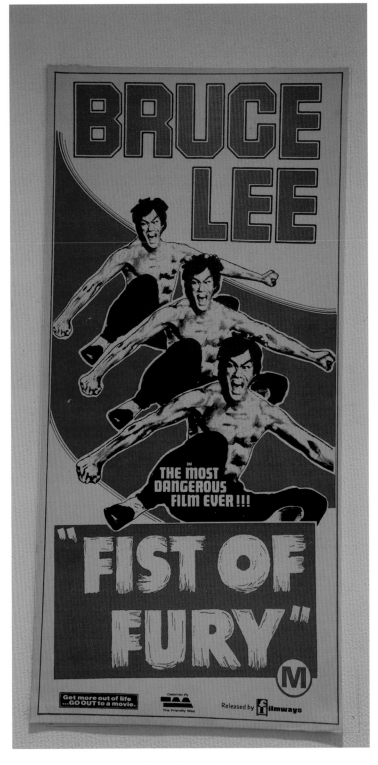

CLOCKWISE FROM TOP LEFT: Original seats to be salvaged. *Fist of Fury* movie poster from ages past. Vintage movie projector found in storage.

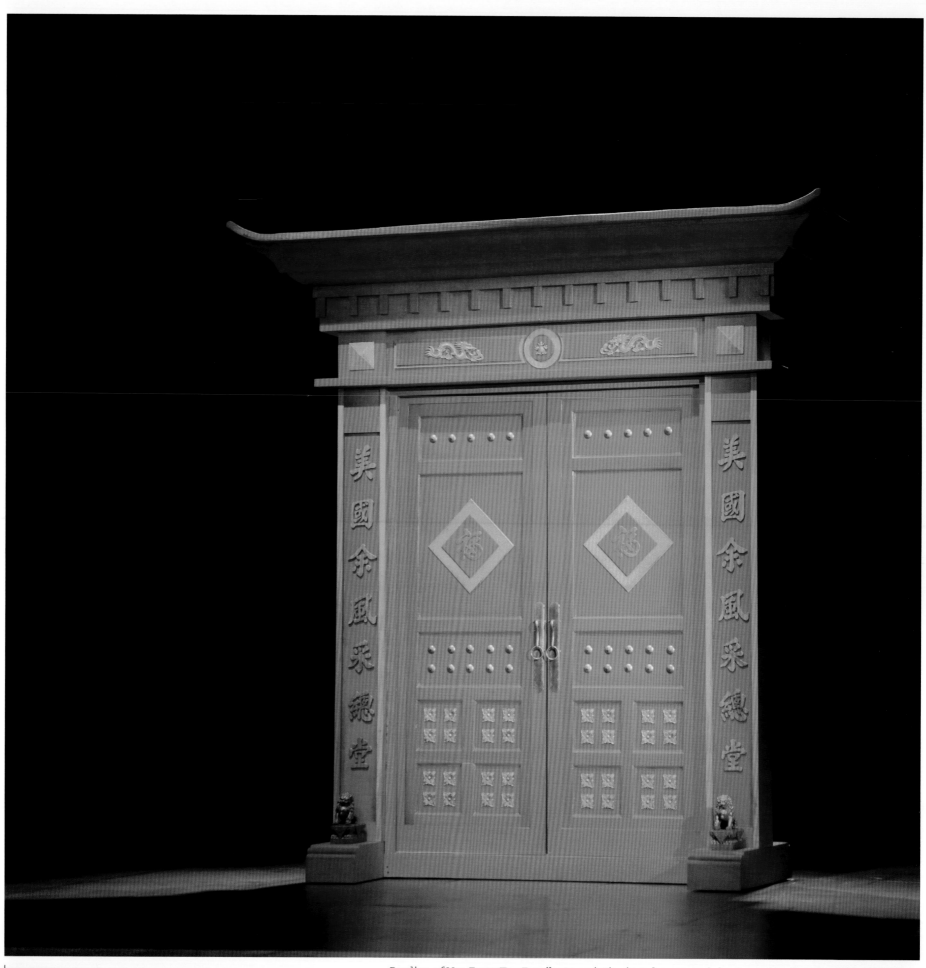

Replica of Yee Fung Toy Family Association's red ancestral door, used in the play *King of the Yees*.

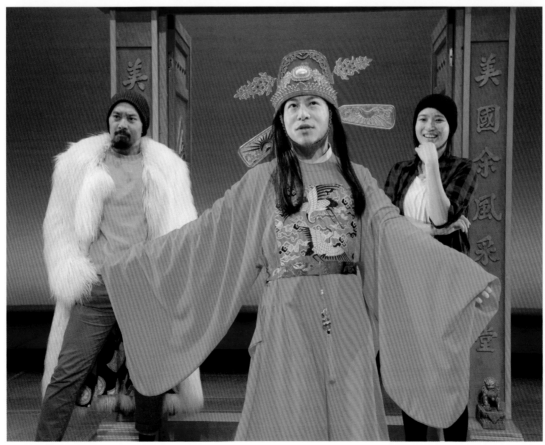

CLOCKWISE FROM TOP LEFT: Actress Krystle Piamonte. *King of the Yees* banner. From left to right: Jomar Tagatac, Will Dao, and Krystle Piamonte.

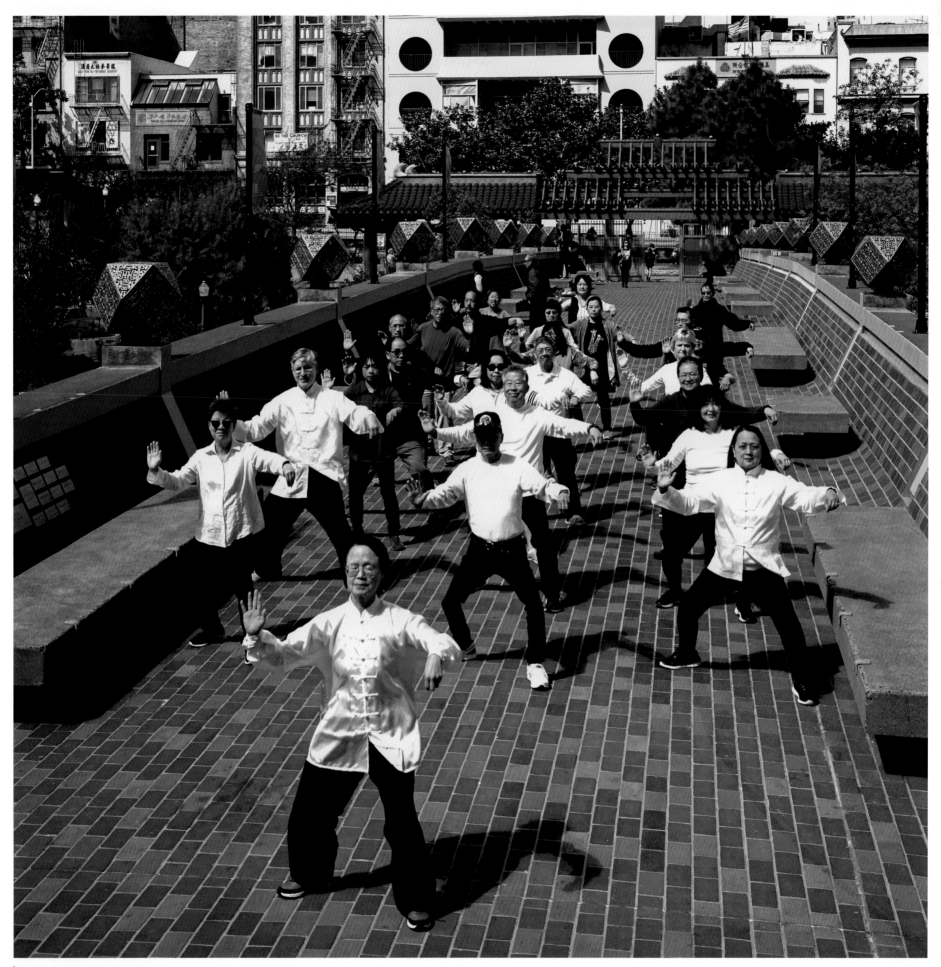

Tai chi instructor Debbie Au leads a group celebrating World Tai Chi Day on the pedestrian bridge between the Hilton Hotel and Portsmouth Square.

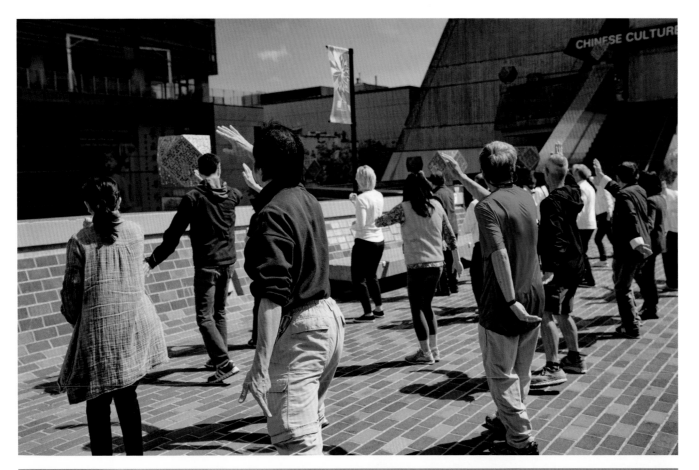

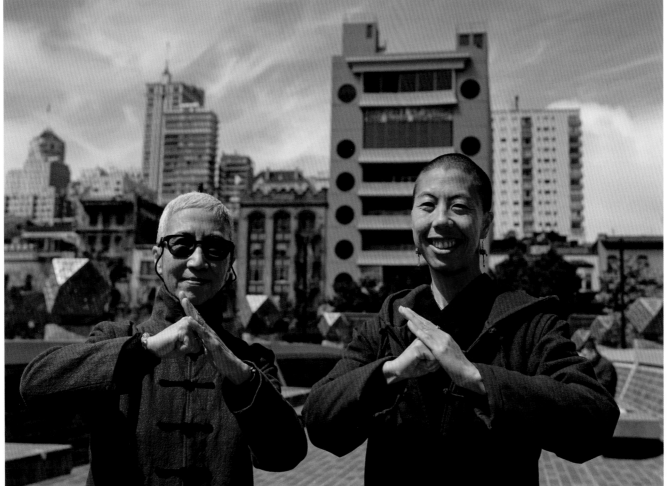

TOP: Learning tai chi moves with teacher C. K. Jeong (third from left). BOTTOM: Artist Ming Mur-Ray and yoga instructor Sasanna Yee in a tai chi hand pose.

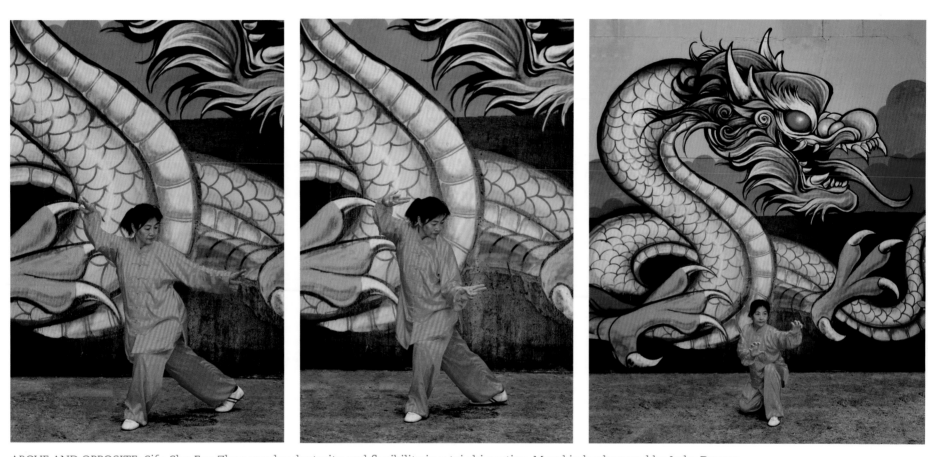

ABOVE AND OPPOSITE: Sifu Shu Fen Zhou exudes dexterity and flexibility in a tai chi routine. Mural in background by Luke Dragon.

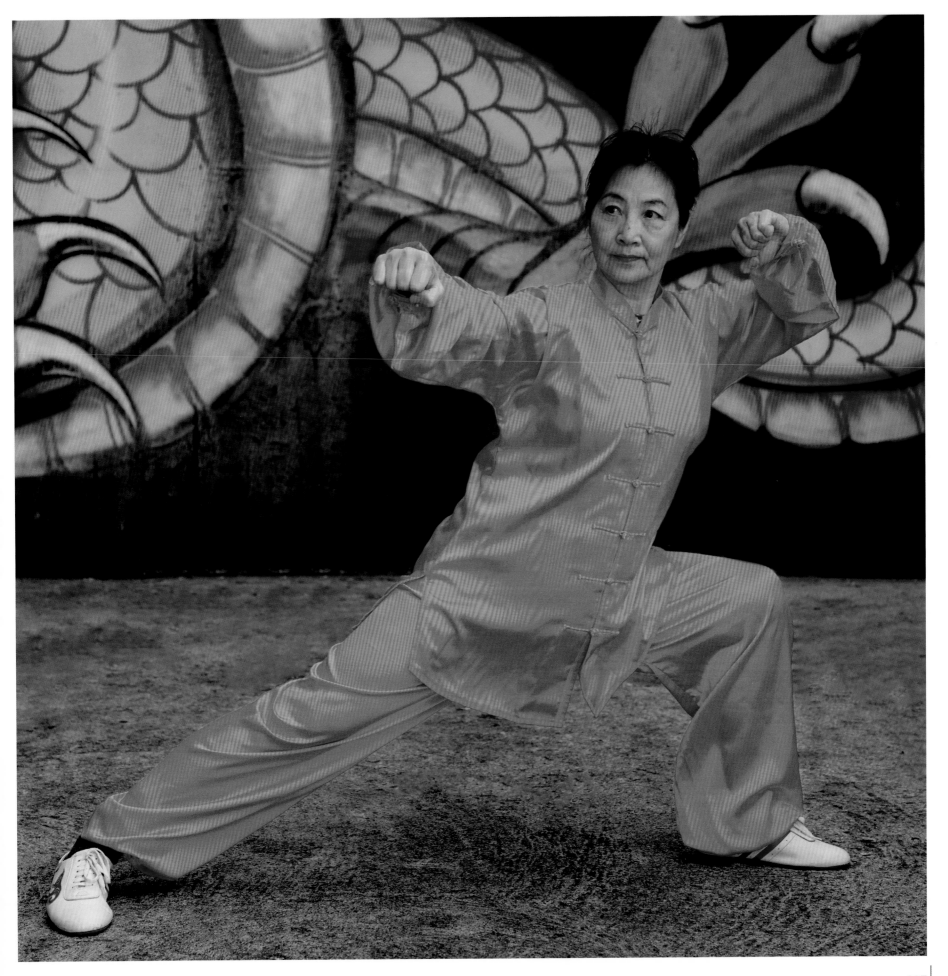

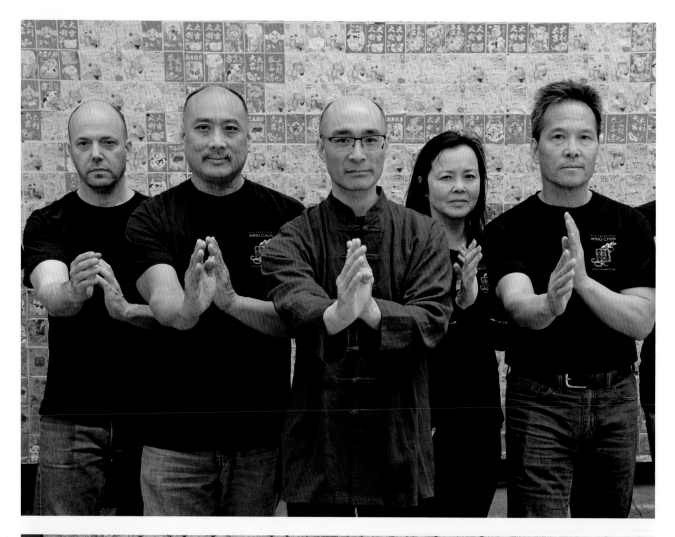

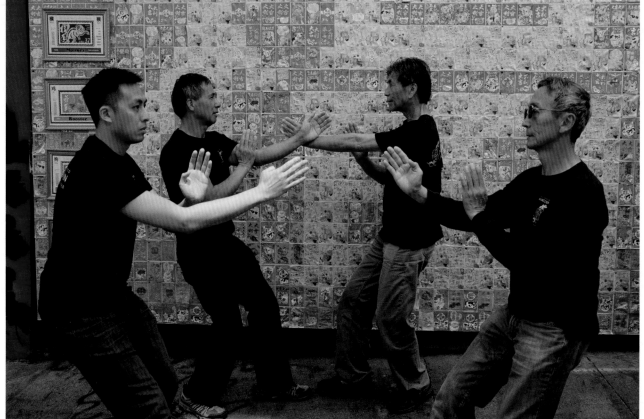

TOP: Members of San Francisco Wing Chun with Sifu Francis Der (center). BOTTOM: Kung fu students spar Wing Chun–style in front of *Zodiac Wall*, a collage created by the Law family, owners of Asiastar Fantasy gift shop.

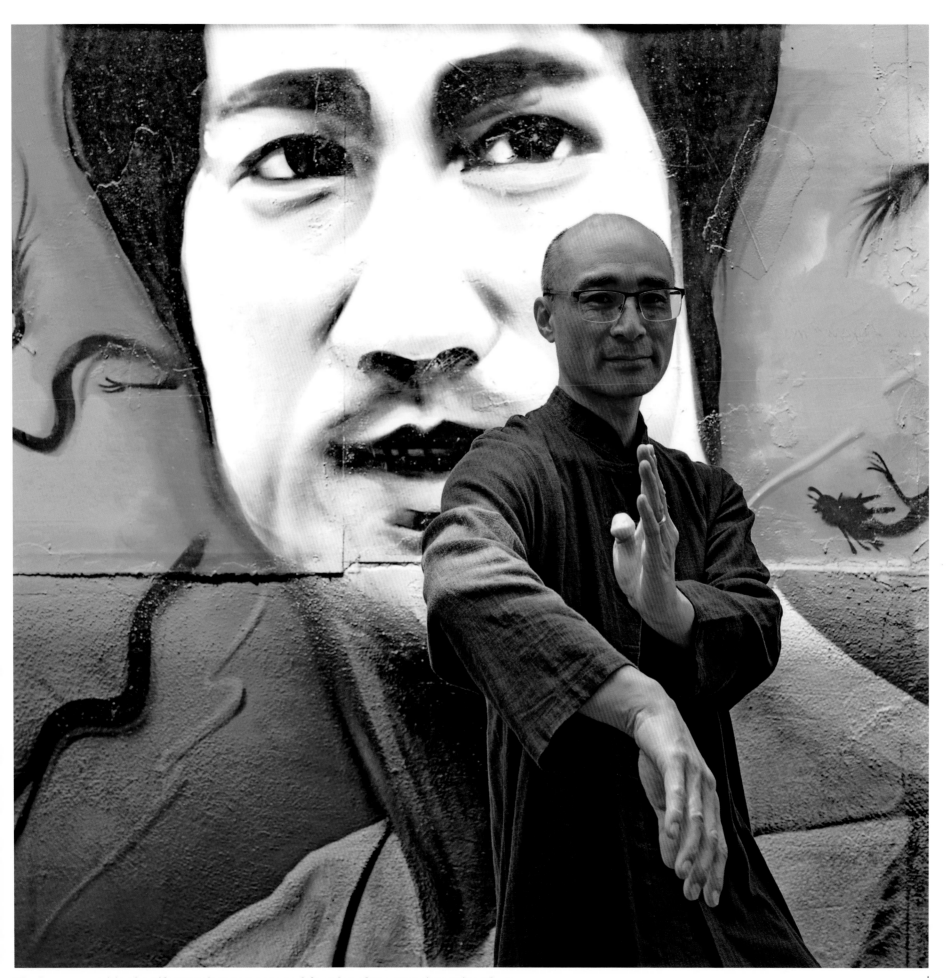

The *bong sao* position by Sifu Francis Der, owner and founder of San Francisco Wing Chun.

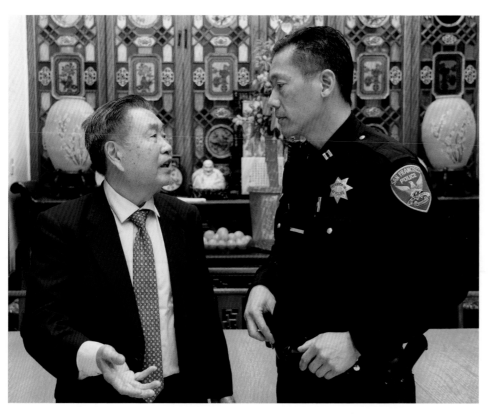

LEFT: Henry H. L. Huey with SFPD Central Station Captain Robert Yick. RIGHT: Supervisor Aaron Peskin with Chuwen Huang.

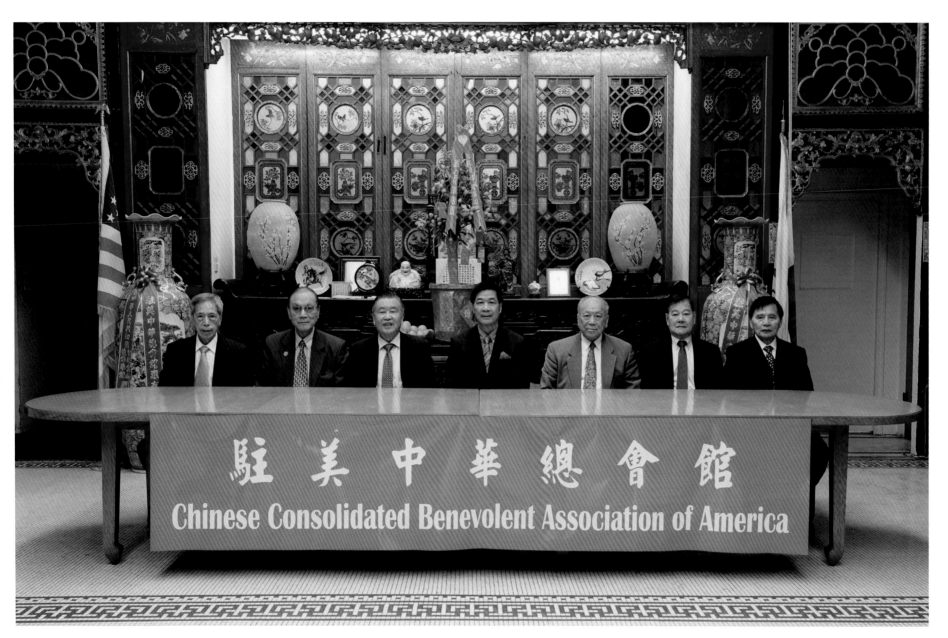

Leaders of the Chinese Consolidated Benevolent Association of America. From left to right: Tung Shek Ho, Steve Ball, Henry H. L. Huey, Chuwen Huang, Glenn L. Fong, Sir Lit Chan, and Wing Ho Lau.

DRAGON BOAT

At the cusp of twilight on Lake Merced, a twenty-person crew is plying the water, paddling in unison. A drummer at the front pounds rhythmically while the steering leader, the cox, controls from the rear. The dragon boat seems to glide effortlessly, but these two-hour drills require tremendous power, coordination, and endurance. Participation is not for the faint of heart.

For these teen boys and girls from Community Youth Center (CYC), dragon-boat racing is a game changer. That powerful sense of belonging, the responsibility, and the physical discipline shield them from activities that might otherwise do them harm. Stories of how the sport and the accountability saved them from gangs, drugs, and self-mutilation are not uncommon.

Henry Ha, CYC program manager, was one of those at-risk youth who found support. As an immigrant attending Galileo High School, he recalls that there was little for him to do after school, and it would have been easy to get mixed up with the wrong crowd. That's when the CYC staff encouraged him and others to start a dragon-boat team in 2001. Since then, more than one thousand youth have benefited from CYC's dragon-boat experience. As a coach, Ha knows all students by name and urges them to attend every practice, rain or shine.

"This program fuels my passion and commitment to give back all that I've learned to the next generation," says Ha. "It gives them encouragement to be their best, build up their self-esteem and confidence, and develop leadership."

Unlike official school teams that require tryouts, CYC accepts everyone who applies. The practices, uniforms, and boat use are completely free. CYC, serving as a community nonprofit for fifty years, is open to helping all but specifically targets high-need, at-risk Asian youth, providing an array of services from counseling to teaching job readiness skills.

CLOCKWISE FROM TOP LEFT: Melissa Lee and Genevieve Chan. Henry Ha, program manager. Bella Chen, team leader. From left to right: Esther Tsui, Ivy Tran, and Madison Wong. Dragon-boat crew on Lake Merced.

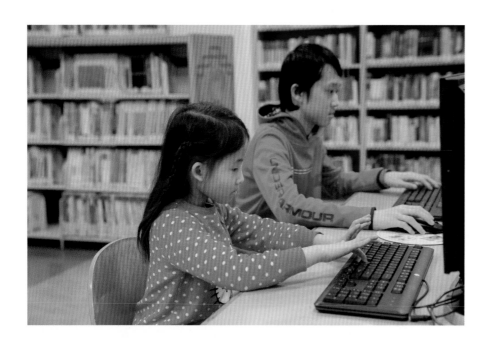

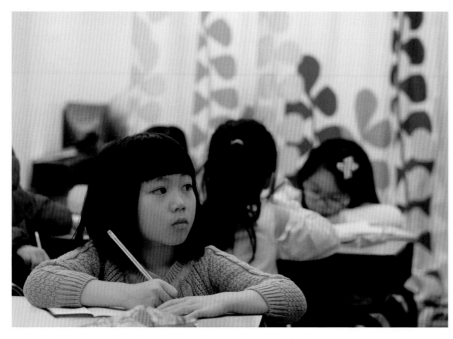

CLOCKWISE FROM TOP LEFT: Elle and Tanner Young go online at Chinatown/Him Mark Lai Branch Library. Chinese-language books. Kevin Liang memorizes vocabulary at St. Mary's Chinese Language School. Jaslynn Luo studies the board intently during Saturday morning Chinese class at St. Mary's Chinese Language School.

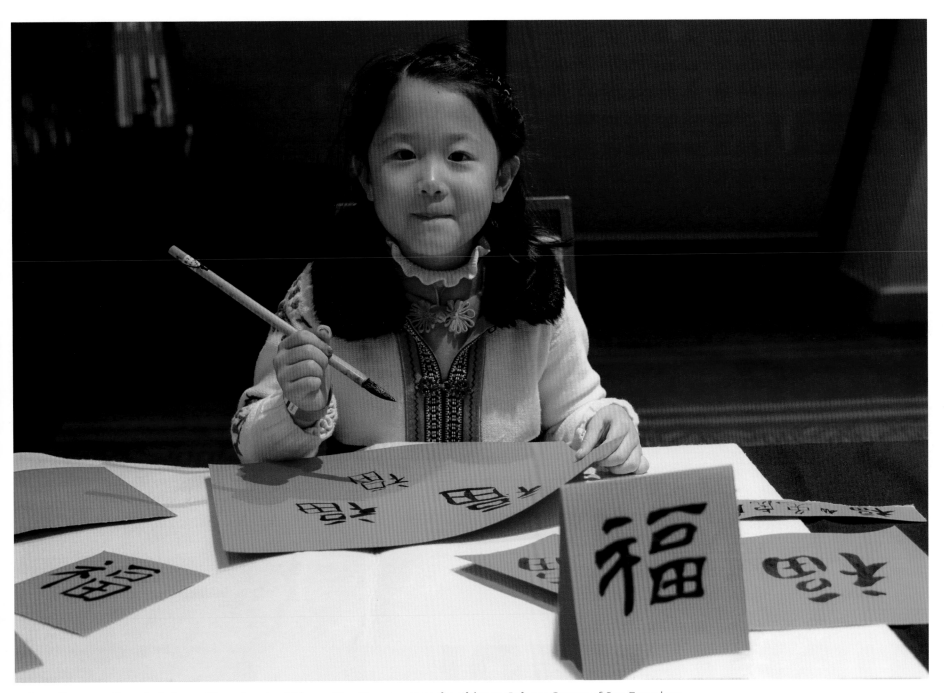

Yuhan Chen, age 6, perfects her calligraphy at a Chinese New Year event at the Chinese Culture Center of San Francisco.

CELEBRATIONS AND TRADITIONS

YAM BUI! (飲杯): DRINK UP!

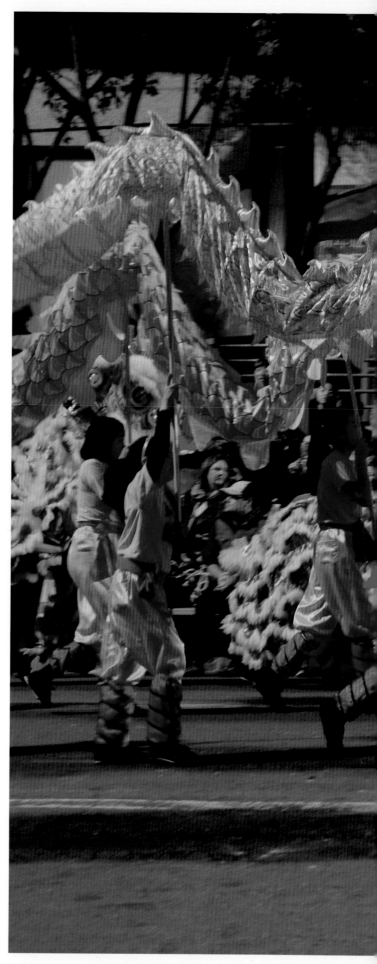

A dragon comes to life on Kearny Street during the Chinese New Y

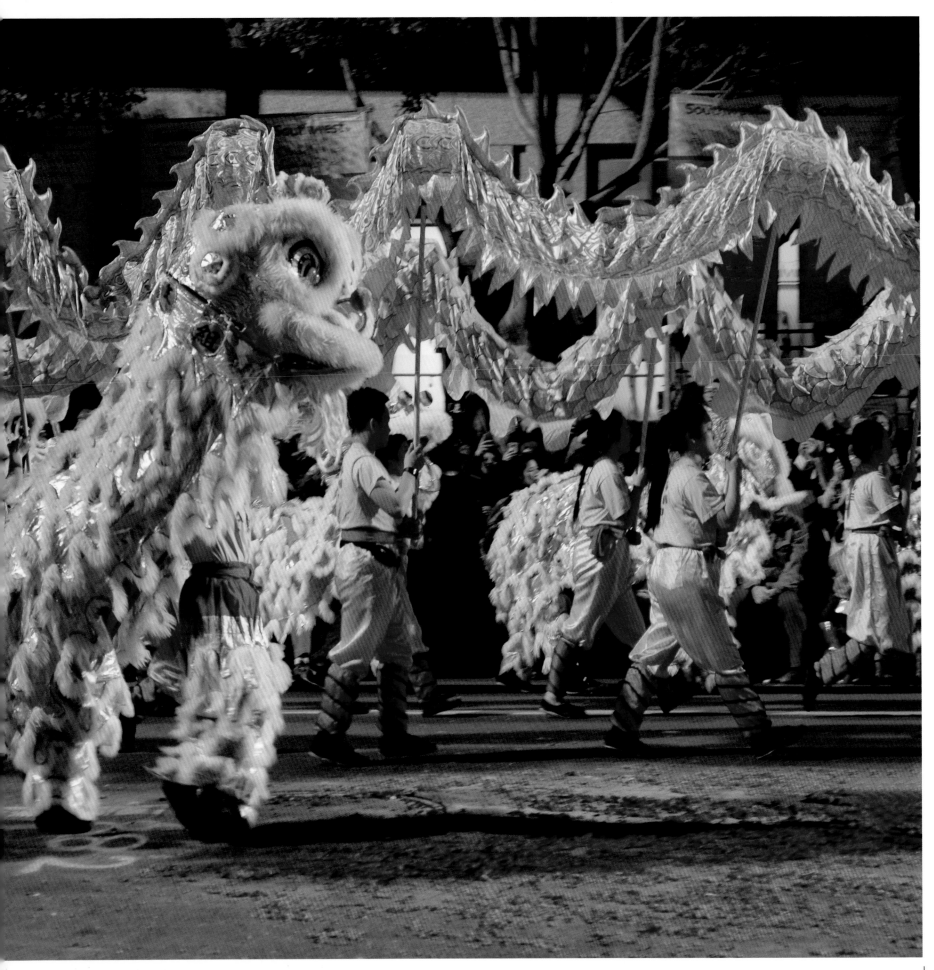

companied by a white lion.

KUNG FU TROUPES. RIBBON DANCERS. And dragons, lots and lots of dragons. Over one hundred costume-studded entries queue up on Market Street for the largest Chinese New Year parade outside of Asia. Once organizers give the thumbs-up to start moving, Miss Chinatown U.S.A. and her court wave to adoring fans while high school bands march in unison. Parade organizers set two million firecrackers ablaze, leaving everybody wincing and cupping their ears. Not to be missed is the crowd favorite: the 288-foot-long golden dragon maneuvered by over one hundred trained martial artists, who bring it to life.

Every January or February, depending on the lunar calendar, Chinatown beams with pride. According to Harlan Wong, Chinese New Year Festival and Parade director, this illuminated night parade draws hundreds of thousands of spectators, greeting one another with *"Gung Hay Fat Choy,"* Cantonese for "Happy New Year." The 1.3-mile route commences on Market Street, weaves around Union Square, and winds up on a straight path down Kearny Street, the border of Chinatown. Blanket-clutching spectators huddle in reserved bleacher seats. Experienced parade-goers arrive hours early to secure the best sidewalk spots. Millions of TV viewers worldwide will observe the evening's events, says Wong.

The San Francisco Chinese New Year Parade, the first in the country, dates back to the 1860s. When the outside world was later invited to attend, the parade was an instant hit. By 1958, the Chinese Chamber of Commerce took over programming and organization. Decades later, when the local TV station televised the parade, the chamber appealed to sponsors for financial support to elevate its pageantry. Today, Southwest Airlines and other corporate sponsors have their names emblazoned on banners and souvenirs. Critics say these company monikers dilute the event's cultural purity. Others counter that the support of corporate America confirms that Chinese traditions are a welcome addition to the country's heritage.

Another Chinatown custom is the Flower Market Fair, held the weekend before Chinese New Year. In preparation for Chinese New Year, which lasts sixteen days, families must clean their homes, sweep out bad luck from the prior year, and decorate with specific flowers and Chinese proverbs. Chinatown is the ideal place to purchase New Year blooms (chrysanthemums, orchids, and cherry or apricot blossoms) and greenery (jade plants and lucky bamboo) for growth and good fortune.

On parade weekend, the Chinese Community Street Fair gives outsiders an inside look at the beloved neighborhood, with over one hundred booths run by nonprofits, corporations, and mom-and-pop businesses. Visitors can sample New Year snacks from a Harmony Tray, a circular dish divided into sections of eight (the number for prosperity) or nine (denoting longevity).

If you pay respects to a Chinese family, honor the hostess with a full bag of oranges. Bring good-luck tangerines with stems and leaves still attached, signifying fertility and secure relationships. Stockton Street markets sell these by the boxful. You can also give children lucky red envelopes, known as *hung bao*, stuffed with coins or fresh dollar bills. Chinatown stationery stores carry *hung bao* of varying sizes and colors throughout the year.

Celebrations are laden with rituals as natural to the Chinese as flying is to birds. Beliefs stem from a combination of ancestral worship, Buddhism, Taoism, Confucianism, and village practices. You can witness these being played out in Chinatown at Chinese New Year and in the fall at the Autumn Moon Festival.

If you come during nonholiday times, keep a lookout for Chinatown customs. See the drummers and lion dancers leaping outside a store? They are blessing a new business with their acrobatic routines and exploding firecrackers, which are said to ward off evil spirits.

In the evening, you may spy a bride and groom stepping into a restaurant for their reception. For decades, San Francisco's Chinatown operated as the wedding banquet capital, where families rushed to book vast venues a year in advance. Not only were couples obliged to invite their parents' friends, they were expected to invite all their parents' associations and business affiliates whether they knew them or not.

These days, fewer Chinese couples are keeping the tradition, preferring to have a destination wedding at a winery or on the beach. Those holding to the cultural nuptials are flocking to newer and bigger banquet facilities in the Asian shopping centers in the suburbs. A few Chinatown restaurants can accommodate big soirees where guests feast on eight or nine (again, the lucky numbers) dishes, each rife with meaning. Midway through the meal, the couple, parents, and bridal party form a human convoy, toasting friends and relatives at each table. Guests should stand and clink glasses, echoing the phrases "*Yam bui*" ("Drink up") and "*gung hay*" ("Congratulations"). By this time, the bride has changed from her Western gown to a form-fitting *cheung sam* dress.

Another marital observance is the tea ceremony. The couple kneel before their seated parents and serve tea with both hands. The parents sip and place *hung bao* on the tea tray while imparting words of blessing, which can move families to tears. In-laws, grandparents, and other relatives take turns as bride and groom humbly offer tea, remaining on their knees. Newlyweds Leanna Tu and Michael Teng upheld the tradition at a community center immediately before their taco rehearsal dinner. Recalls Tu, "I thought my grandparents would be happy and feel honored to be served tea, especially because they live in New York

Chinatown and are familiar with the ceremony. I knew my grandma also wanted me to wear a Chinese dress, so this was a great opportunity."

Cultural conventions don't stop at weddings. They ripple throughout a lifetime. Babies make their debut at Red Egg and Ginger parties. Far East Café specializes in these affairs, where an entire roast pig greets guests on the buffet line. Bowls of red-dyed boiled eggs and pickled ginger for prosperity and good fortune function as decor as well as appetizers. Partygoers give *hung bao*. Relatives bestow gold jewelry, jade bracelets, or gold coins.

Festivities to honor the elderly can be equally important, if not more so. As in wedding banquets, the family and the honoree, who has turned seventy, eighty, or any decade year after that, roam table to table for a ceremonial toast. The multicourse meal always ends with long-life, *lo mein* noodles. When dished into bowls, noodles should never be cut so as not to shorten anyone's time on earth.

The end of life also overflows with symbolism. A family must place a blanket on top of the deceased for comfort. A relative is usually designated the task of handing out candy in white envelopes, a custom to erase bitterness and bring forth sweetness. In Chinatown, the formal Chinese funeral is a specialty at the Green Street Mortuary, where its namesake band leads a person's final journey through Chinatown streets. The unique processional is considered an only-in-Chinatown fixture.

The dead are remembered annually on *Ching Ming*, or Tomb-Sweeping Day, set around late March or early April depending on the lunar calendar. For the *Ching Ming* festival, Chinatown florists order extra blooms. Families gather in cemeteries to clean the tombstone area. Those adhering to Buddhist or Taoist religions burn paper play money for the deceased to use in the afterlife.

In fall, *Baat Yuet Jit*, or the Autumn Moon Festival, reveres hard work and harvest. In September, the Chinatown Merchants Association organizes a gala weekend with a parade, family activities, cultural demonstrations, and food and merchandise booths. Maggie Wong, television commentator for Chinese channel Sky Link TV, plays the character of the Moon Goddess, a central figure in the fall holiday. As she floats through the streets in colorful costume and takes pictures with tourists, she relates the Chinese fairy tale about the moon goddess who drank the elixir of immortality and flew to the moon to live forever. "A lot of people don't know why there is a Moon Festival, so this gives me a chance to explain it to them, and they are very appreciative," she says. "Doing events like this is fun. Plus, I inherited a large collection of these costumes because my parents were in Chinese opera and in Chinese movies in the 1950s and 1960s."

During this time, pastry makers create, box, and stack hundreds of moon cakes in the windows of Chinatown bakeries. These are as intrinsic to the holiday as turkeys are to Thanksgiving. Many variations exist, but the typical palm-sized Cantonese moon cake consists of crust filled with lotus seed paste and one or two preserved egg yolks. The

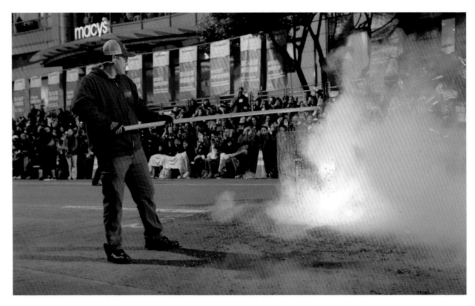

A brave volunteer tames a pile of lit firecrackers.

dense round confection, sold in a gift box of four, is made to be shared. As the cakes are sliced, each person gets a part of the moon.

Visitors may want to keep a lookout for a Chinese opera performance by My Opera Institute, an opera troupe headquartered in Chinatown. Professional performers in embroidered silk robes and wide sleeves sing in high-pitched Cantonese, acting out classic tales. Up until the mid-twentieth century, Chinatown theaters were synonymous with Chinese opera. But when audiences waned, so did the number of troupes and shows. Frank Leong Jr., the son of immigrant parents from China, recalls attending many operas with his mother as a young boy in the 1960s. The plumage, majesty, and theatrical sword fighting were mesmerizing. "We would go backstage, and then I saw the actors taking off their makeup and realized they were regular people," he says. "That was a revelation for me."

From the pop-popping of firecrackers to the aroma of spit-roasted pig, Chinese rituals and celebrations are high-sensory, high-spirited affairs. Every day, Chinatown draws visitors from all over the globe, curious about Chinese ways and institutions. Meanwhile, Chinese traditions filter outward into American classrooms and corporations. Kids learn to make red paper lanterns in elementary school as companies host Chinese New Year parties for employees on their premises. Such mainstream acceptance would have brought tears to the eyes of the immigrants who landed on Angel Island. To all Chinatown guests, we toast, cheering, "*Yam bui!*"

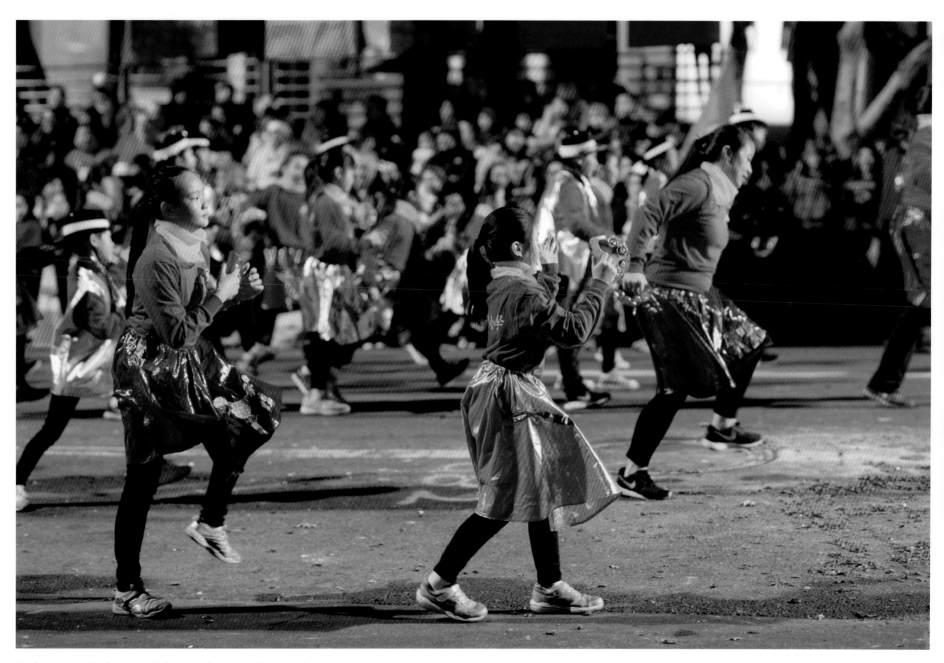

Welcome to the largest night parade in North America.

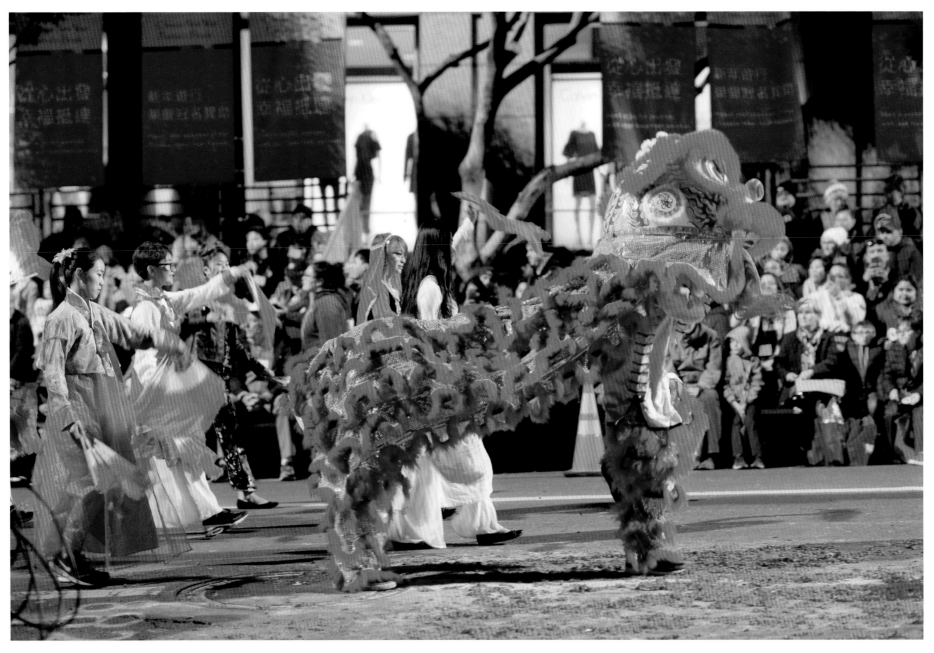

Lion dancers wow the crowd.

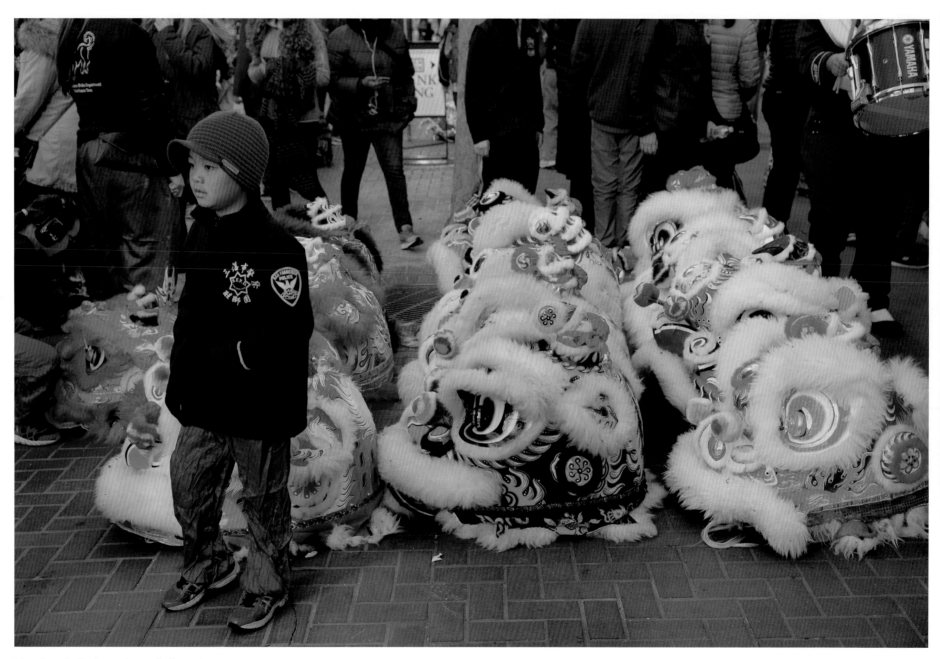

Lion heads lie in wait until showtime.

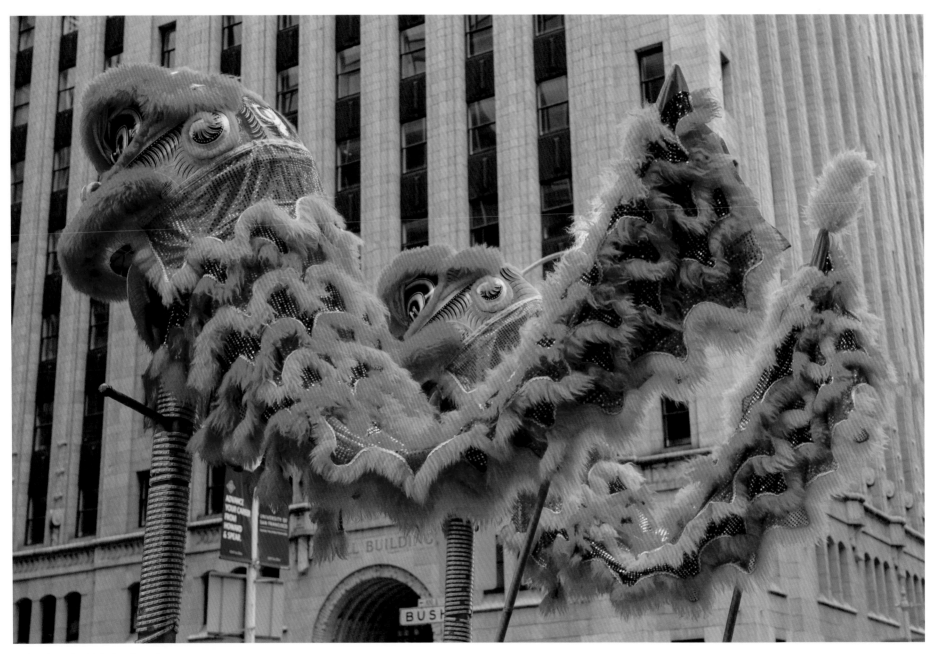

Twin lions bobble in the air.

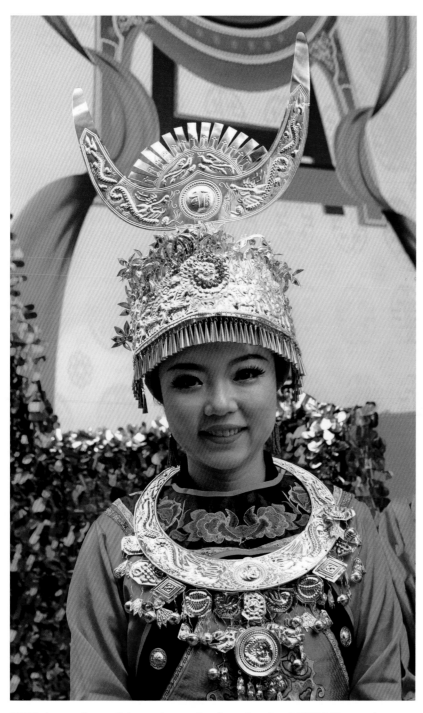

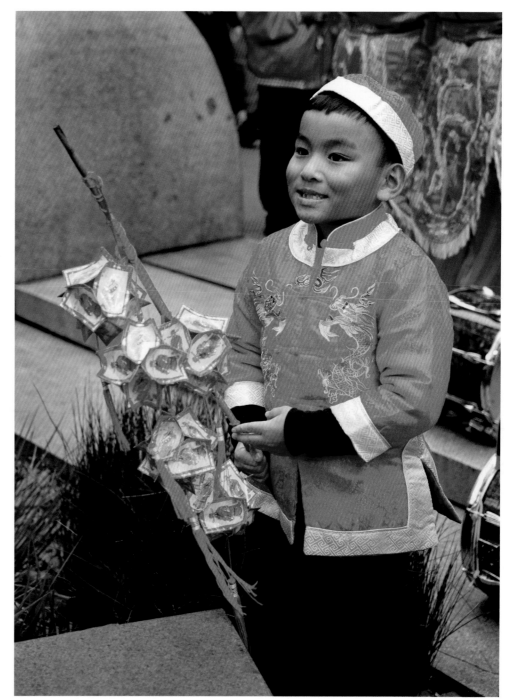

LEFT: A parade participant in regal cultural attire. RIGHT: No one is too small to play a big part in the parade.

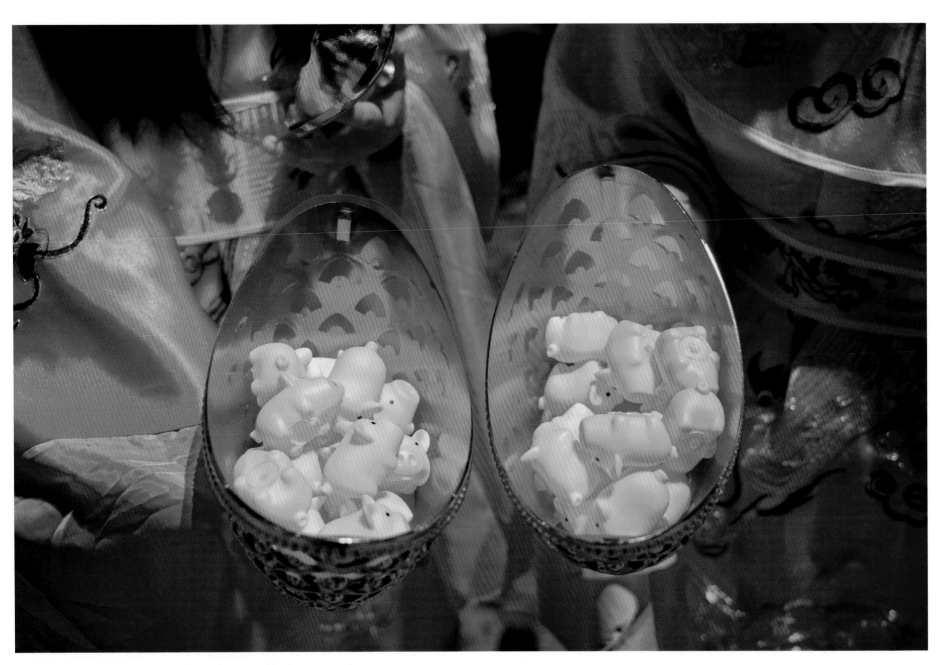

Decorative pigs for 2019 Year of the Pig nested in ingot vessels.

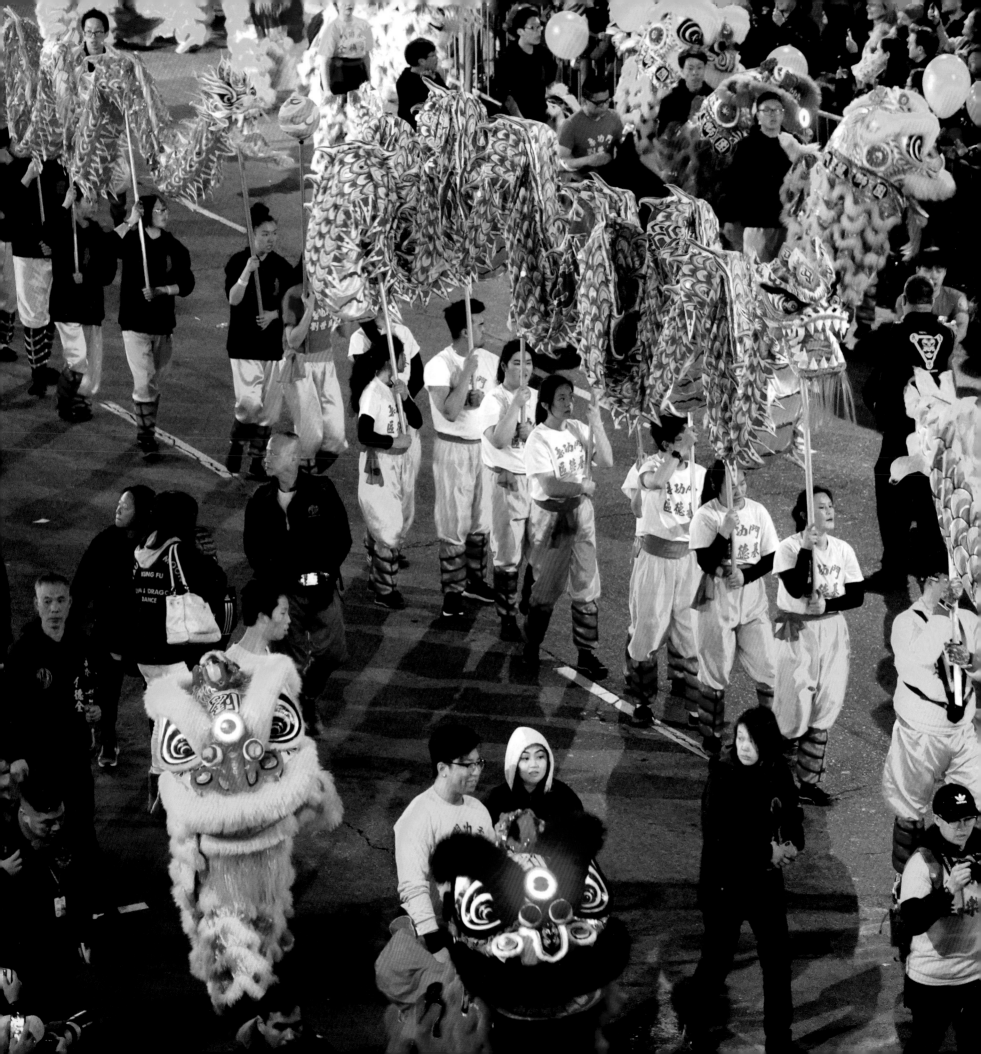

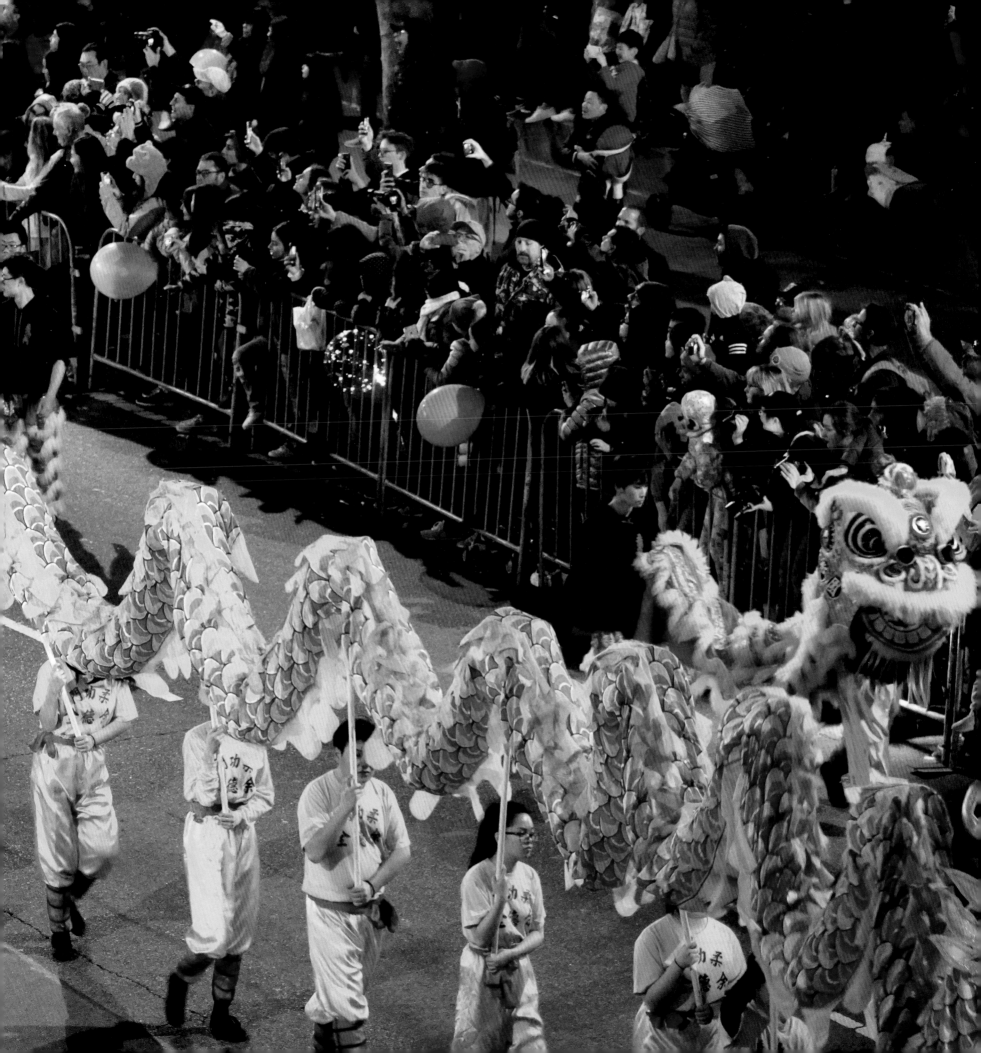

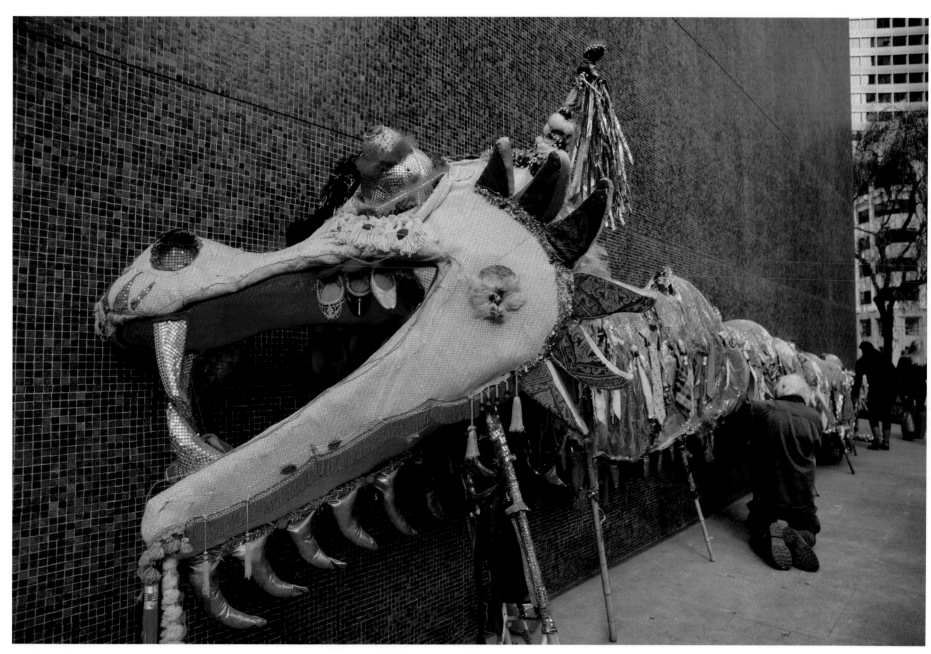

PREVIOUS: Young men and women hoist dragons over the one-plus-mile parade route. ABOVE: Dragon made of slippers, neckties, and other recycled materials.

Parade float about to emerge from a warehouse on Embarcadero pier.

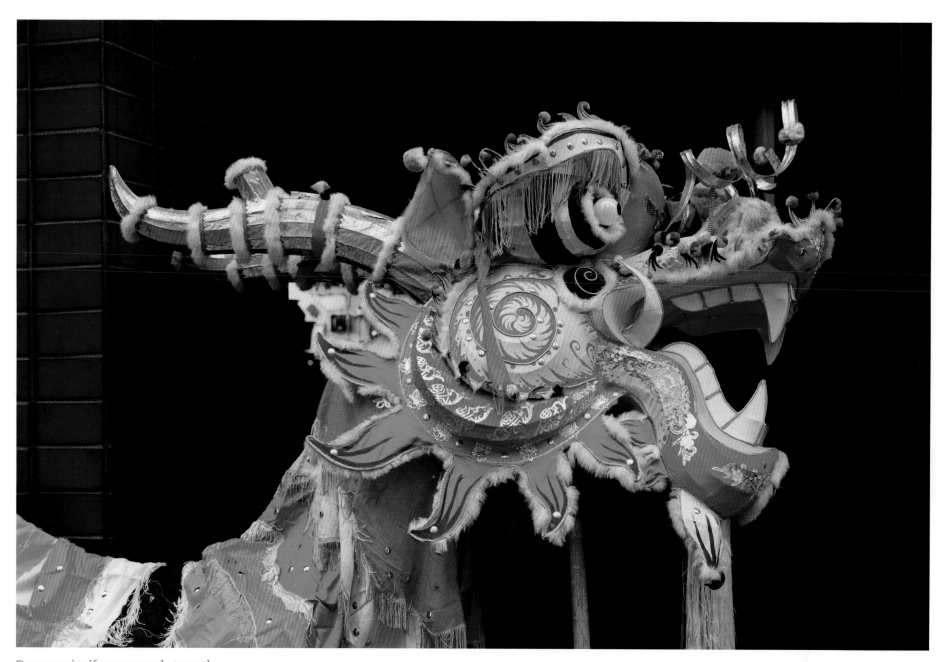

Dragons signify power and strength.

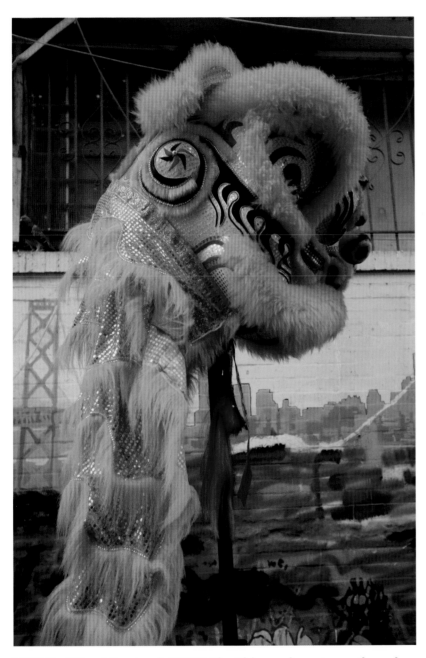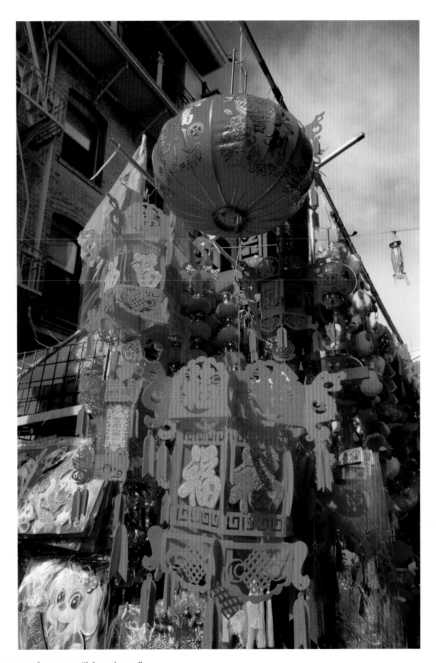

LEFT: Traditional lion head. RIGHT: The Chinese character on these decorations translates as "blessings."

LION HEAD

It was the lion that got back its roar. A dilapidated lion head costume in the garage of his martial arts teacher caught Corey Chan's eye. Or maybe it beckoned him. At that moment, he was intrigued with the idea of bringing it back to life, so he took it home and transformed it into something exquisite. Since that first resurrection in 1978, the lion head restorer has rescued dozens.

Approximately the size of a thirty-inch ball, lion heads are made in China and range from $400 to $2,000. Acrobats performing the ancient lion dance mimic the animal scratching, jumping, and licking its fur. Lion heads can last for several years or break after one performance. The bulbous blinking eyes, gaping mouth, and flapping ears are manipulated by hidden strings, which can fray and snap. Thin layers of paper, painted to a glossy sheen, cover the bamboo and wire armature, and can be easily punctured.

Accessories such as metal disks, silk balls, fringe, and fake fur give them personalities. The heads weigh only five to eight pounds but feel heavy in the arms of an amateur. "Without training, you cannot last the length of a parade. You can get tired after a few minutes," Chan explains. "You are not just walking around with it on. You must make it look and act like a live creature."

Each cat comes to Chan with its own set of problems. Chan replaces inferior parts. He strengthens the controls operating eyelids and ears. "It is like bringing memories back to the lion head," he says. "You can almost feel the gratitude of the lion, and it knows people will see it perform again. Even if I don't know all the stories associated with the lion, it will have the opportunities to create new ones."

CLOCKWISE FROM TOP LEFT: John Yee from LionDanceME. Shayla Chung, Kaila Trinh, Crystal Yao, and Verena Lee take a break from swordplay. Wenna Lu shows off her strength and agility. Corey Chan with a prized lion head.

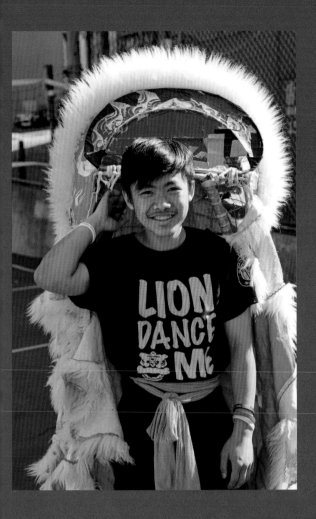
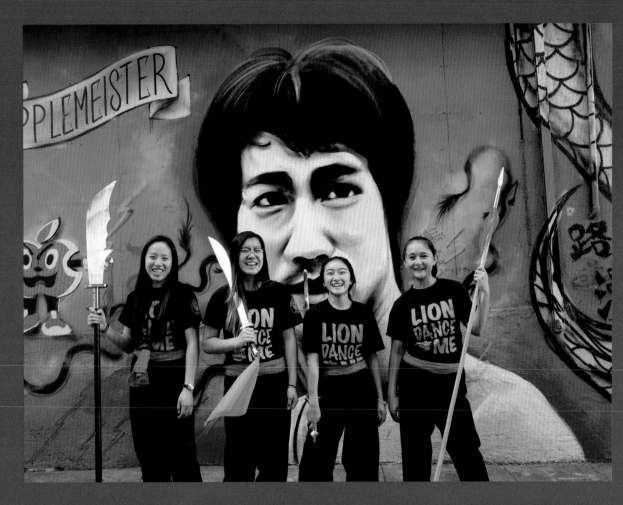
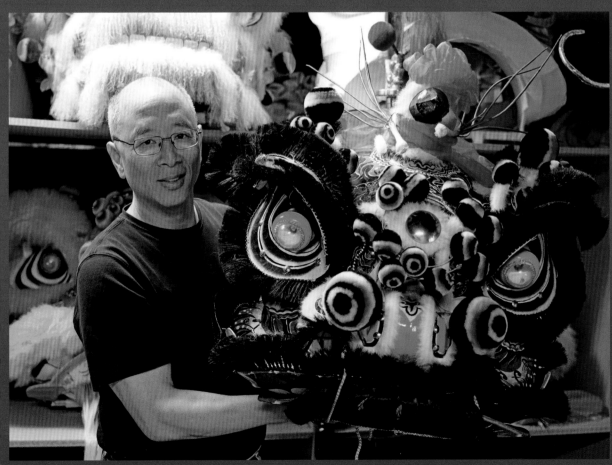
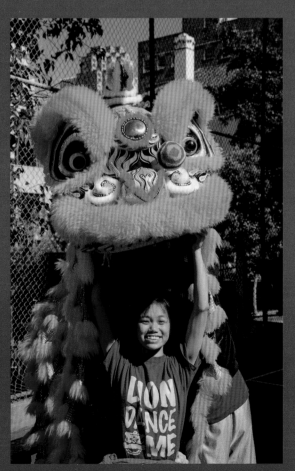

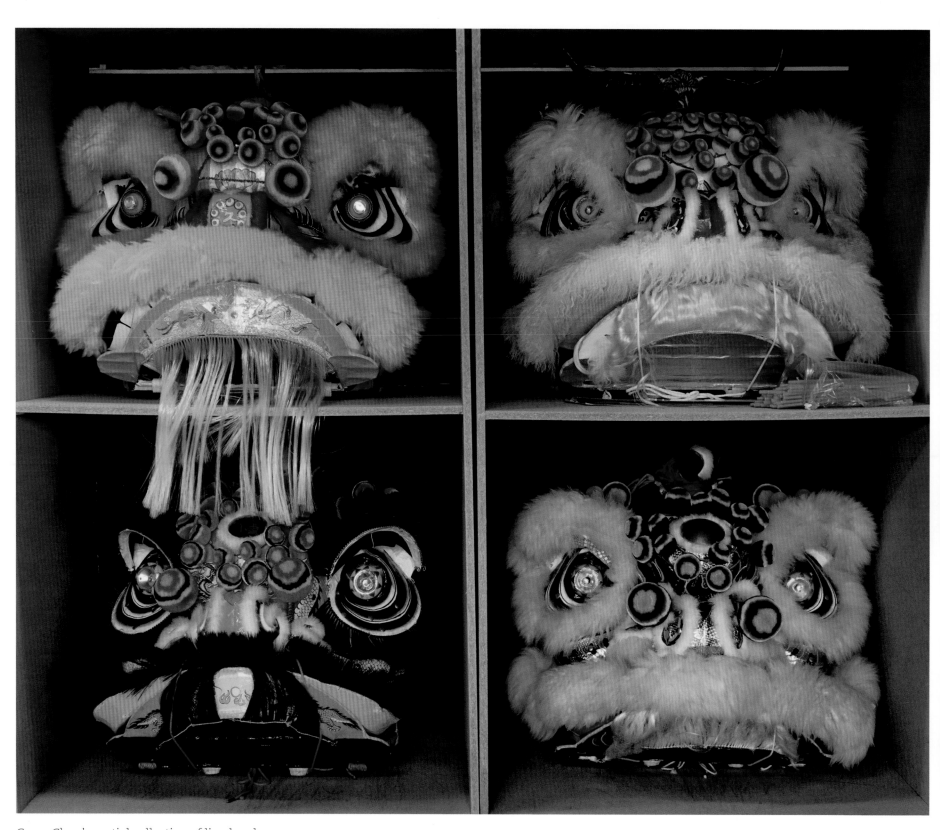

Corey Chan's partial collection of lion heads.

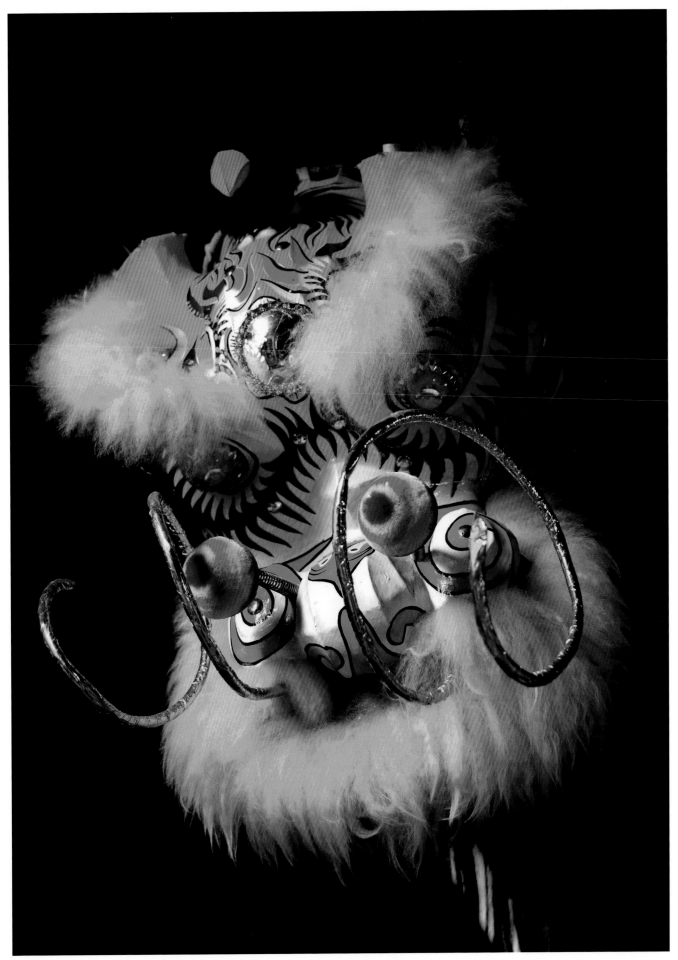

A dragon head, poised and ready for action.

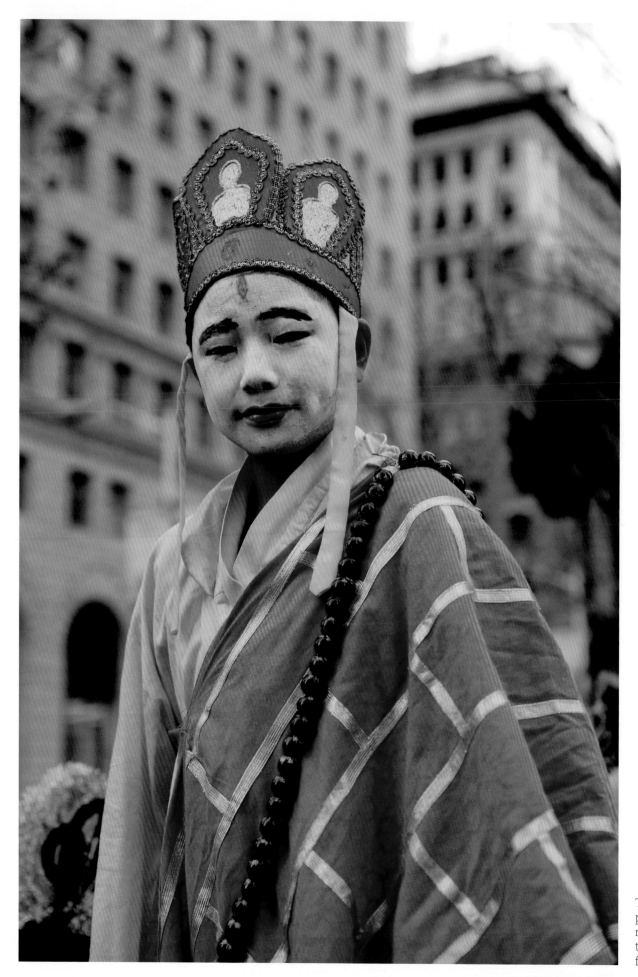

Tyler Tom, age 13, portrays Tang, a Buddhist monk from "Journey to the West," a Chinese folktale.

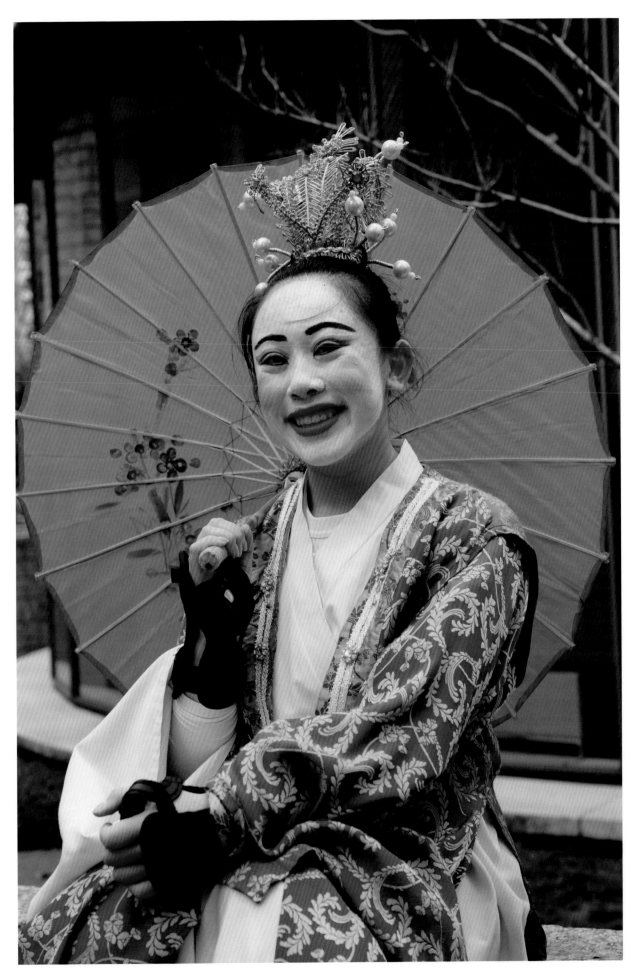

Zoe Tao, age 14, plays an ancient noblewoman from China.

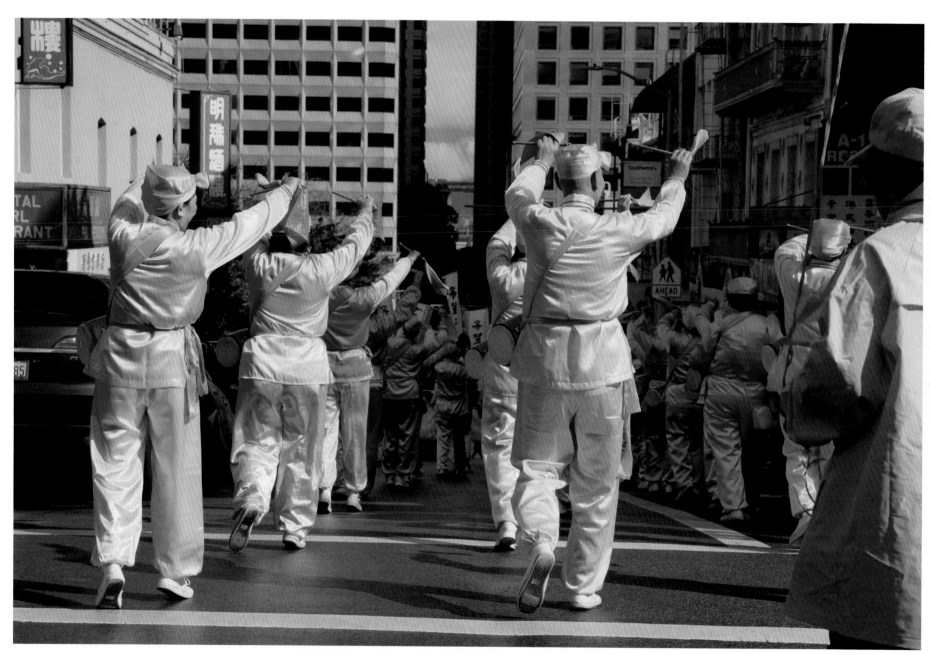

Parade performers entertain at local festivals.

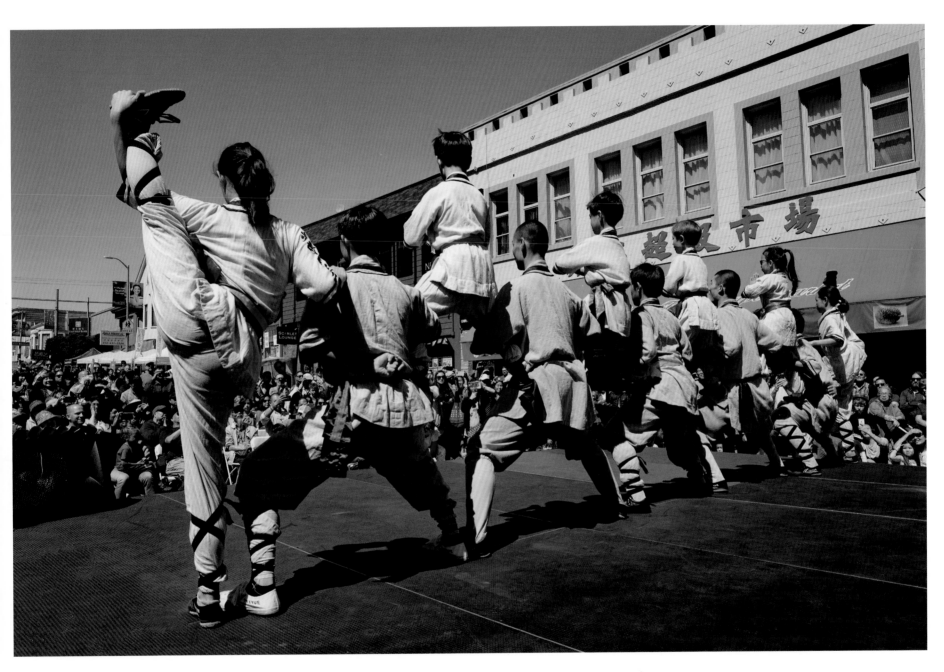

Acrobatics on Clement Street.

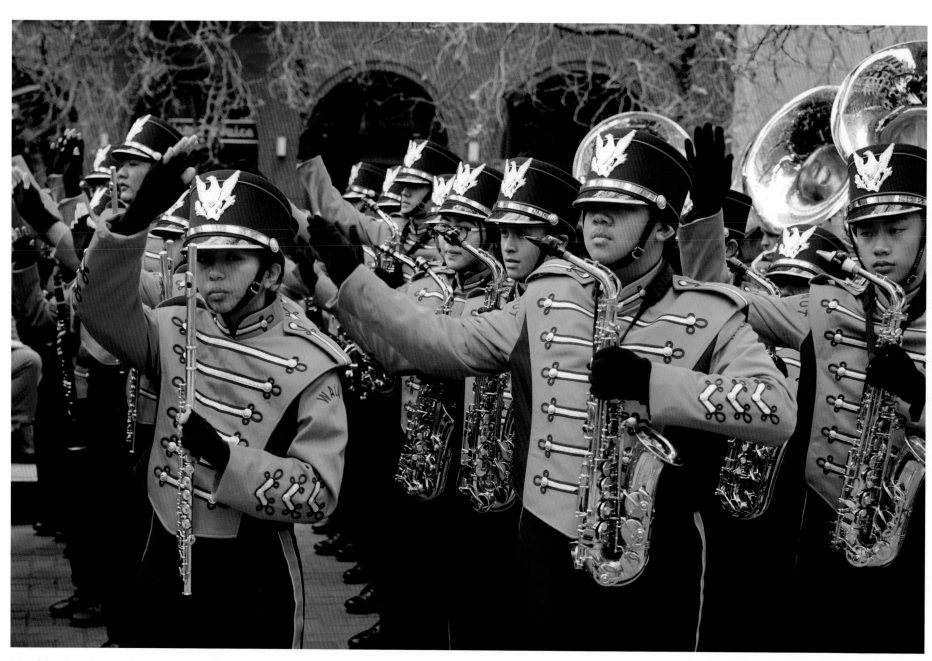

Marching band steps in time at the Chinese New Year Parade.

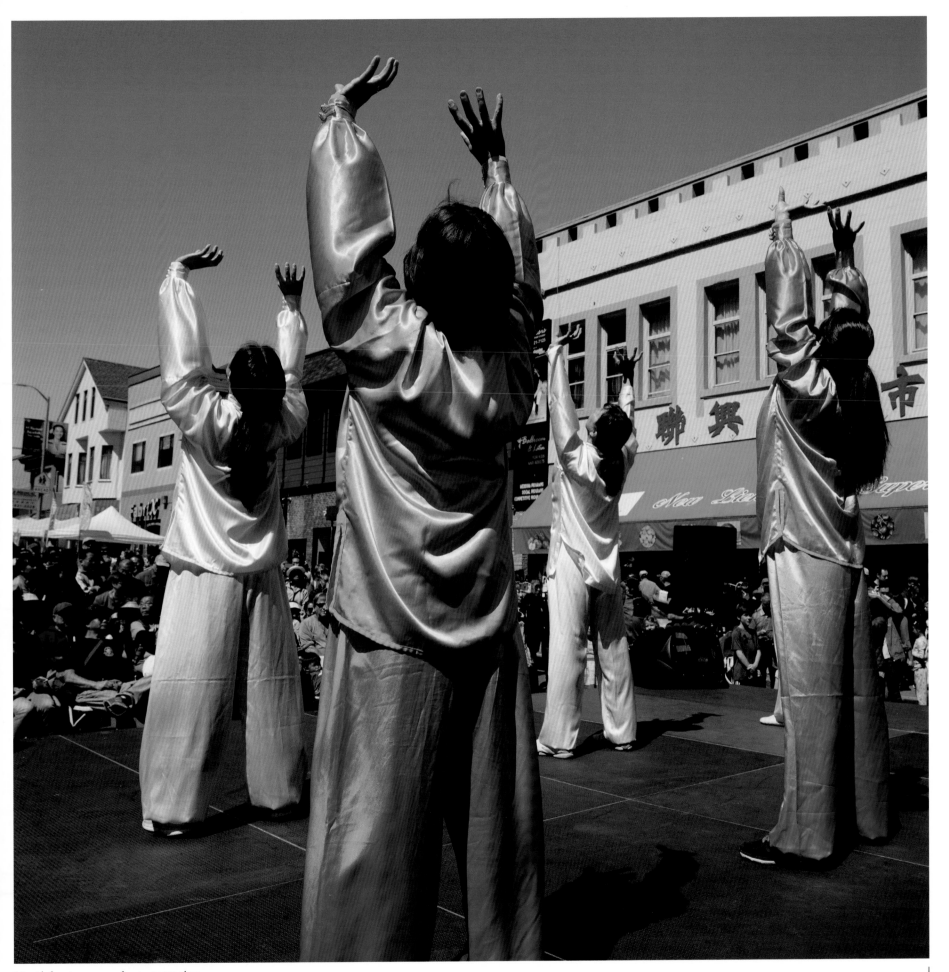

Martial arts group demonstration.

RED ENVELOPES

No color compares to the auspiciousness of red in Chinese culture. The color of success, the color of wealth, the color of happiness, the color of longevity—it is a catchall for everything good in life. That is why the Chinese money envelopes, known as *hung bao*, are red.

According to one Chinese myth, a monster would come out annually before Chinese New Year, devouring livestock and people. To combat this rampage, the villagers set out red firecrackers and red lanterns to scare it away. The deafening racket and threatening color stopped the monster from appearing again, and the tradition of lighting firecrackers and hanging red lanterns carries through to today.

The red-envelope history stems from the early dynasties of China when currency came in the form of coins with square holes in the center. During Chinese New Year, families gave out a chain of coins strung together with a red string. Later, when bills were printed, it only made sense that red envelopes were used to hold the paper money.

Today, red envelopes signify wishes for blessing and prosperity. Chinese married couples distribute *hung baos* to parents, single siblings, and children during Chinese New Year. Notes must be new and crisp, never used. In China and Hong Kong, employers hand out envelopes to their staff. Friends may even distribute them among peers. Guests typically give newlyweds a red envelope embossed with the double-happiness character. *Hung bao* as a baby gift or a birthday present is also appropriate.

And when Chinese aren't sure of what type of gift to buy, a red envelope stuffed with cash always seems to save the day.

CLOCKWISE FROM TOP LEFT: Tyler Pham holds up his *hung baos* in front of *Lady Liberty*, a mural by Luke Dragon on Clay Street. Modern *hung baos* come in multiple hues. Golden pig wall hanging commemorating 2019 Year of the Pig. Traditional *hung baos*. *Zodiac Wall*, a collage mural by the Law family, on Jack Kerouac Alley.

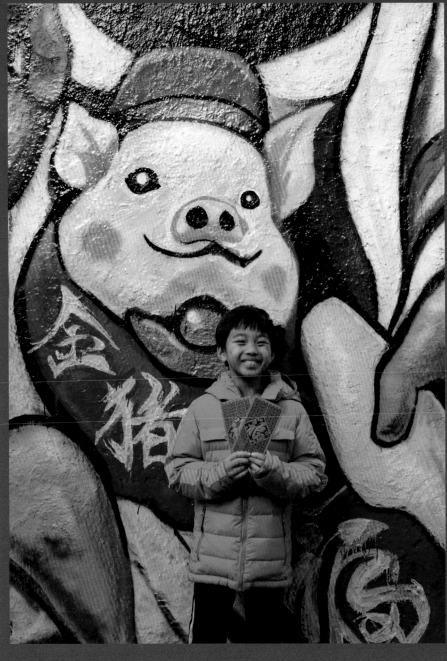

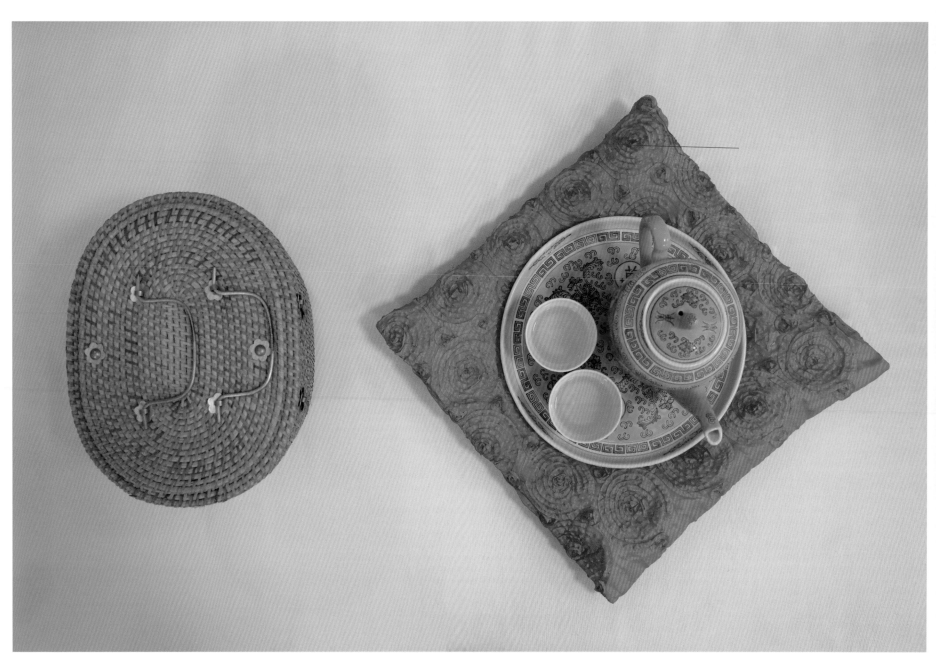

Tea set prepared for a Chinese wedding tea ceremony.

Newlyweds Leanna Tu and Michael Teng.

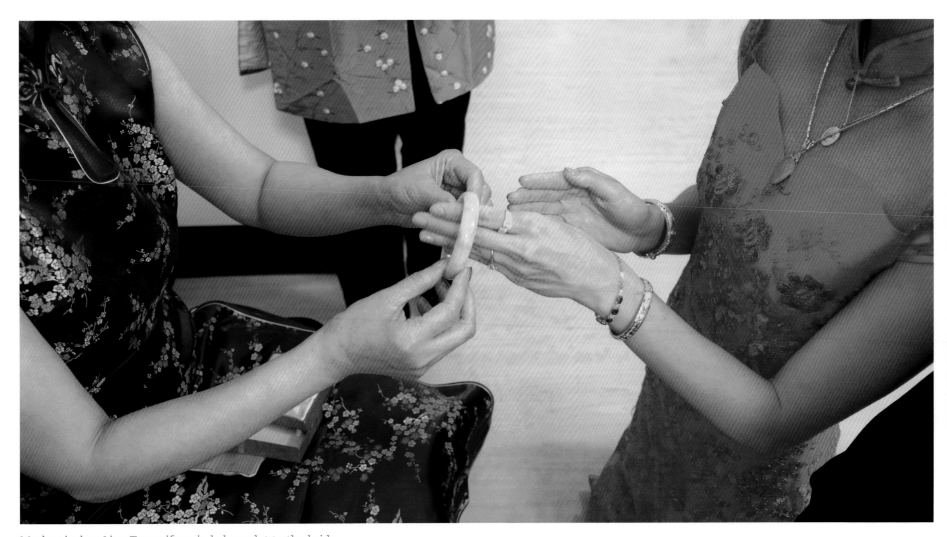

Mother-in-law Liyu Teng gifts a jade bracelet to the bride.

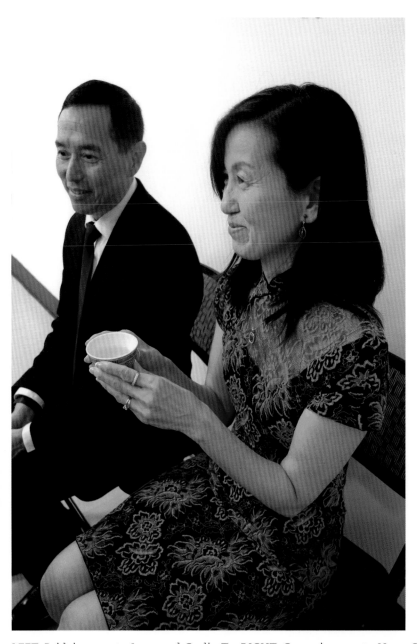
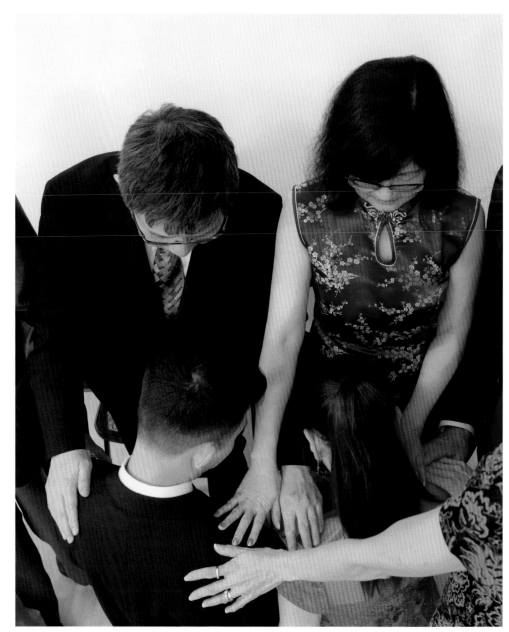

LEFT: Bride's parents, Jerry and Carlin Tu. RIGHT: Groom's parents, Yong-Guang and Liyu Teng, and family pray for the couple.

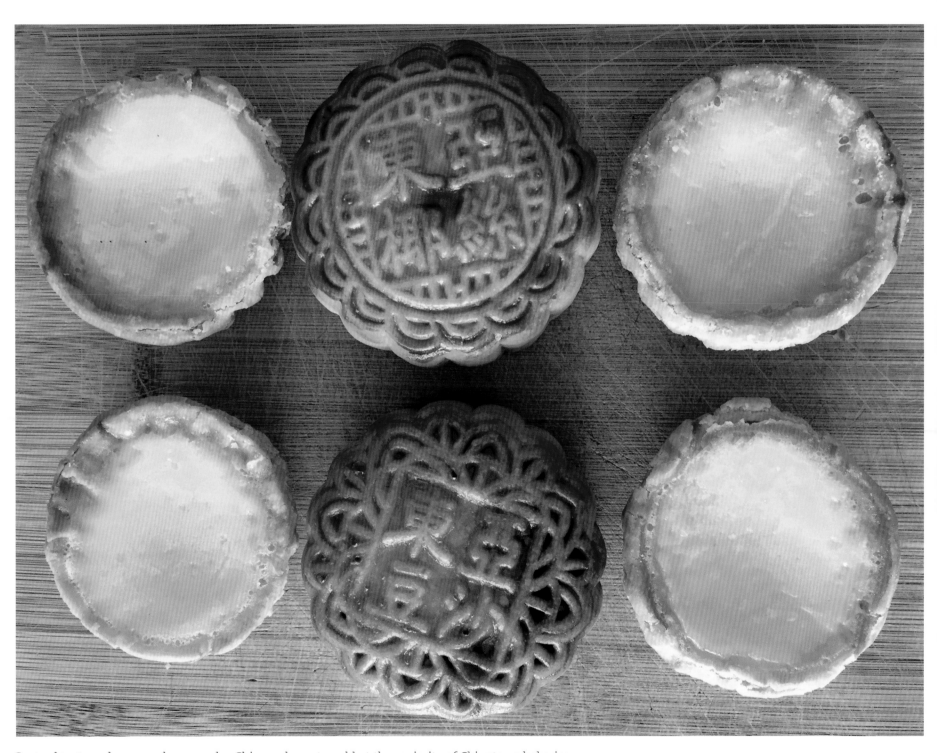

Custard tarts and moon cakes, popular Chinese desserts, sold at the majority of Chinatown bakeries.

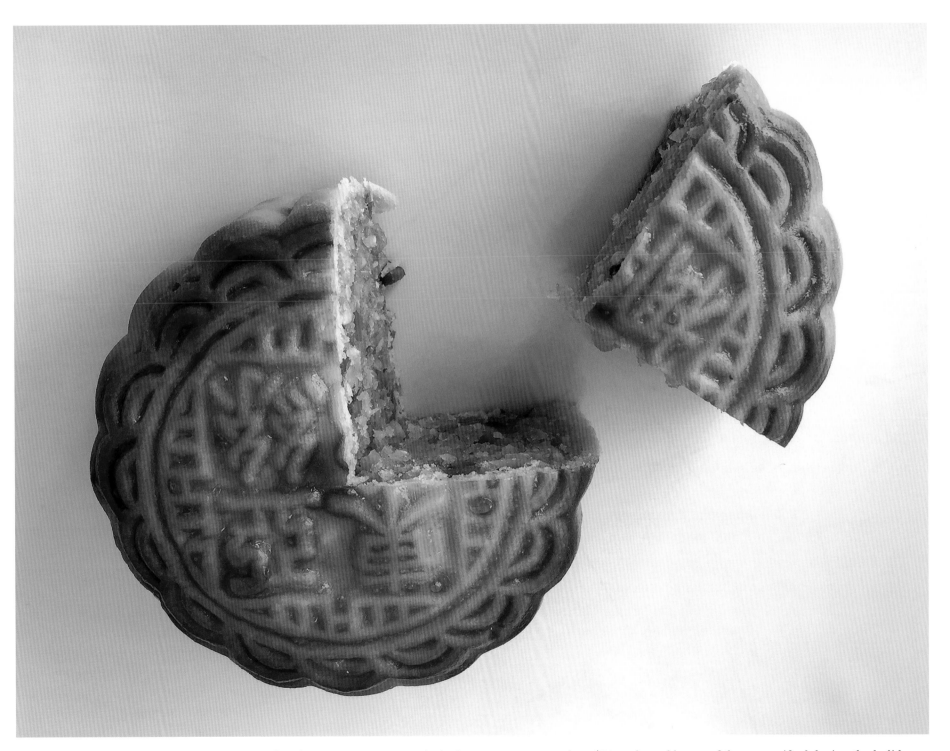

Dense, sweet moon cakes are a must-have during the Autumn Moon Festival. They can cost as much as $10 each, and boxes of them are gifted during the holiday.

MISS CHINATOWN

Winning the 2019 Miss Chinatown U.S.A. competition was the proverbial dream come true for Katherine Wu. But it wasn't her only dream. The world-ranked athlete from San Francisco practices archery up to five hours a day, aiming for a spot on the US Olympic team. And when she visited schools and read books to preschoolers after her pageant victory, the goodwill ambassador seized the chance to tell children, "Work hard, be kind, and amazing things will happen."

To be eligible for the coveted crown, every applicant must be between the ages of seventeen and twenty-six, and of Chinese descent. Past honorees include a tech entrepreneur, an Emmy-winning TV journalist, and a software engineer. Rose Chung, the 1982 Miss Chinatown U.S.A., was born and raised in the neighborhood. "You can imagine me being the poor girl fantasizing about the life of Miss Chinatown," she said in an interview for the Chinese Historical Society of America. "It changed my life. I have never had a boring day in my life."

Chinese American beauty pageants date back to 1915. The contests were held in great esteem by the community because in the 1930s, the Miss America pageant was open only to those "of good health and of the white race." The rule would not be revoked until 1940. But even then, Chinese women were hesitant to enter.

By 1953, San Francisco's Chinese Chamber of Commerce had created the Miss Chinatown contest for local participants. Five years later, the chamber renamed it Miss Chinatown U.S.A. as a way of inviting Chinese women all over the country to participate. Today, the winner receives $10,000 in cash and makes appearances as a cultural ambassador. "The moment I was crowned Miss Chinatown U.S.A.," says Wu, the 2019 winner, "it was no longer about me. It's about inspiring others to be the best they can be."

CLOCKWISE FROM LEFT: Katherine Wu, 2019 Miss Chinatown U.S.A. Practicing archery. Playing with students from Wah Mei School. Aiming for the US Olympic archery team.

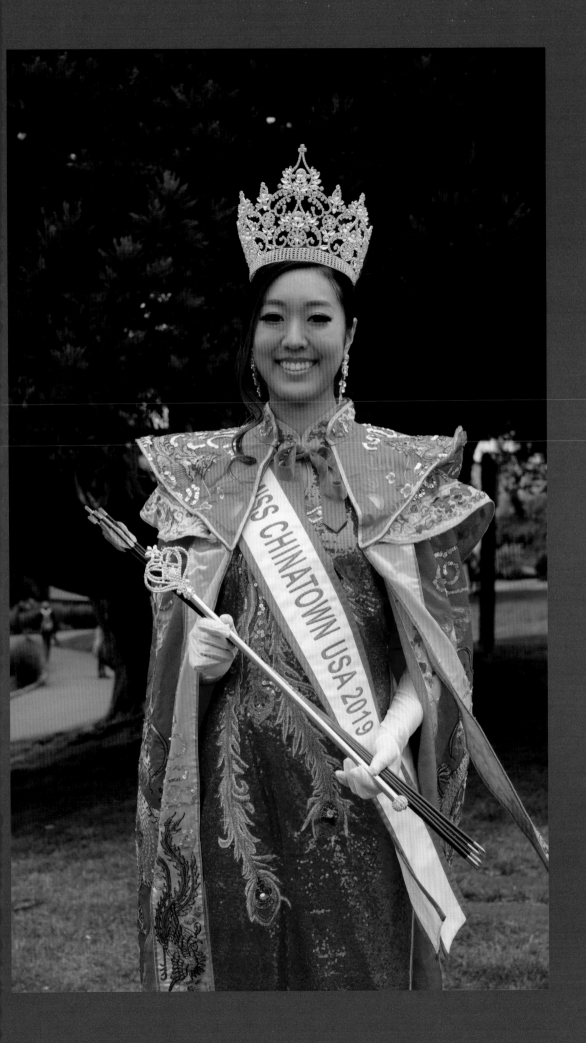

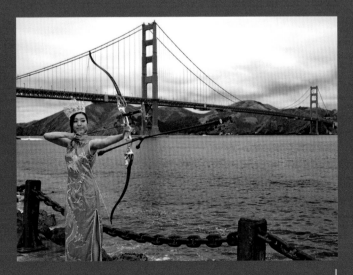

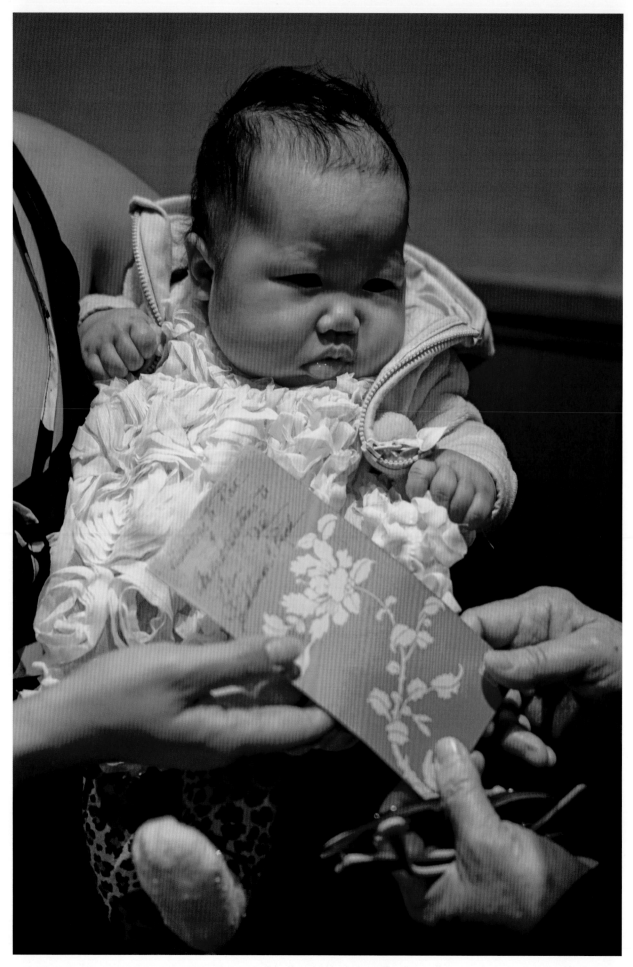

Lucky red envelope containing money for Baby Rose.

Baby Rose Tong Ahn with her immediate and extended family at Far East Café for her Red Egg and Ginger party, a traditional coming-out celebration.

TOP: Baby Rose's "welcome to the world" cake.
BOTTOM: This Jello dessert is red for good fortune.

Lucky red party punch
for additional prosperity.

GREEN STREET MORTUARY BAND

It is a familiar sight and sound in Chinatown. The uniformed marching band playing soulful hymns. The rolling rat-tat-tat of the snare drum. The photo of the deceased on the roof of a custom-built Cadillac. For more than a century, funeral bands have led processions for Chinese families honoring loved ones with a final farewell.

When author Amy Tan's mother, Daisy Tan, passed away, Amy requested the band to play "Daisy Bell" on every corner in Chinatown. "It was marvelous," recalls Lisa Pollard, the band leader for over twenty-five years. "We were lucky and felt honored to be a part of this beautiful, honorable tradition."

The beloved institution started in 1911 when Chinatown shop owner Wilson Wong formed the Cathay Boys Band made up of Chinese and Anglo boys. They performed before adoring crowds throughout San Francisco and were soon asked to play at Chinatown funerals. By the mid-1950s, however, the group disbanded.

In 1992, manager Clifford Yee from the Green Street Mortuary in North Beach approached jazz musician Lisa Pollard with the opportunity to start a funeral band. She convinced trumpeter and musical arranger John Coppola to be its first musical director. The working partnership between Pollard and Coppola happily turned into a marital one. Years later, Pollard took the reins after her husband passed away.

The ten-member Green Street Mortuary Band has faithfully kept to its mission of offering comfort and closure. Clad in a uniform of military caps with gold trim, crisp white shirts, and black suits, the band plays a variety of music. Hymns, classics, and the occasional Chinese folk song permeate Chinatown's streets during a typical procession. "There is a lot of love in what we do," says Pollard. "Our musicianship elevates the service into something singularly special for the family."

ALL: The Green Street Mortuary Band plays a Chinese funeral processional. TOP LEFT: Lisa Pollard, music director.

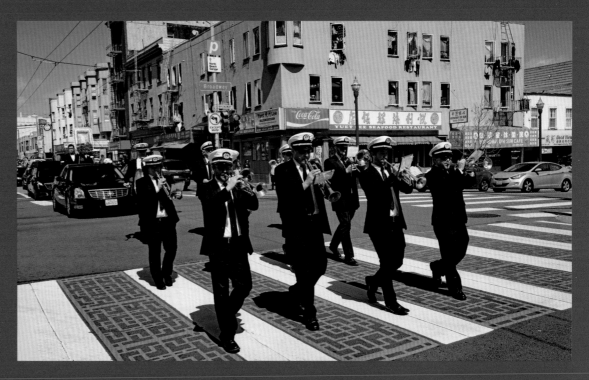

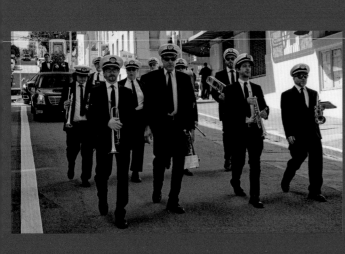
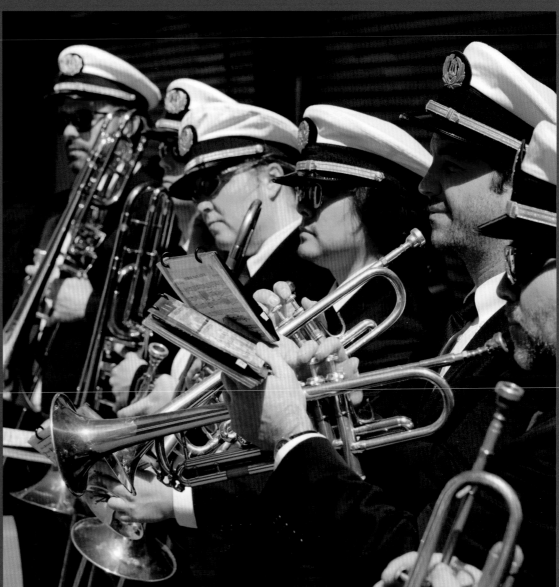

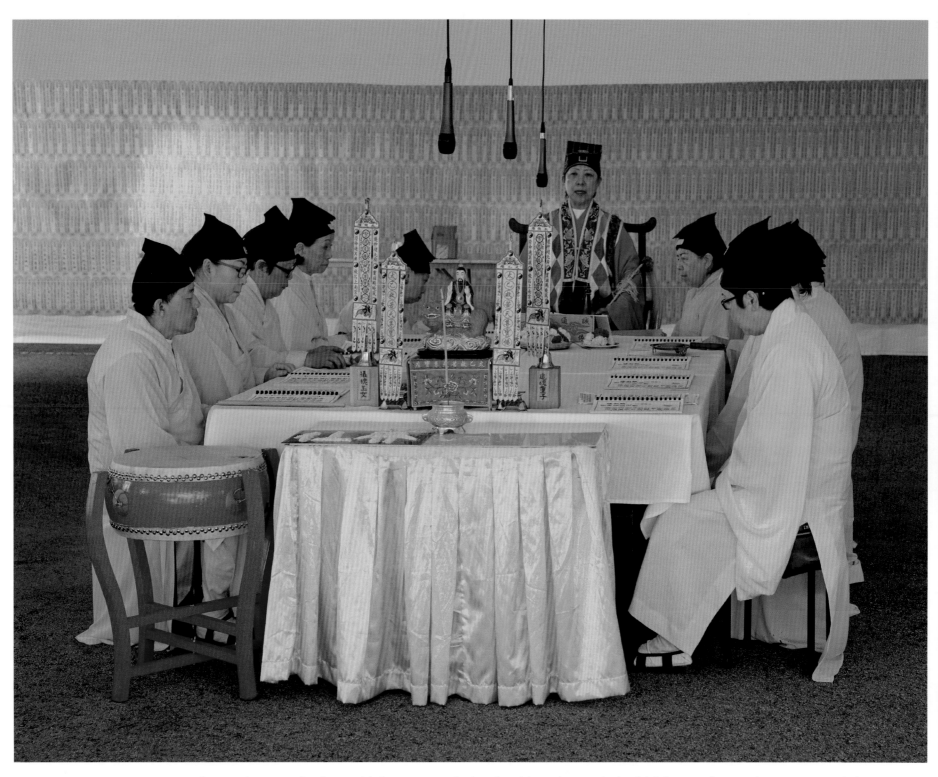

ABOVE AND OPPOSITE: Lotus Taoism Institute monks chant with instruments during the Ching Ming Festival, which honors deceased ancestors, at Skylawn Funeral Home and Memorial Park in San Mateo.

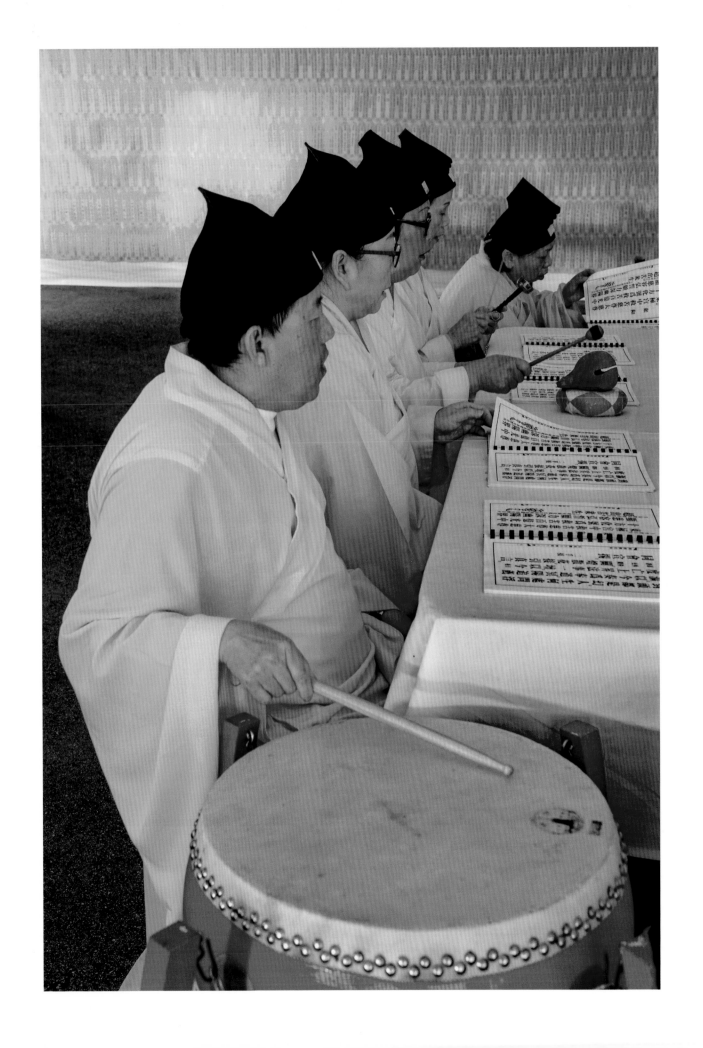

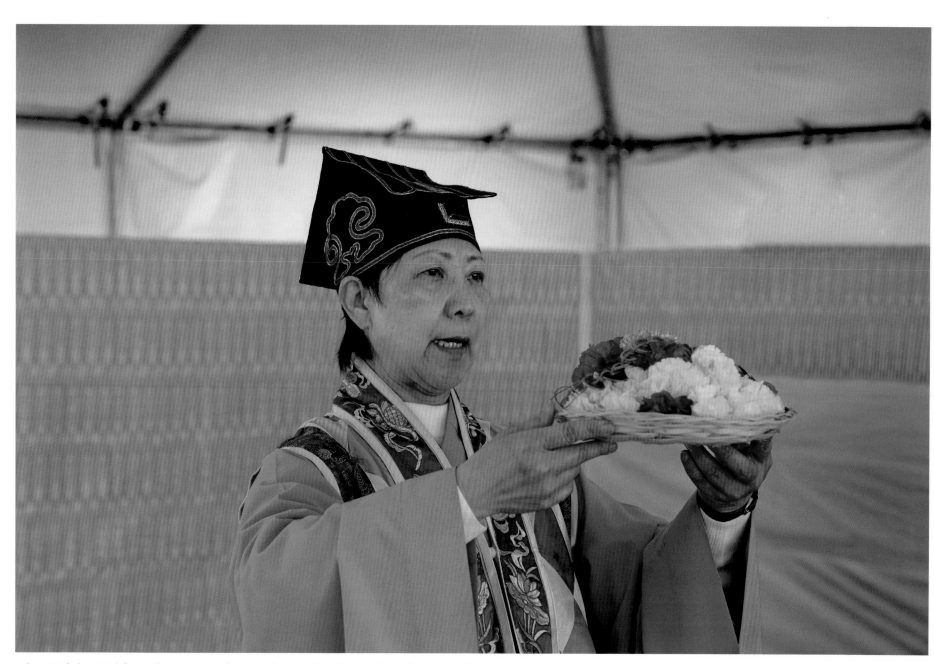

Priest Melaine Wai from the Lotus Taoism Institute offers flowers in a ritual to relieve human suffering.

Preparing bags of money and other symbolic items to burn at gravesides for Ching Ming.

CLOCKWISE FROM TOP LEFT: Golf-themed headstone at Skylawn Funeral Home and Memorial Park in San Mateo. Ceremonial gate with stone lion for protection. Tibetan prayer flags. Gate at Skylawn.

LEFT AND RIGHT: Kuan Yin, goddess of mercy and compassion, overlooks the Pacific Ocean.

Musician Chen Xiao Hua tunes a *guzheng*, or Chinese zither, for an opera performance at the Scottish Rite Masonic Center.

Stagehand Chan Tsz Wing erects props for the upcoming opera performance.

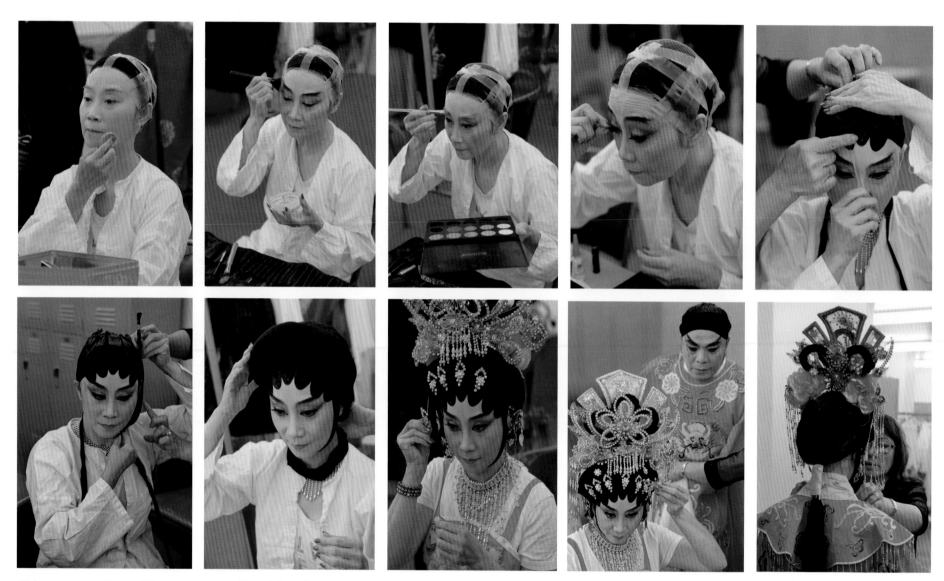

Chinese opera singers Zheng Nan Feng (female) and Zhou Zhan Zhong (male) of My Opera Institute prepare for a show at the Scottish Rite Masonic Center.

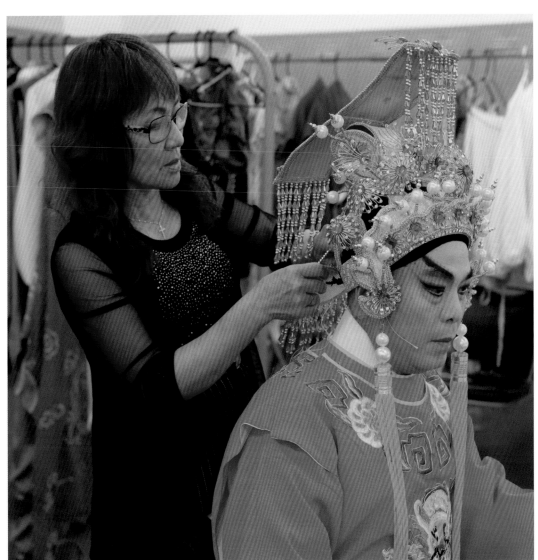

LEFT AND RIGHT: Zhou Zhan Zhong prepares for the upcoming performance.

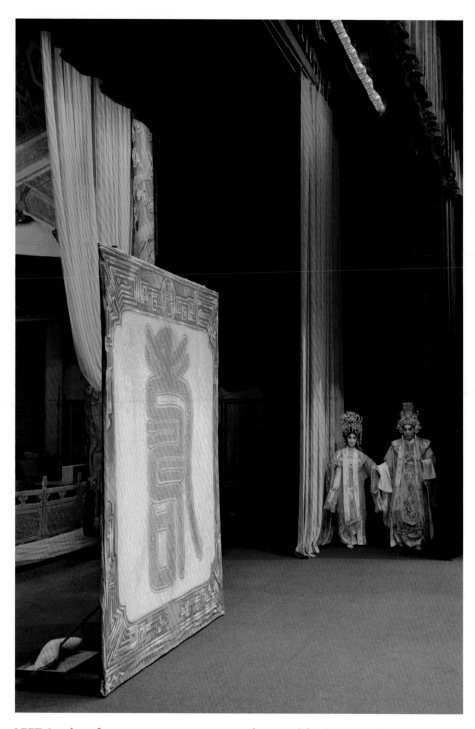

LEFT: Lead performers emerge onstage at the Scottish Rite Masonic Center. RIGHT: Zheng Nan Feng (left) and Zhou Zhan Zhong (right) pose with Eva Tam (center), founder of My Opera Institute. OPPOSITE: Cantonese opera delivers on pageantry and storytelling.

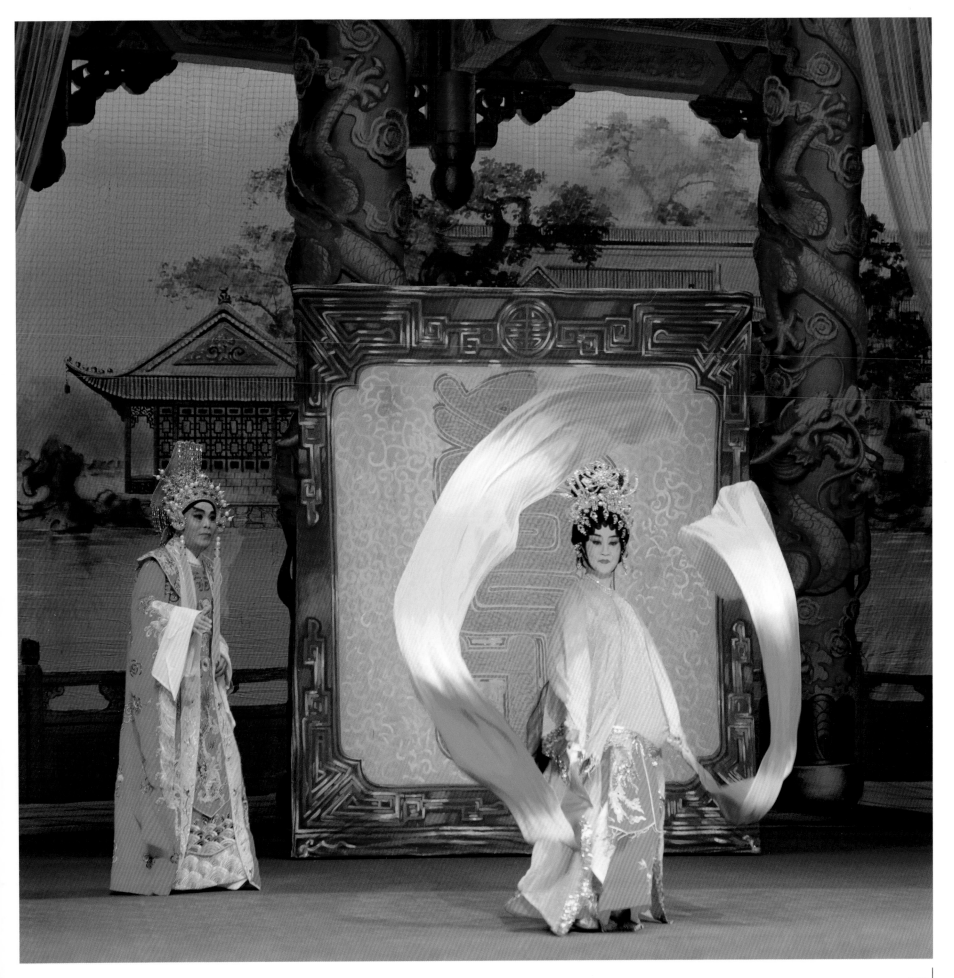

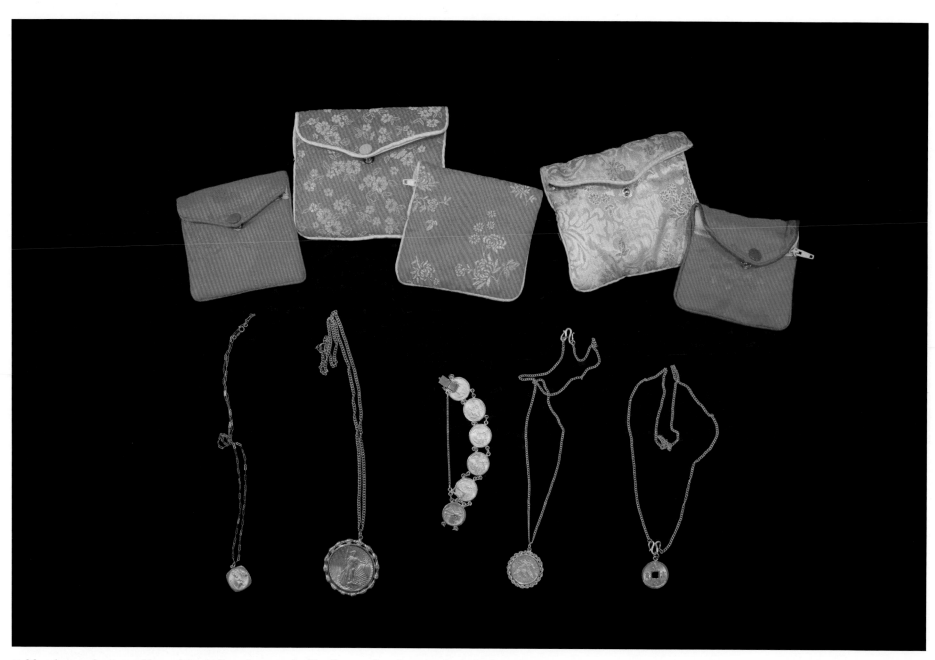

Gold-coin pendants and bracelets, believed to ward off evil, are often kept in the safe-deposit boxes of Chinese American families.

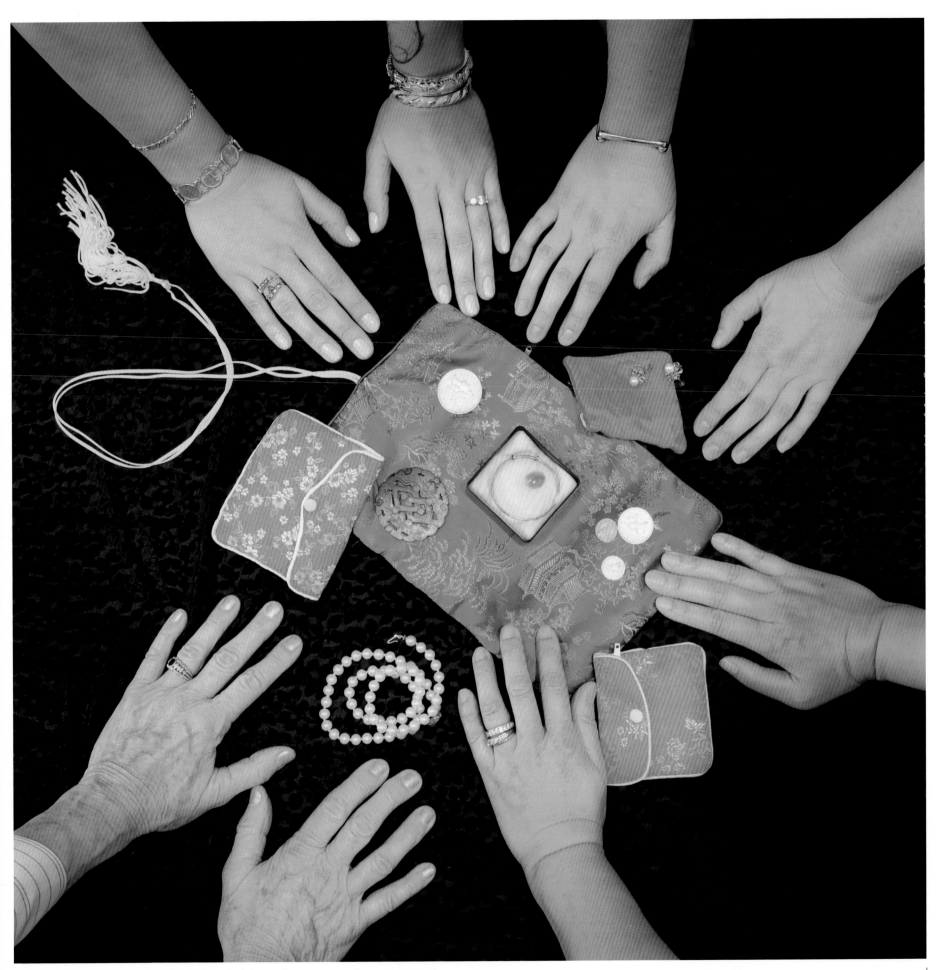

Quintessential Chinese jewelry is handed down from generation to generation.

Close-up of 24-karat dragon bracelet.

Maeve Lai Fong
MacLysaght models
family heirlooms.

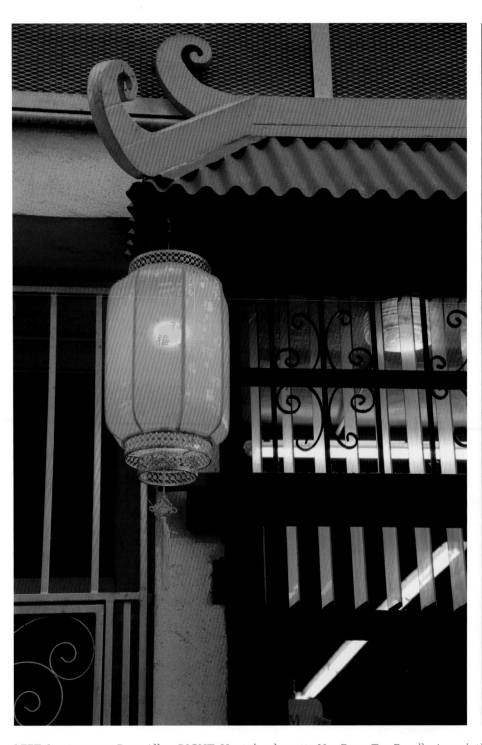

LEFT: Lanterns on Ross Alley. RIGHT: Upstairs doors to Yee Fung Toy Family Association on Waverly Place.

PHOTOGRAPHER'S STATEMENT

Midway through this project, I took some shots from the Hilton Hotel rooftop. The perspective from five hundred feet is quite different from that at ground level. What struck me most is that Chinatown is an island, surrounded by high-rise buildings to the east, south, and west. Only to the north, where it borders North Beach, is there a less dramatic demarcation. Still, it is absolutely clear where San Francisco stops and Chinatown begins.

Perhaps this is not surprising, given the almost two-hundred-year history of the neighborhood and the deep commitment to its culture. The value of these twenty-four square blocks for potential development adjacent to the Financial District is in the billions of dollars. Yet, powerful safeguards are in place to keep that from happening. One of my aspirations for this book was to identify and document the people, culture, and organizations that have contributed to such a resilient community.

One of the first organizations that I contacted to help understand Chinatown was the Chinese Culture Center of San Francisco (CCC). They were immediately supportive of the project and became important collaborators. May Leong, interim executive director during the early stages of the project, became a key sounding board. Even after accepting another career opportunity, she has continued to be an invaluable contributor to and cultural liaison for the project. Cora Yang, the current executive director of CCC, has continued the vital support.

Early on in the project, I recognized that I needed someone to help uncover Chinatown's stories. Fortuitously, I read an article about America's Chinatowns in the *New York Times*, and that is how I found Bay Area freelance writer Kathy Chin Leong, who has now interviewed over one hundred people and written the text for the book and for the website. Kathy has become a true partner in the creation of this book.

There have been many other supporters and advisors, as well as dozens of (mostly) patient photo subjects. I would like to especially thank Maggie Wong, Frank Jang, Sue Lee, Gimmy Park Li, Betty Louie, Yasemin Kant, and Rev. Norman Fong for their help. The acknowledgements to this book include many others who contributed to this portrait of today's Chinatown.

Technical Note: Images in the book were taken with a Sony A7 RIII camera body with Sony/Zeiss lenses at 24–105mm, 24–70mm, 16–35mm, and fisheye focal lengths.

Maggie Wong and Welson Tso tell the story of the Moon Goddess for the Autumn Moon Festival as they stroll through Chinatown in costume.

ACKNOWLEDGMENTS

Developing a project of this magnitude takes tremendous resources and coordination. This book could not have been completed without the support of Chinatown insiders who provided interviews and access to family association halls, SROs, and abandoned spaces; Chinatown merchants who offered behind-the-scenes tours, meals, and lodging; long-suffering friends and family members who chauffeured us to historic sites, posed as models, and corralled their friends for photo shoots; and professional writers and Chinese American history experts who pored over the text for grammar, style, and accuracy. May Leong, consulting editor and former interim executive director of the Chinese Culture Center of San Francisco, was crucial to the team from the outset. She located hard-to-find sources, set up our photo shoot for World Tai Chi Day, proofread every line, helped curate photos, and advised on the direction and overall feel of the book.

While we are unable to list all the people who participated in interviews or photo sessions—thank you, if you are one of them!—we are humbled and grateful for the opportunity to hear their stories and get a glimpse of their daily lives in this constantly evolving place, which is, and will forever be, a Chinatown for the people. It has been an honor.

Debbie Au
Corey and Laurene Chan
Jason Chan
Mike and Mae Chan
Norma Fong Chan
George Chen and Cindy Wong-
 Chen
Cecilia Chiang and family
Eric Chin
Gordon Chin
Harvey Chin
Susie Chin
William Chin
Jeff Chinn
Nolan Chow
Juli Cortino
Francis Der and San Francisco
 Wing Chun students
Gretchen Evans
Kathy Fang
Alex Fong
Ben Fong-Torres
Linda Fong
Rev. Norman Fong
Ron Fong
Henry Ha and Community Youth
 Center Dragon Boat team
Kelly Harris and Hilton San
 Francisco Financial District
 staff

Darryl Honda
Steve Hong
Frank Jang
Jennifer Jansons
C. K. Jeong
Yasemin Kant
Susan Kerr
Yulanda Kwong
Al and Susan Lam
Kari Lee
Linda Lee
Sue Le
Aaron Leong
Frank Leong Jr.
Gwen Leong
Russell Leong
Marguerite Zientara Lessard
Gimmy Park Li
Ningyao Li
Betty Louie
Diana Luoh
Alice Luong
Scott Mace
Maeve Lai Fong MacLysaght
Rory MacLysaght
Jaynry Mak
Darryl Mar
Ben Mok

Rachel Ng
David Needle
Tina Pavao
Aaron Peskin
Sally Chin Pham
Tyler Pham
Julie Pitta
Lisa Pollard
Debbie Recine
Nancy Ruhle
Ron Tong
Simon Tsui
Maggie Wong
Matt Wong
Tamiko Wong
Katherine Wu
Calvin Yan
Cynthia Yee
Larry Yee
Lauren Yee
Nancy Lim Yee
Ed Ying and family
David and Vivian Young
Elle Young
Tanner Young
Judy Yung
Michelle Zhang
Shu Fen Zhou

Photo by Christin Evans

Photo by Francis Der

ABOUT THE AUTHORS

DICK EVANS, a San Francisco–based photographer with an interest in documenting the colorful and rapidly changing neighborhoods of the city, is the author of *San Francisco and the Bay Area: The Haight-Ashbury Edition* and *The Mission*, a finalist for the 2018 Next Generation Indie Book Award in the art category. Born into a ranching family in Eugene, Oregon, he graduated as an engineer from Oregon State University and subsequently obtained a master's in management from Stanford. He has spent his fifty-year career in the global metals sector, living in five countries and multiple locations in Africa, Europe, and North America. It was during these travels that he developed an appreciation for the diversity and richness of different cultures—both global and local—and an interest in documentary photography.

KATHY CHIN LEONG is an award-winning journalist who has been published in the *New York Times*, *Los Angeles Times*, *Sunset Magazine*, and many other newspapers and magazines, as well as *National Geographic* books. She is the executive editor of BayAreaFamilyTravel.com, an online magazine for families who love adventure. As a second-generation ABC (American-born Chinese), she grew up in San Francisco's Sunset District and spent nearly every weekend in Chinatown visiting her grandmother and helping her mother shop for groceries. Though she has traveled widely, rediscovering her Chinatown roots through her work on this book has been the journey of a lifetime. She lives in Sunnyvale, California, with her devoted husband, Frank Leong Jr., and is the proud mother of two grown children, Gwendolyn and Aaron.

Banners for the Chinese Culture Center of San Francisco, located on the third floor of the Hilton Hotel on Kearny Street.

ABOUT THE CHINESE CULTURE CENTER OF SAN FRANCISCO

750 Kearny St, 3rd Floor
San Francisco, CA 94108
https://www.cccsf.us/
@cccsanfrancisco

Chinese Culture Center (CCC), an arts organization and the artistic hub of Chinatown, is deeply rooted in the community and focuses on social justice issues. CCC exhibits art in its gallery as well as on the streets of Chinatown through its Museum Without Walls initiative. CCC also offers educational programs: Artbuds teaches visual literacy to the youngest of students, and Chinatown Tours presents a specially curated tour of the community through a social justice lens. CCC's annual dance and music festivals provide unique platforms for musicians and dancers in Chinatown's alleyways and public spaces.

CCC's reputation as a cultural and artistic leader has been celebrated by many awards, including Best Public Art by KQED, a National Endowment for the Arts' Our Town grant, and a finalist for the Americans for the Arts' Robert E. Gard Award.

The author has dedicated his portion of the proceeds of this book to CCC.

Lanterns descend over the Peking Bazaar Building on Grant Avenue.

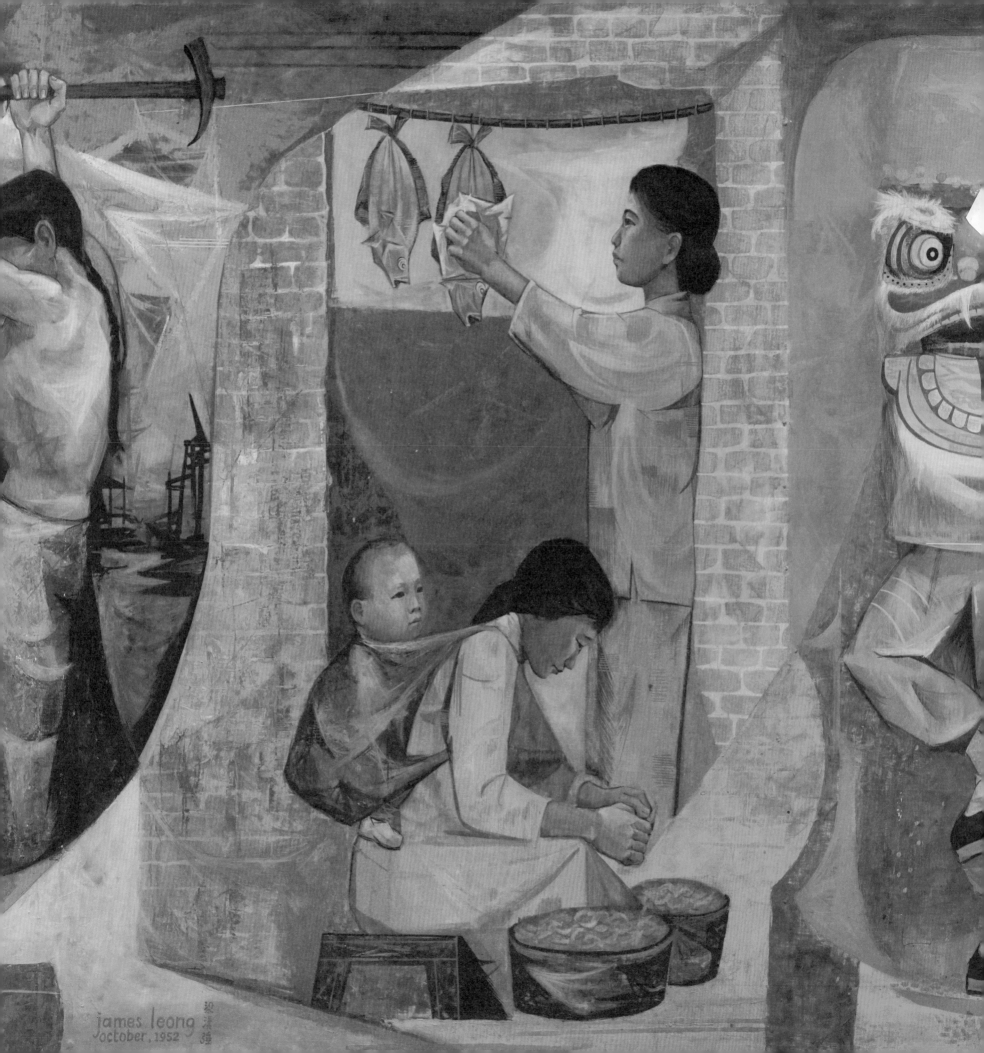